MUSEUM OF THE MISSING

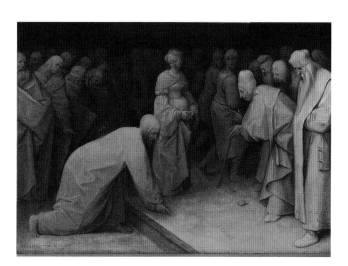

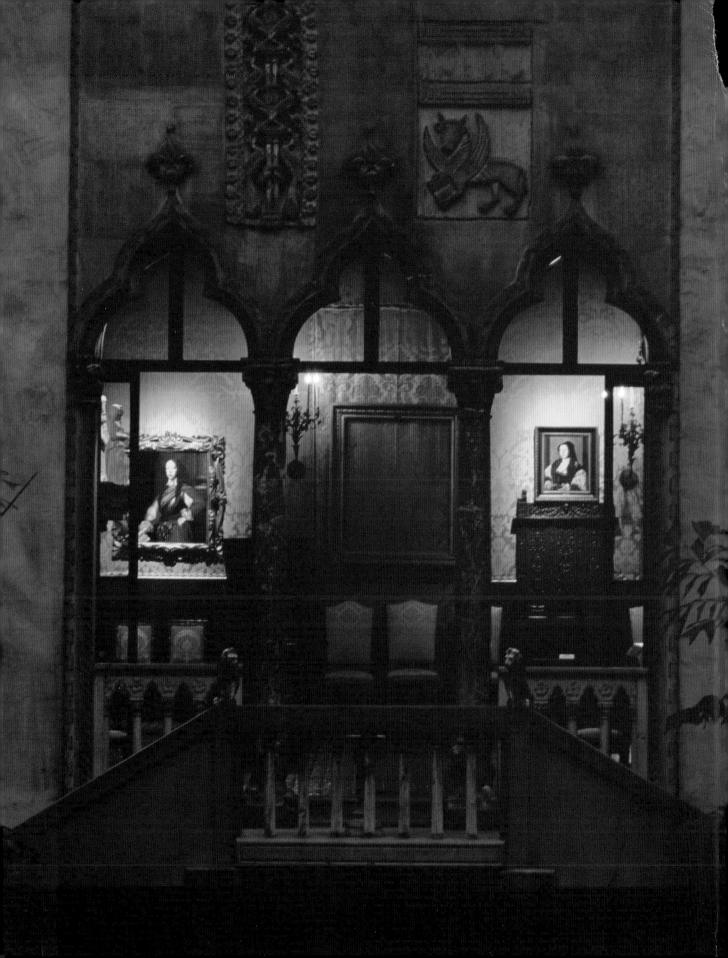

MUSEUM *of the* MISSING

THE HIGH STAKES OF ART CRIME

SIMON HOUPT

FOREWORD BY JULIAN RADCLIFFE
CHAIRMAN OF THE ART LOSS REGISTER, LONDON

KEY PORTER BOOKS

A KEY PORTER BOOKS LTD./MADISON PRESS BOOK

This edition published by Key Porter by arrangement with The Madison Press Limited.
Text © 2006 Simon Houpt
Foreword, Jacket, Design, and Compilation © 2006 The Madison Press Limited

Library and Archives Canada Cataloguing in Publication
Houpt, Simon
Museum of the missing / Simon Houpt.
ISBN 1-55263-869-3
1. Art thefts. I. Title.
N8795.H68 2006a 364.16 '2 C2006-903143-6

Printed and bound in China.

06 07 08 09 10 5 4 3 2 1

THE CANADA COUNCIL | LE CONSEIL DES ARTS
FOR THE ARTS | DU CANADA
SINCE 1957 | DEPUIS 1957

ONTARIO ARTS COUNCIL
CONSEIL DES ARTS DE L'ONTARIO

The publisher gratefully acknowledges the support of the Canada Council for the Arts and the Ontario Arts Council
for its publishing program. We acknowledge the support of the Government of Ontario through the Ontario Media
Development Corporation's Ontario Book Initiative.

We acknowledge the financial support of the Government of Canada through the Book Publishing
Industry Development Program (BPIDP) for our publishing activities.

Key Porter Books Limited
Six Adelaide Street East, Tenth Floor
Toronto, Ontario
Canada M5C 1H6
www.keyporter.com

Note: All dollar values in the text are given in U.S. currency, unless specified otherwise.

Every effort has been made to ensure the accuracy of the information contained in the text. We acknowledge,
however, that there are sometimes multiple (and sometimes conflicting) authoritative sources regarding artworks
and artists. If any error has been made unwittingly, we will be happy to correct it in future editions. Please
direct any comments to the Editorial Department, Madison Press Books (see address below).

Produced by Madison Press Books
1000 Yonge Street, Suite 200
Toronto, Ontario
Canada M4W 2K2

CONTENTS

FOREWORD BY JULIAN RADCLIFFE
THE TRADE IN STOLEN ART / 6

INTRODUCTION / 10

CHAPTER ONE
ART AS A COMMODITY / 14

CHAPTER TWO
THEFT IN A TIME OF WAR / 30

CHAPTER THREE
THE UNCOMMON CRIMINAL / 70

CHAPTER FOUR
THE LOST ART DETECTIVE AGENCY / 104

CHAPTER FIVE
THE SPACE ON THE WALL / 132

APPENDIX
GALLERY OF MISSING ART / 146

PICTURE CREDITS / 178

INDEX / 183

SELECTED BIBLIOGRAPHY / 190

ACKNOWLEDGMENTS / 191

THE TRADE IN STOLEN ART

As you will realize in reading the pages of this book, art theft has become a global problem. It is a crime that affects all of us. Nearly half of all items recovered by the Art Loss Register are found outside the country where they were stolen. For high-value pieces, the number taken out of the country of origin is even higher. Great amounts of money are involved, there are links to organized crime, and the lost pieces of our cultural heritage are irreplaceable. Yet with the exception of Italy, art theft is a low priority for most of the world's police forces. Why is this so?

Unfortunately, since the general public does not recognize the serious-ness of the issue, elected politicians are reluctant to spend taxpayers' money on the resources needed to deal with such crime. And Interpol, the international police organization, can only facilitate the sharing of infor-mation among different police forces. It does not have the jurisdiction to conduct investigations.

The solution, at least in theory, is an international database of stolen art. If everyone involved in the art trade searched such a database before making a purchase, then any unique stolen item (which, by definition, would include the most valuable stolen pieces) would be identified and recovered. Consistently following this procedure would not only recover stolen art but also develop a considerable bank of criminal intelligence by revealing the chain of buyers and sellers. Since art would become less valuable to thieves because of the difficulty in selling it, there would be reduced criminal activity in the art world.

Opposite: In 1994, thieves broke into the National Gallery in Oslo, Norway, by entering through a smashed window. They emerged moments later with Edvard Munch's *The Scream*. Months later, the painting was recovered. A second version of *The Scream*, stolen from the Munch Museum in 2004, has never been recovered.

There is already evidence that systematic searching is having a beneficial effect. The Art Loss Register first became available to auction houses in 1992, with a relatively small database of just 20,000 items. At that time, the Art Loss Register routinely found one match per 5,000 searches for Sotheby's and Christie's. Often the stolen items were consigned by a handler, or fence, with close ties to the thief. As the size of the database has increased over the years—currently, approximately 170,000 items are listed—the number of matches has actually declined to about one per 11,000. In part, this is because the auction houses themselves have tightened up their procedures. More significant, however, is the reluctance on the part of those in possession of items of doubtful provenance to risk selling them where a database search is likely. These days, when a stolen item is discovered in a respectable auction house or dealer's inventory, it is less likely to have been consigned by a fence than by a good-faith purchaser who should have carried out more due diligence before buying the work.

Why has it taken so long for the art trade to adopt the database search as the foundation of due diligence when secondhand-car dealers, for example, accept the practice as a matter of course?

The art trade is unregulated. Trade associations are relatively weak, rely entirely on their members for subscriptions, and have little capacity to enforce rules. Many dealers flatly deny that there is a problem. Some resent the cost. And then there is the added time and effort required when a search turns up a stolen item that must somehow be returned to its rightful owner. This, in turn, might lead to questions that could adversely affect the dealer's reputation. In addition, all dealers value their confidential relationship with sources and clients and are unwilling to risk either.

While stolen art may represent a very small proportion of the total volume of the annual turnover in art and antiquities, it still represents a relatively high proportion of the profits made. When a stolen item is recovered, it is usually apparent that the dealer involved has bought a high-quality item at a price way below its true value. In much the same way, dealers sometimes stumble upon a "sleeper," that is, an object that has not been recognized for what it really is and consequently can be acquired at a bargain price. In short, there is money to be made in stolen art.

So perhaps it's not surprising that with the exception of the major auction houses, the most reputable dealers and the most prestigious fairs (such as Maastricht), the trade has been reluctant to make a database search part of routine practice.

Fortunately, the law in most countries is changing. In the past, buyers often have been able to claim title to a stolen object as long as they could demonstrate that it was acquired in "good faith." Increasingly, they have to show some evidence of due diligence, either search of an established database or proof of legitimate provenance. Provenance used to be of interest primarily to prove authenticity; now the historical record may constitute a defense in a title dispute. (The dispersal of significant art collections as a result of the Holocaust has given the historical record particular significance in recent years.) Major museums and collectors now require their acquisitions to come with a full provenance and search certificate.

Still, efforts to recover stolen art need to be integrated into an overall strategy. It is especially important that victims of theft be dissuaded from paying for the return of the stolen item with no questions asked and without telling the police—a course of action this is both counterproductive and often illegal. There is a clear difference between paying a reward (with the permission of the police) for information that leads to useful intelligence, and the payment of a ransom. A ransom—payment made under duress without police permission—merely benefits and encourages the criminals.

As searches and recoveries become customary, media coverage will be devoted increasingly to the success stories rather than to the devastating loss of yet more precious items. Organizations such as the Art Loss Register are hugely important in raising global awareness of art theft and the efforts to thwart it. So is a timely book like *Museum of the Missing*.

—Julian Radcliffe
Chairman of the Art Loss Register

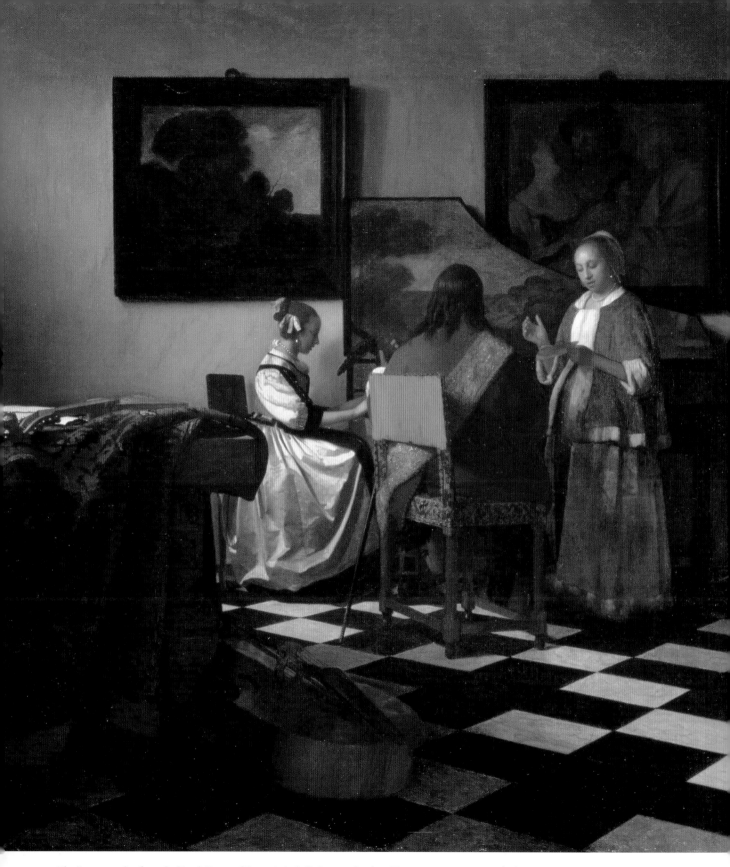

The Concert, stolen from the Dutch Room of Boston's Isabella Stewart Gardner Museum in 1990, is one of Johannes Vermeer's mid-career works, painted circa 1664–1667. It is still missing.

INTRODUCTION

It may be the most haunting work of art in the world.

It has no canvas, no oil paint, no artist's signature. Official appraisals would say it is worthless. It is just a single carved wood frame, the color of burnished gold, hanging on an easel draped in heavy brown fabric. Until one late winter night in 1990, that frame held *The Concert*, one of only thirty-six known works by Dutch artist Johannes Vermeer. Like so many of Vermeer's paintings, *The Concert* is famously enigmatic. It quietly imposes itself on the viewer, insisting on contemplation. And here, in the Dutch Room on the second floor of the Isabella Stewart Gardner Museum in Boston, a wide-backed chair upholstered in light green Victorian fabric sits in front of the easel, courteously placed there so that a visitor might pause to reflect on the painting's luminous beauty and the many secrets it holds.

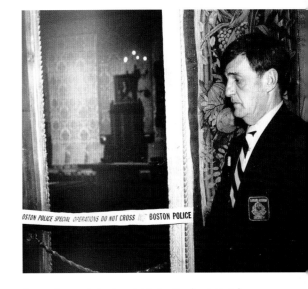

A security guard stands outside the Gardner's Dutch Room the morning after the March 1990 theft.

But in 1990, when two thieves ransacked the museum during the city's post–St. Patrick's Day inebriated haze, plucking the Vermeer and twelve other treasures, including three Rembrandts and a Govaert Flinck from this same room, the greatest secret of *The Concert* became its location. Now, if you go to the Gardner, you will see a heartbreaking tableau: that chair staring up at the empty frame, as if in eternal contemplation of the loss.

When Isabella Stewart Gardner died in 1924, her will decreed that her museum remain as she left it, effectively frozen in time. For museum administrators around the world who have lost art to thieves, time is indeed frozen on the day of their loss; like a loved one who disappears without leaving any trace, the missing art makes it difficult to move on. So time stands still in the Dutch Room, stuck not in the 1920s as Gardner desired, but on March 18, 1990, the last date the parlor was altered in any significant way, when its heart was ripped out and secreted away from the everyday world.

Time stands still in thousands of other places around the world. At the Louvre in Paris, it is always May 3, 1998, when a thief cut Jean-Baptiste-Camille Corot's soothing peasant landscape *Le chemin de Sèvres* out of its frame and slipped away without being noticed. At the Munch Museum in Oslo, Norway, it is always August 22, 2004, when a pair of armed bandits in black balaclavas stormed in and forced about seventy early-morning visitors to drop to the floor before they snatched Edvard Munch's *Madonna* and *The Scream* and fled in a waiting car. At the Montreal Museum of Fine Arts, it is always September 4, 1972, when armed thieves descended from a skylight and, after tying up the lone guard on duty in the middle of the night, grabbed eighteen paintings and other objects, including a Rembrandt Harmensz van Rijn, two Corots, a Pieter Brueghel (the Elder), a Thomas Gainsborough, a Ferdinand Delacroix, and a Peter Paul Rubens.

Alas, not every burgled museum is stuck so firmly on one day in the past. At the Victoria & Albert Museum in London, thefts have occurred with tragic regularity through the decades.

Art theft is big business. There are tens of thousands of missing paintings and sculptures, perhaps more than one hundred thousand. Interpol, the international association of police agencies based in Lyon, France, believes the market for stolen art and antiquities is third on the list of worldwide illicit activities, right behind drugs and arms trading. Estimates range from $1.5 billion to $6 billion annually. But if we can put the money aside for a moment, the cultural losses are even greater. Art defines our societies, outlines our aspirations, shows us ways of seeing the world that science never could. When a painting goes missing, we all lose a piece of our common heritage.

Imagine you could collect all of those lost works together in one place. You would have a world-class museum—an accidentally curated one, to be sure, but comprehensive in scope. There would be tens of thousands of the finest paintings, prints, sculptures, drawings, and other pieces of rare art. It would be choking on Old Masters and modern heroes, dreamy landscapes and ironic Pop Art.

This museum of the missing would hold perhaps one hundred and fifty Rembrandts and five hundred Picassos. You could stroll through the Renaissance galleries to admire Raphaels and Titians, da Vincis and Dürers, Rubenses and Caravaggios. The Impressionist section would include works by Renoir and Degas, Monet and Manet and Matisse, Pissarro and his friend and sometime-student Cézanne. You could skip your way through the history of Western art via Vermeer and van Gogh, Constable and Turner, Dalí and Miró, Pollock and Warhol. If the pieces hanging in this imaginary museum are not literally ours, they are the Western world's collective cultural heritage, and their absence renders all of us much poorer.

Back in the real world, in Boston, all of the empty frames remain in the spots where Gardner had them placed for her pleasure in the last century. Those frames are a call from beyond the grave to restore Gardner's unique vision, and they stand as a metaphor for the tens of thousands of artworks missing from museums, galleries, and private homes around the world. They reprimand the public for being both too much in thrall to fine art—sending its value escalating so high that it is all but irresistible to thieves—and also strangely indifferent, not caring if police forces and other government agencies make art crime a priority.

Isabella Stewart Gardner's friend, Anders Leonard Zorn, painted this portrait of her watching fireworks over the Grand Canal from her Venice balcony in 1894.

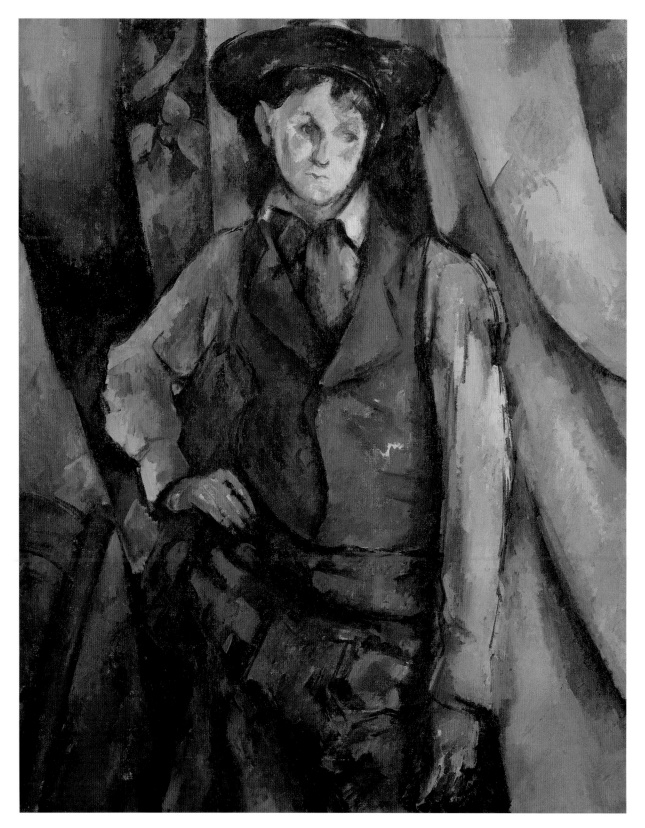

Paul Cézanne's 1890 *Le garçon au gilet rouge* was one of the Impressionist works on the block at Sotheby's 1958 auction and was sold for $610,000. The long-haired boy is thought to have been a professional model.

ART AS A COMMODITY

Art theft is a disease that is slowly eating away at the heart of the art market. And like a parasite that can only thrive on a healthy host, art theft is an epidemic only because fine-art values have skyrocketed over the last few decades.

If you want to find a single moment when everything began to change, when the host began to grow so big and active that no self-respecting parasite could ignore it any longer, you'd have to turn back to the London of the late 1950s. After a long period of listlessness and post-war shortages, the city was on an upswing, bolstered by a growing economy and the lifting of exchange controls, which enabled a freer flow of currency between England and other countries.

Late on the evening of October 15, 1958, fourteen hundred invited guests gathered at the headquarters of Sotheby's auctioneers on London's fashionable New Bond Street. Only seven paintings would go under the hammer that night, all from the estate of Jakob Goldschmidt, a Berlin banker who had fled the Nazis before the war: two works by Cézanne, a van Gogh, a Renoir, and three Manets. Their sale would confirm that there was a growing appetite for Impressionist and Post-Impressionist artwork. But the evening would also provide a case study in how a dash of canny salesmanship can alter the course of an entire industry and put it on a flight path to the stratosphere.

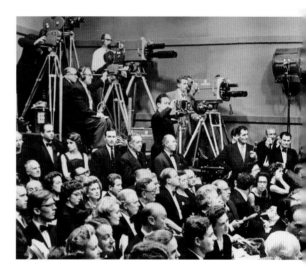

Sotheby's 1958 invitation-only auction was the brainchild of its chairman, Peter Cecil Wilson. His glittering black-tie affair attracted much attention from the media.

Sotheby's had a new chairman in the person of Peter Cecil Wilson, a former MI5 agent and an inveterate promoter who had previously convinced the deposed King Farouk of Egypt to let the London auction house handle the sale of his art collection. Under Wilson's watch, even Queen Elizabeth stepped out and into the Sotheby's showroom for the first time—she came to view a collection of Impressionist pieces about to go on the block.

Wilson saw the 1958 Goldschmidt sale as an opportunity to bring a new glamour and higher profile to the auction trade. For the first time ever, Sotheby's published a sales catalog with full-color illustrations of every artwork, a practice that quickly became de rigueur. They installed closed-circuit televisions for an overflow crowd. And in an inspired and precedent-setting move, they staged the auction as an evening affair—a first for Sotheby's since the eighteenth century —dictating a high-society dress code of black ties and evening gowns.

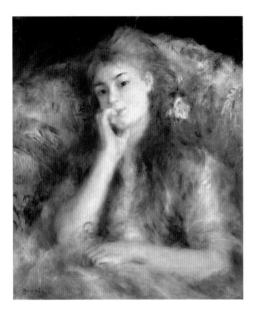

Pierre-Auguste Renoir's 1876–1877 *La Pensée*, or *Young Woman Seated*, was one of the Goldschmidt paintings sold at the 1958 Sotheby's auction.

It was a remarkable sight, for it hadn't been that many years since the cream of society viewed auction houses as a necessary evil. The bulk of art sales was still handled away from the public's prying eyes by private dealers who, backed by years of old-money tradition, provided collectors with the confidence that they could buy or sell their pieces to like-minded gentility.

In America, auctioneering still suffered from the residue of its association with slaves, who had been auctioned around the country from the same platforms as cattle. On both sides of the Atlantic, auctioneers themselves were considered as déclassé as actors, morally dubious and often dissolute types who would do almost anything for money.

So perhaps it was a bit of a shock that night to see actor Kirk Douglas sitting in the same room as the wife of Sir Winston Churchill, the prima ballerina Margot Fonteyn, and the novelist Somerset Maugham. Up on the podium, Wilson himself welcomed the guests and led bidders through the sales. Bidding for the first five lots was spirited but

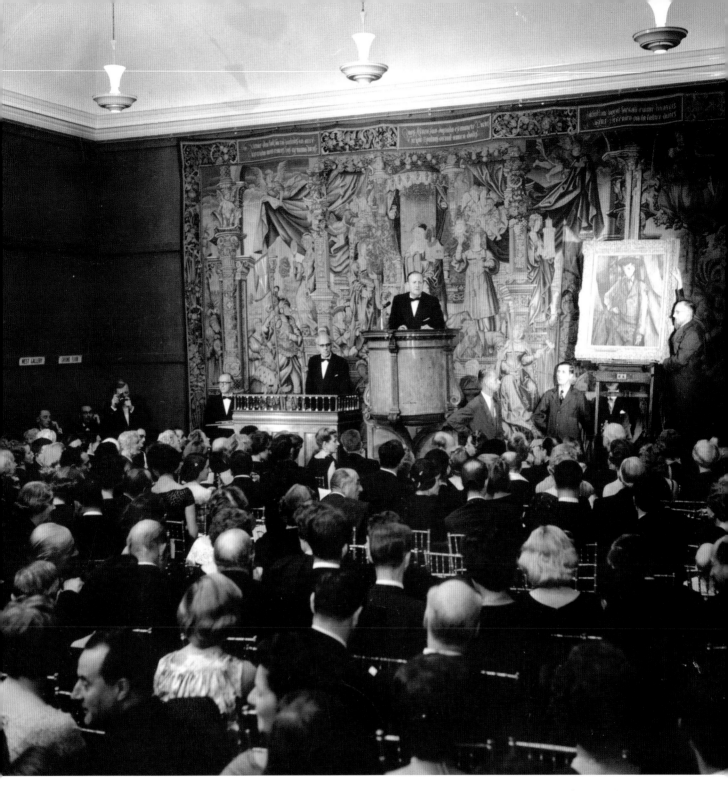

Le garçon au gilet rouge is displayed for invited guests in Sotheby's London showroom. The work went for more than five times the previous record high for a painting at auction. It is now part of the collection at the National Gallery of Art in Washington.

unremarkable. Then came the sixth, Paul Cézanne's *Le garçon au gilet rouge*. As the bids spiraled upward, whipsawing between two New York dealers, each representing an unknown collector, the crowd sat in disbelieving, paralyzed silence. When bidding hit £220,000 ($610,000), one of the hopefuls finally dropped his paddle in disappointment and the shocked crowd broke into sustained, thrilled applause. Though they may not have known it at the time, the price was more than five times the previous record for a painting sold at auction.

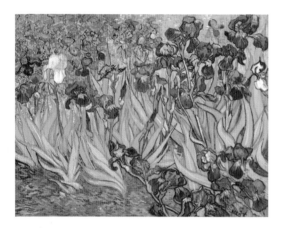

Vincent van Gogh's 1889 *Irises* fetched $49 million at a 1987 auction. It now hangs in the J. Paul Getty Museum.

THE FORTUNES THAT ARE HANGING ON MUSEUM WALLS

News of the record sale shook the art market to its core. Though the victorious bidder was a dealer representing a client, collectors began turning away from dealers. They instinctively recognized that public auctions were more likely to fetch the highest possible prices. Over the course of forty-one years, Sotheby's and its rival Christie's saw their combined annual sales spiral up more than two-hundred-fold. In 1958, the auction houses handled less than $25 million worth of sales. By 1989, that figure had grown to almost $5 billion, turbocharged in part by breathless publicity departments laboring to turn the dry business of fine-art auctions into mainstream news.

Certainly there were the cynics who suggested that since artworks had no intrinsic worth beyond the materials used for their creation—canvas, some paint, a few sticks of wood for the frame—the entire enterprise was little more than an oil-on-canvas Ponzi scheme cooked up by dealers and auction houses. In 1979, the esteemed *Time* magazine art critic Robert Hughes compared the art boom to the irrational mania for tulips in seventeenth-century Holland. Men, it is true, are capable of strange behavior when they're under a spell. Gold also has little intrinsic value, yet it continues to command prices far above its cost of production. And it's hard to ignore the fact that since Hughes wrote his cautionary article, ten more records have been set for the priciest paintings sold at auction. Indeed, a study by the Rand Corporation, issued in the summer of 2005,

Priced to Move

In New York, London, Paris, Rome, and other cities around the globe, tourists stampede to pay hefty admission fees to see the world's great art. But much of it can be seen for free in the days leading up to major sales at auction houses, where looking at the art carries an extra thrill from sneaking a glance at the sale estimates placed nearby. (At the Musée D'Orsay in Paris, do you think they'd ever stoop to mentioning that dreamy Edgar Degas canvas is valued at $20 million?)

Christie's and Sotheby's compete in setting world-record prices. The figures achieved by some of their auctioneers offer a stunning illustration of why thieves have become so attracted by fine art and rare collectibles over the last couple of decades. The nine most expensive paintings sold at auction have all gone under the hammer since 1987. They include van Gogh's *Portrait of Dr. Gachet* ($82.5 million; May 15, 1990, at Christie's); Renoir's *Bal au moulin de la Galette, Montmartre* ($78 million; May 17, 1990, at Sotheby's); van Gogh's *Irises* ($49 million; November 11, 1987, at Sotheby's); and Rubens' *Massacre of the Innocents* ($76.7 million; July 10, 2002, at Sotheby's).

Of course, many paintings would fetch much more if put up for auction. In 1962, the Louvre earned a citation from the *Guinness Book of World Records* when it took out a $100-million insurance policy on the *Mona Lisa* prior to its U.S. tour. Today, that figure would work out to more than $600 million.

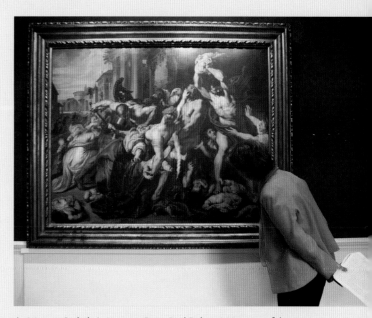

A visitor to Sotheby's inspects Peter Paul Rubens' *Massacre of the Innocents,* painted between 1609 and 1611. The painting represents a new complexity in Flemish artwork of the time.

suggested that collectors motivated by the investment potential of art, rather than its inherent qualities of beauty, craft, and insight into the human condition, were pricing other art lovers and the world's most prestigious museums out of the market.

So if criminals used to let news about fine art pass them by—convicts generally aren't likely to be subscribers to *The Art Newspaper*—the record prices trumpeted over the last few decades from the front pages of newspapers around the world had a way of making even hardened philistines salivate at the sight of a pretty picture. Many began to view paintings as multimillion-dollar bills that were calling to them from the walls of poorly guarded museums. For collectors, the high prices gave their artworks legitimacy outside the art world: banks accepted paintings and sculptures as collateral for loans. For the lay public and art lovers, it was becoming harder to look at a renowned piece of art without musing about its purchase price. Talking in terms of money seems to ensure the public will sit up and take notice. News reports about art heists almost invariably lead with the value of the booty rather than the names of the artists or the pieces themselves.

Pablo Picasso's *Garçon à la pipe*, painted in 1905, entered a May 2004 auction at Sotheby's with an estimate of $70 million. Spirited bidding rocketed it up to $104 million, a new record.

Through the years, many pieces have achieved a dubious sort of fame chiefly because of their sale price. Few people had heard of Pablo Picasso's Rose-period masterpiece *Garçon à la pipe* until it suddenly appeared on newscasts around the globe in the spring of 2004. Perhaps many of those who saw the painting on television couldn't tell a Picasso from a Pollock. But in fetching $104 million, thereby far outstripping all other paintings to become the most expensive ever sold at auction, its greatness—at least on a monetary level—was impossible to ignore. Still, covetous thieves would have no chance with that canvas: the buyer was anonymous and has yet to be unmasked.

If we're inclined to place at least partial blame on collectors for making art attractive to thieves by driving up its price, we also have to offer them some credit. For collectors helped to create the modern notion of

Sorry, Our Hands Are Tied

Martin Johann Schmidt's *Madonna and Child* was included in the confiscated Feldmann collection.

Dr. Arthur Feldmann was one of the greatest collectors of Old Master drawings in Europe, but when the Nazis invaded Czechoslovakia in March of 1939, his villa in Brno was seized and his collection confiscated. More than seven hundred and fifty drawings were spirited into Germany, including works by Rembrandt, Carracci, Guercino, Parmigianino, Fragonard, Veronese, and von Aachen. For the next two years Feldmann and his wife lived hand to mouth, until he was arrested in March 1941, and tortured. He died from a stroke a few days later, before a death sentence could be carried out. His wife, Gisela, died in Auschwitz.

More than sixty years later, four drawings from Feldmann's collection were identified in the holdings of the British Museum. His heirs applied for the return of the drawings and the trustees of the museum agreed the case represented a "unique moral claim" they wanted to meet. But fearing that a successful claim by the Feldmann heirs might open the institution to other claims of cultural property acquired under controversial circumstances—such as the Elgin Marbles or the Rosetta Stone—the museum sought an opinion from the U.K. High Court. In May 2005, the court told the museum it did not have the legal right to give back the drawings. Justice Andrew Morritt wrote, "No moral obligation can justify a disposition by the Trustees of an object forming part of the collections of the museum." The court added that if the museum really wanted to do the right thing, it should pressure the British Parliament to pass a special law permitting it to do so.

art for art's sake, freeing artists to follow their muses down previously unexplored avenues. The Renaissance saw the first of many genres that later became staples of painting: nature paintings, landscapes, self-portraits, and female nudes. Prior to the advent of collecting, artists were considered to be talented craftsmen who toiled for utilitarian purposes, making ritual objects, educational aids, illustrations of myths and religious stories, and illuminated manuscripts. Even the influential Medici family, who helped to popularize the notion of collecting in the Renaissance, primarily commissioned depictions of religious imagery to reinforce the popularity of Christianity among the masses.

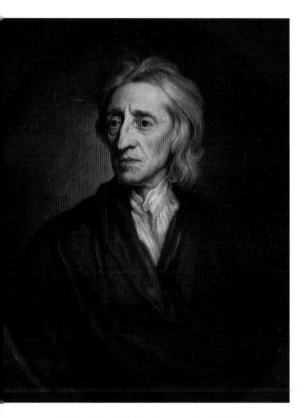

Sir Godfrey Kneller's 1697 portrait of British philosopher John Locke was part of Sir Robert Walpole's collection. In the latter years of his life, Locke lived as a recluse and devoted himself to his studies.

In the beginning, collectors were as satisfied to possess objects of natural history—shells, minerals, animals, and other curios—as they were to gather works of art. Indeed, in 1785, when an American portraitist by the name of Charles Willson Peale opened what he believed to be the first museum in the United States, he exhibited both artistic and scientific items. To collectors, all of the objects—whether relics from the fields of art or natural science—possessed the key quality of rarity, and thus desirability. The European bourgeoisie could therefore use the objects to set themselves above and apart from the common man. In time, this competitive factor proved to be best served by a focus on art: if you own an original painting, you have an object that is unique in the world.

The British Royal Family and its inner circle began collecting art in earnest in the seventeenth century. It was just a matter of time before the moneyed classes embraced fine art as a vehicle of social aspiration and began, in the perceptive expression of author Robert Lacey, "bidding for class" with their purchases. Art's inherent uselessness simply reinforced desire of the bourgeoisie to become the Continent's new royalty.

In Britain, one man helped art vault from the province of royalty to the growing aristocracy. Sir Robert Walpole, the Whig statesman and 1st Earl

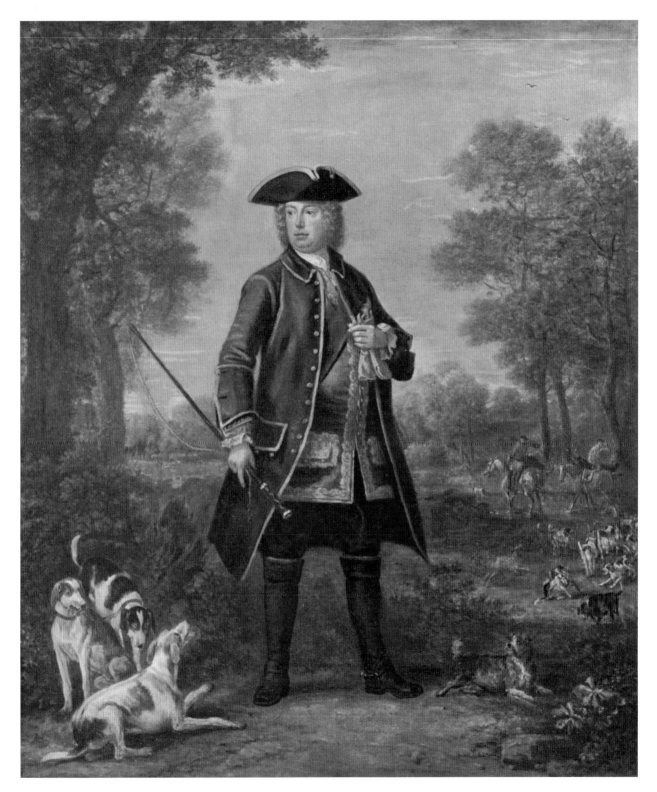

Britain's Walpole wasn't just an avid collector of paintings (he possessed hundreds at the time of his death in 1745). He also commissioned portraits of himself, including this one by John Wootton.

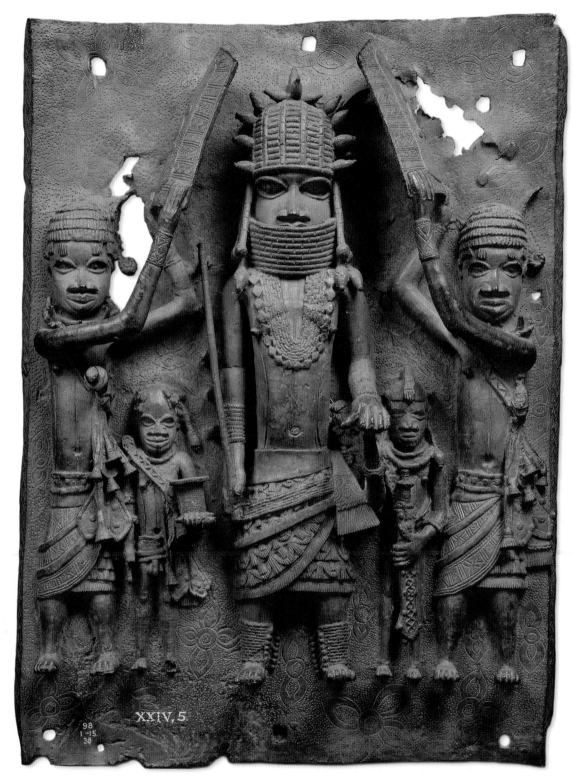

In 1897, Admiral Harry Rawson led a force against the Kingdom of Benin as punishment for the killing of eight British representatives there. As a result, much of the kingdom's art was destroyed or dispersed, including this brass plaque, which depicts the Oba, or king, and his attendants.

of Orford who is generally regarded as the first prime minister of the United Kingdom, was one of the most passionate collectors of the early eighteenth century. By the time of his death in 1745, he had amassed hundreds of paintings from across Europe. His grandly rebuilt Houghton Hall in Norfolk, northeast of London, displayed works by Rembrandt, Rubens, Sir Anthony van Dyck, Bartolomé Esteban Murillo, Claude Lorrain, and more than a dozen by Carlo Maratti.

Alas, Walpole's passion for art and other indulgences led him to rack up enormous debts, forcing his sons to sell more than one hundred canvasses after his death. Still, his collection was so impressive that the British Parliament began to see it as the foundation for a new national gallery. But Walpole's estate remained in financial chaos, and to quiet the creditors, his grandson sold off the rest of his holdings, one hundred and ninety-eight paintings in all, to Catherine the Great of Russia. To British nationalists, the most grievous harm of the whole enterprise stemmed from the fact that five paintings were by members of the English School: the notion of George I hanging in the Hermitage was a sacrilege.

THE ART OF WAR

An impartial observer might suggest it was only fair play. For centuries, the European powers had helped themselves to the artistic riches of other nations. In the early sixteenth century, Spain conquered Peru and carried off galleons full of gold treasure, despoiling Incan culture in the process. Almost two hundred years later, Napoleon's armies rampaged across Europe and Egypt in a two-decade campaign motivated as much by a desire to collect statues and other relics as by the idea of military subjugation. In the middle of the nineteenth century, after the First Opium War, France and England competed over the spoils to be had in Canton, China. Together, they looted thousands of Asian treasures.

In 1897, British forces sacked the African kingdom of Benin and removed from the royal palace more than one thousand brass plaques depicting animals and scenes of

Thomas Bruce, the 7th Earl of Elgin, became interested in ancient sculptures while ambassador to the Ottoman sultan between 1799 and 1803.

Lord Elgin removed the marble friezes from the Parthenon, which was built between 447 and 438 BCE and dedicated to Athens' patron goddess, Athena.

court life. About eight hundred of the brasses were sold to help defray the cost of the military expedition. The rest ended up in the British Museum. In the middle of the twentieth century, the museum allowed Nigeria, which had assumed much of Benin's territory, to buy back about fifty plaques. But the destitute country was forced to pay an exorbitant sum to reclaim the scattered pieces of its own heritage.

One mass plunder is still causing reverberations through diplomatic corridors around the world. At the beginning of the nineteenth century, Thomas Bruce, the 7th Earl of Elgin, served as official representative of the British government in what was then the flagging Ottoman Empire. He set his eye on a crumbling treasure, the decorative marble friezes ringing the Parthenon at the Acropolis in Athens, as well as other sculptural elements. Currying favor with the local authorities, Elgin secured permission to remove the Marbles, arguing that he could best save the fifth-century stones from environmental degradation and looters by taking them out of their natural habitat. Between 1801 and 1805, more than two-thirds of the sculptures were cut away and shipped back to England, where they were eventually sold to the British Museum in London. Since 1939, they have been housed in the Duveen Gallery there, built by the wealthy art dealer Joseph Duveen specifically for their glory.

But the Elgin Marbles' life in Britain has been scarred by physical and diplomatic battles. In the 1930s, under the orders of Duveen, they were cleaned with a harsh chemical solution that permanently damaged the honey-colored stones. The museum fired the hapless restorers and

A Master Opportunist

"Europe has a great deal of art, and America has a great deal of money," observed Joseph Duveen (1869–1939), a British-born entrepreneur who made a fortune by bringing the two together. He shifted Duveen Brothers, the firm founded by his uncle and father, from dealing in porcelain and tapestries to fine art. Taking a long-term view of things, he bought up the collections of European aristocrats on the skids—everything from Old Masters to fine French furniture—and then created a market for his precious stock by educating nouveau riche Americans desperate to demonstrate that they had class as well as cash.

Arriving in the United States in the early twentieth century, Duveen was a shrewd operator who found himself in the right place at the right time. He maintained a network of spies to keep track of art around the world, and in New York, the site of most new business, he smartly relocated Duveen Brothers' Manhattan base to a highly visible location on Fifth Avenue. His clients included some of the most notorious robber barons in America. He sold large collections to Henry Clay Frick, J.P. Morgan, Andrew Mellon, John D. Rockefeller, and William Randolph Hearst. Among them, Duveen was with his own kind, having once been called "a man as predatory as any of the big carnivores of the jungle."

Named Lord Duveen of Millbank for his service to British culture (he donated wings at the Tate Gallery and the National Gallery), he was admired as the man who set the template for the modern practice of art dealing. Nonetheless, Duveen has been judged harshly by history. Shortly before he died, he paid workers to secretly "restore" the Elgin Marbles to a blinding white sheen using wire brushes, copper chisels, and acid.

British entrepreneur Joseph Duveen, one of the most successful art dealers of all time, was so adept at convincing clients to buy Old Masters that Andrew Mellon once observed that "paintings never looked as good as when Joseph Duveen was standing in front of them."

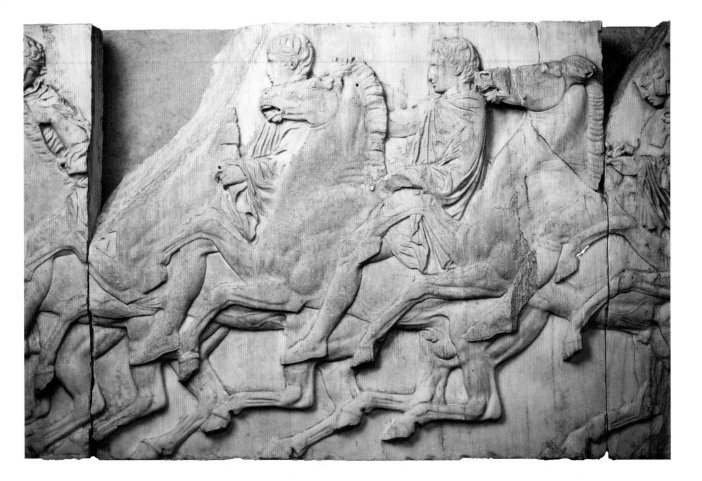

A group of horsemen from the Parthenon frieze. This portion of the marble sculpture now resides in the British Museum.

chastised Duveen, but the mistake reflected the insouciance, if not the arrogance, of many Western collectors and institutions that have helped themselves to treasures from other cultures.

Frequent international campaigns, including a strong effort just before the Summer Olympic Games in Athens in 2004, have failed to budge the trustees of the British Museum from their position that the Elgin Marbles will never leave England. The British government shrugs its shoulders and says it would be powerless to do anything even if it wanted, since the Marbles belong to the museum rather than the government. Indeed, the museum's director Robert Anderson strongly resists the notion that the Marbles belong to the citizens of any one nation on Earth. The British Museum, he said, "transcends national boundaries; it has never been a museum of British culture, it is a museum of the world, and its purpose is to display the works of mankind of all periods and of all places. The idea of cultural restitution is anathema

of this principle." In late 2002, a group of major cultural institutions—including the Louvre in Paris; the Hermitage in St. Petersburg; the Metropolitan Museum, the Guggenheim, the Museum of Modern Art, and the Whitney in New York; the Rijksmuseum in Amsterdam; the State Museums in Berlin; and the Prado in Madrid—backed the British Museum by issuing a declaration opposing wholesale repatriation of cultural artifacts seized centuries ago.

But is it too much to charge, as some have, that Elgin and the other imperial conquerors lie on a continuum with the gangs who slip into museums and country houses today and make off with someone else's treasure? No one would suggest that the Gardner deserved to be robbed. There's no justice in the repetition of an injustice. But there may yet be a modicum of poetic irony in collectors like Isabella Stewart Gardner falling victim to theft, for you might say they were unwittingly inspired to pursue their hobbies by thieves, albeit thieves with titles. There is even a connection between Isabella Stewart Gardner and the Elgin Marbles: the young art critic Bernard Berenson was Gardner's primary adviser in her quest to assemble a stellar collection. Often, Berenson purchased paintings from his good friend Joseph Duveen, earning Gardner's praise for his keen eye while pocketing twenty-five percent of Duveen's commission in a comfortable kickback scheme.

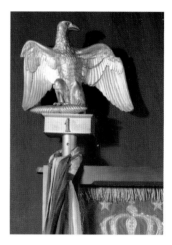

The bronze eagle finial from the pole of a silk Napoleonic banner was also taken the night of the Gardner theft, though its value is slight compared to the stolen art.

Of all the mysteries in the Gardner theft—and, to be sure, just about everything will remain a mystery until the paintings are recovered—one of the strangest centers on an odd prize swiped by the thieves during their rampage through the museum on that March night in 1990. According to police, the thieves spent an unusual amount of time trying to wrest a Napoleonic flag from its pole. When their efforts proved fruitless, they settled for the gilded eagle finial from the top of the pole.

Why were they so keen to have the Napoleonic banner? Thieves often commit acts that seem odd to the outside world, but which hold coded meaning within their corrupt circle. The banner may have been a trophy that would have given a gang bragging rights. One private investigator muses that it may have been a nod by Irish-born thieves to the French general who once floated the idea of teaming up with Irish rebels to defeat English rule. Or was it simpler than that? Was it just a tip of the hat to one of the greatest art thieves the world has ever known?

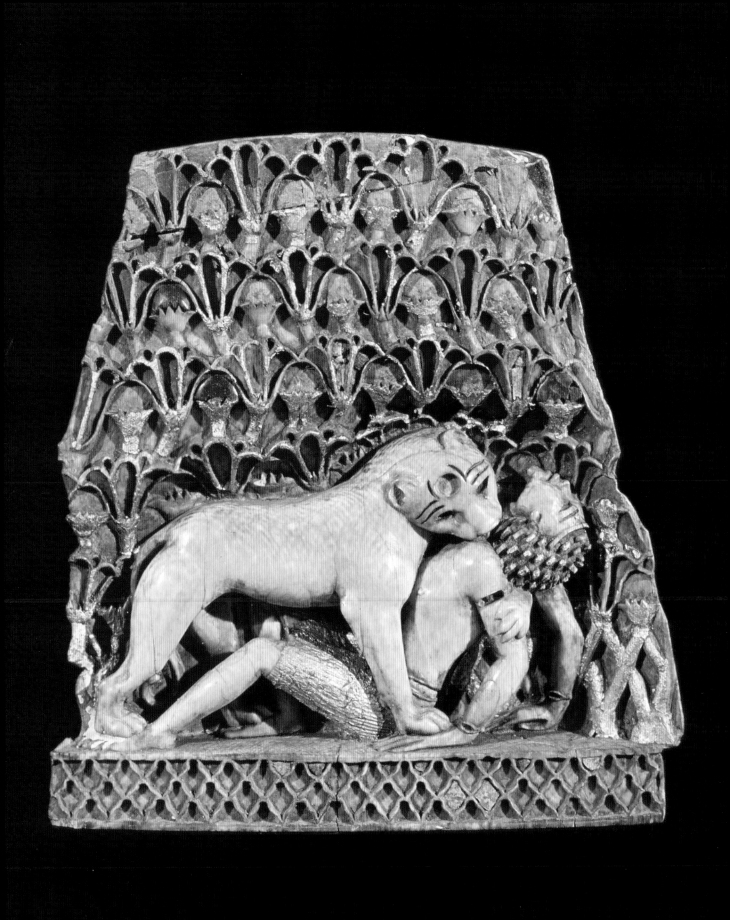

THEFT IN A TIME OF WAR

If the circumstances are good, just about anybody will steal art. And war makes for great circumstances.

When Saddam Hussein fell from power in the spring of 2003, a handful of Iraqi citizens looted the Iraq National Museum, gutting the collective cultural heritage of ancient Mesopotamia. The looters weren't the only ones to take advantage of the chaos. Foreign civilians, soldiers, and locals helped themselves to cratefuls of ancient souvenirs, as well as modern art from the Saddam Art Center. The looting from archaeological sites continues still, feeding a black market in antiquities that authorities estimate is worth hundreds of millions of dollars every year, and which likely helps support terrorist activities both in Iraq and elsewhere. Mohammed Atta, one of the hijackers in the September 11 attacks, reportedly explored the idea of selling Afghan art to fund the murderous undertaking.

Above: A despairing Mushin Hasan, Deputy Director of the Iraq National Museum, sits amid artifacts destroyed during looting in Baghdad in April 2003.
Opposite: An ivory plaque from Nimrud in ancient Iraq, dating from the eighth century BCE, depicts a lioness attacking a Nubian. It was taken during the looting.

But looters shoplifting a few ancient treasures are just taking their place in a foul tradition that stretches back millennia. Until the last half of the twentieth century, art and other cultural relics were widely accepted as ancillary prizes that rightfully fell to the victors of military conflicts. The term "spoils of war," which comes from the Latin word *spolium* (translated as the "hide stripped from an animal"), has been in use for about seven hundred years. The practice of extracting spoils goes

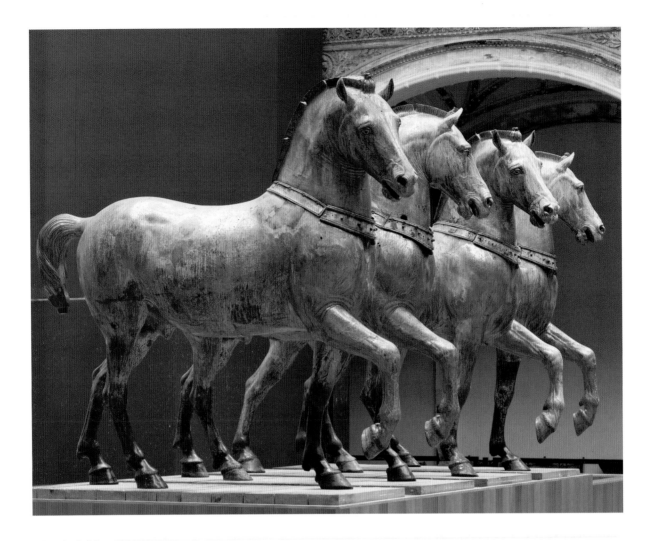

The collars on the four Horses of San Marco were added in 1204 to obscure where the bronze animals' heads were severed to facilitate their transportation by ship from Constantinople to Venice.

back even farther. Roman soldiers took home religious relics when they sacked Jerusalem. The Greeks plundered Troy. Kings in feudal China displayed prizes from the provinces they defeated. During the fall of Constantinople in 1204, the Venetians snatched the bronze Horses of San Marco and other treasures, and held on to them for almost six hundred years.

All of those conquerors, though, are mere amateurs when they stand next to one man. In conception and execution, Napoleon Bonaparte was, for his time, one of the most audacious art snatchers the world had ever known.

THE EMPEROR OF ART THEFT

From 1796 to 1815, as Napoleon's armies stormed across Europe and into Egypt, vanquishing their opponents with lightning speed and brilliant strategy, the budding emperor turned to a painter and archaeologist for advice. Known as "Napoleon's Eye," Baron Dominique-Vivant Denon became director-general of French museums in 1802, compiling comprehensive shopping lists to satisfy his master's desire. He accompanied Napoleon on military expeditions to Austria, Poland, and Spain, and, in 1797, had overseen the relocation from Venice of those same bronze Horses of San Marco.

Some individuals not in government took advantage of the chaos of the Napoleonic Wars to nab art for themselves. François Lefébvre, a Frenchman who served as curator of the Albertina Museum in Vienna in the early nineteenth century, either stole outright or illegally sold possibly hundreds of works by Albrecht Dürer, the leading artist of the German Renaissance. Lefébvre sold perhaps as many as one hundred Dürers to Antoine François Comte Andreossi, Napoleon's man in Vienna.

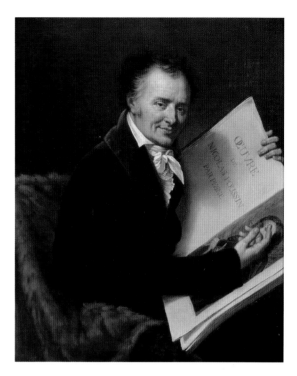

Robert Lefèvre's 1808 portrait of Baron Dominique-Vivant Denon, who "collected" for Napoleon.

It must have been easy for Lefébvre to get away with it, for his haul was a drop in the bucket compared to what Napoleon's forces were taking. In Italy, Denon oversaw the removal of more than five hundred paintings and a smattering of sculptures from the Vatican to Paris. The booty was used in manifold ways to glorify the conqueror: after the magnificent Greek statue of the Trojan high priest Laocoon and his sons being devoured by snakes was featured in a parade through the streets of Paris, Napoleon commissioned a set of china featuring an image of the triumphal procession.

But the Emperor contended that he was taking the artworks for the glory of the French people and not for himself. Laocoon and many of the other treasures were installed at state-run museums such as the Louvre, whose holdings expanded rapidly as a consequence of the military expeditions. The museum's Egyptology department was built on a foundation of Napoleonic plunder.

François Lefébvre enriched himself with art treasures during the confusion created by Napoleon's rampage through Europe.

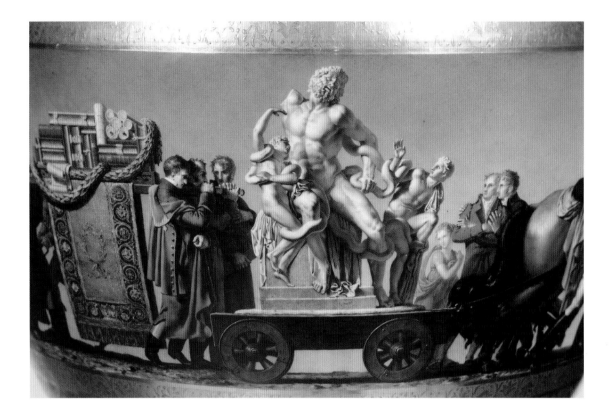

Above: Napoleon's parade through the streets of Paris featured the Greek statue of Laocoon, as depicted on this Etruscan-style vase by Antoine Beranger.
Opposite: Louis-Charles-Auguste Couder's painting shows Napoleon I inspecting the Louvre with two architects.

Alas, the Louvre had to do without the priceless Rosetta Stone. The tablet, which bears the scripts for both Greek and ancient Egyptian and thus gave academics a key for the translation of hieroglyphs, was discovered by Napoleon's forces, but he handed it over to British troops in 1802 as part of a surrender agreement. It now resides in the British Museum, just a few galleries away from the Elgin Marbles.

To be sure, Napoleon was no philistine. He genuinely sought to understand Egyptian society, even as he plundered it, and hoped his expedition might open up an East–West cultural dialogue. The Egyptian treasures awed Baron Denon. He noted, with a curator's appreciation, how the artifacts had inspired the Greeks and Romans, which in turn inspired European styles. He brought the same eye of the intelligent appraiser to the paintings and sculptures taken from Belgium, Germany, Italy, and elsewhere. Indeed, Denon recognized the fine talent evident in the plundered art, and championed foreign artists at a time when that stance flew in the face of increasing French chauvinism. His advocacy led to a much wider appreciation among French society for other artists and civilizations.

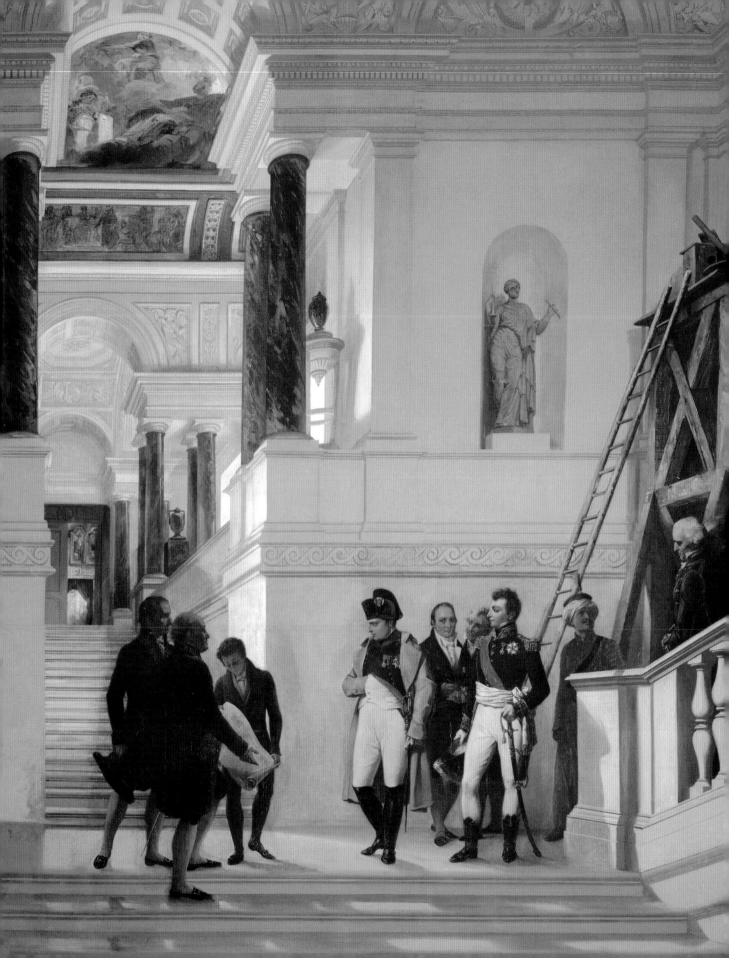

THE CONQUEROR AS ART CRITIC

Though art can open people's eyes to the capacities and wonders of other cultures, it can also serve to shut them tight. Truth, like beauty, is in the eye of the beholder: people see what they want in art. When Adolf Hitler seized power in Germany in 1933, he brought some very specific attitudes toward art into the chancellor's office. Hitler saw himself as a deeply cultured man. Though he was turned down twice by the Academy of Arts in Vienna, he studied painting, sculpture, and architecture, and briefly supported himself by selling watercolor postcards to tourists who fancied his hackneyed romantic realism. He attended opera, theater, and music recitals, and cultivated a particular fondness for the work of Richard Wagner (and not just because the composer was a notorious anti-Semite).

Hitler, however, did not embrace all art. He held German paintings and sculpture to be the greatest artistic achievements, and instructed his underlings to find the German roots of European masterpieces (which were, naturally, nonexistent for the most part). He scorned the avant-garde and "unfinished" art that he couldn't understand, labeling works by more than fourteen hundred celebrated artists "degenerate." In his 1923 autobiography *Mein Kampf*, Hitler declared Dadaism to be "the degenerate excess of insane and depraved humans." He railed against Impressionists, Cubists, Expressionists, Surrealists, and just about every other modern movement.

Hitler possessed complex and often contradictory theories of art to justify his own personal taste, but he wasn't interested in a debate that might have shown him to be confused. The National Socialists, or Nazis, banned art criticism and secured the removal of many artists from teaching posts, including the painter Paul Klee at the Düsseldorf Academy of Fine Arts. They made it illegal for discredited or Jewish artists to paint anything at all, sending officers into private homes to check on suspected lawbreakers by sniffing the air for chemical residues. Even Emil Nolde, a fervent member of the Nazi Party, was banned from painting in 1941 because he was an Expressionist.

Joseph Goebbels, the Third Reich's minister for public enlightenment and propaganda, owned a few choice German Expressionist paintings himself, but he quietly dumped them after Hitler voiced his disapproval.

Carnival, the 1920 work of German Expressionist Max Beckmann, is an example of the art Hitler designated as "depraved." Beckmann fled to Amsterdam in 1937.

Art for the People

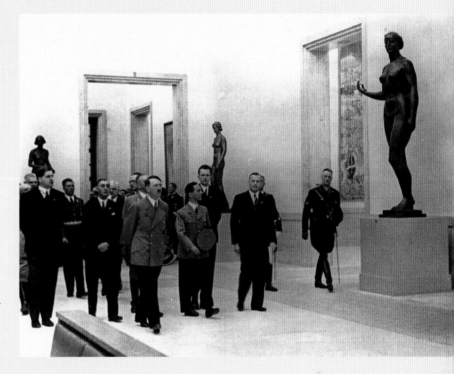

Adolf Hitler, fourth from left, and Joseph Goebbels, to his right, at the House of German Art during the Day of German Art celebrations, which included a five mile long parade of German culture.

On July 18, 1937, one day before the opening of the Third Reich's Degenerate Art exhibition, which demonized modern artists, Hitler presided over ceremonies opening the new House of German Art, a stark monument designed in the Aryan architectural style and built to house the best German art—according to Hitler's own pedestrian and retrograde tastes. To celebrate the occasion, he proclaimed a Day of German Art. A bizarre pageant titled "Two Thousand Years of German Culture" wound its way through the streets of Munich. It featured more than seven thousand marchers in a strange succession of scenes and floats that depicted the country's history: Viking warriors, Henry the Lion, Charlemagne, and Wehrmacht and SS storm troopers.

Inside the new museum, guests found heroic portraits of Nazi leaders, including one of the Führer as a mounted knight clad in silver armor. Works featuring the female nude were well represented, alongside folk art and agricultural scenes. Every July until 1944 brought another exhibition, often stultifyingly similar to the previous year's.

When Hitler presided over the museum's opening, he declared, "The artist does not produce for the artist, he produces for the people, just as everybody else does! And we are going to take care that it will be the people who from now on will again be called upon as judges over its art...." Indeed, the people spoke loudly and clearly, delivering a message he probably didn't want to hear: The Degenerate Art exhibition, which opened on July 19, 1937, drew record crowds. But the inaugural exhibition of the finest German art suffered poor attendance and abysmal sales.

In the late spring of 1937, Goebbels went much further. He passionately took up his leader's cause to "cleanse" Germany's state museums of art that the Führer considered to be poisonous. At first, he ran into some difficulty when museum directors, notoriously more concerned with the permanent truths of art than the ephemeral fashions of politics, refused to cooperate.

Goebbels was forced to obtain a decree from Hitler himself that obligated the museums to relinquish their holdings. Directed by Adolph Ziegler, the president of the Reich Chamber for the Visual Arts, a Nazi committee stormed through more than two dozen German museums over the course of a few days, seizing in excess of sixteen thousand pieces, including the Cubist paintings of Pablo Picasso and Paul Klee, the Expressionist works of Oskar Kokoschka, Edvard Munch, Wassily Kandinsky, and Max Beckmann, Surrealist pieces and paintings by Amedeo Modigliani, as well as the distinctive modern work of Jewish artists Camille Pissarro and Marc Chagall.

Many of these artists, particularly the Expressionists who trafficked in modish notions of the human psyche, represented the best of Germany. It didn't matter: the Reich aimed to create a German culture that celebrated a simplistically heroic ideal of man rather than one that delved into the troubling complexity of the mind. (Never mind that psychoanalysis was itself founded by Germans and Austrians.) In a 1935 speech, Hitler had declared that "the Dadaists, Cubists, and those futuristic expressive ones and those objective chatterers will under no circumstances participate in our cultural renaissance. Thus we acknowledge that we have overcome the degeneration of our culture."

So it was that in July 1937, more than six hundred and fifty of the seized works were gathered in Munich and exhibited to a "scandalized" German public under the title *Entartete Kunst*, or Degenerate Art. As the show went on to other German and Austrian destinations before winding up its tour in April 1941, more than three million people filed past the paintings and sculptures, ironically making it perhaps the most successful modern art exhibition in history.

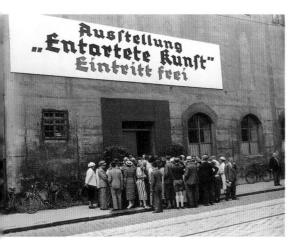

Above: In Munich alone, two million visitors filed through the Degenerate Art exhibition, which was organized by such subject matter as "Insult to German Womanhood" and "Mockery of God." Minors were banned from the show.
Opposite: Ernst Ludwig Kirchner's 1910 *Self-portrait with Model* was considered a "degenerate" work.

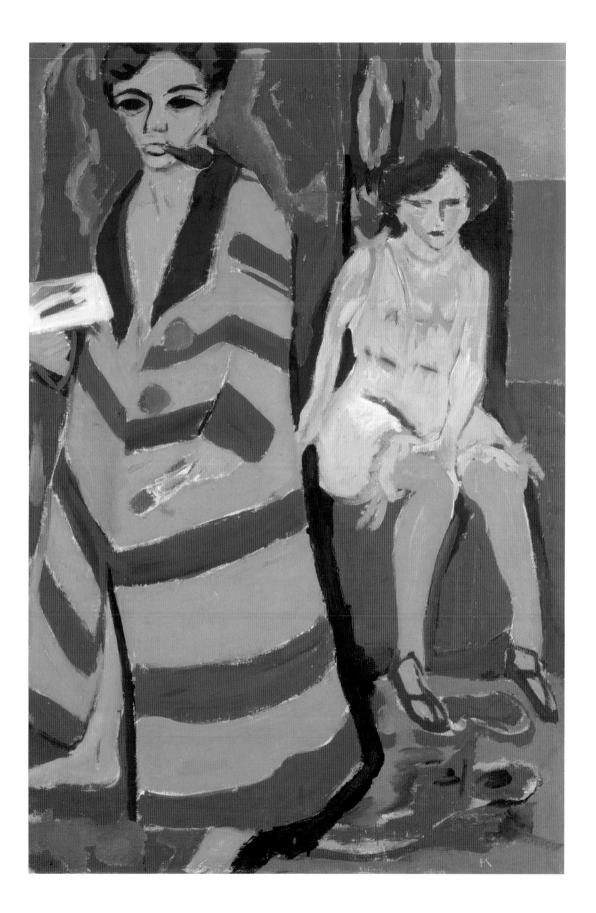

BONFIRE OF THE TUILERIES

The Reich's attitude toward modern art was not merely posturing and politics; it resulted in some very real and permanent damage. Thousands of works that didn't make it into the Degenerate Art exhibition were traded or sold at cut-rate prices to raise foreign currency for Germany. In one notorious auction in Lucerne, Switzerland, in June 1939, one hundred and twenty-six pieces went under the hammer, including a self-portrait by Vincent van Gogh, four Picassos, and a highly prized Tahitian Paul Gauguin. Joseph Pulitzer Jr. picked up Henri Matisse's *Bathers with a Turtle* (1908), telling friends he wanted to protect the painting from destruction or an uncertain future. (After the war, he donated it to the Saint Louis Art Museum.) Untold thousands of pieces suffered a worse fate. On March 20, 1939, more than five thousand paintings, drawings, and sculptures were thrown onto a bonfire overseen by the Berlin Fire Department. Paintings by Picasso, Georges Braque, Fernand Léger, and André Masson were burned in a July 1943 bonfire in the Tuileries Garden in Paris.

Not all of the demeaned art was ruined. In a foreshadowing of the way stolen art would be used as collateral by drug dealers and other criminals in the latter half of the twentieth century, many of the "degenerate" artworks were treated as devalued wartime scrip and traded for other paintings coveted by the Nazi elite. Some were smuggled out of Germany or the occupied countries via diplomatic pouch.

The degenerate art campaign marked the Nazis' first focused effort at organized appropriation of cultural objects. In time, it proved to be merely the overture for the greatest collective theft of art the world has ever seen, showing up Napoleon to be a rank amateur in the plunder trade. Through the course of their terrifying reign over Europe and Russia, the Nazis pursued the continent's finest paintings, prints, sculptures, tapestries, and artifacts with brutal efficiency.

ONE FAMILY'S STORY

After cutting their teeth with the seizures of the "corrupting" art in state-run museums, the Nazis trained their sights on the collections of German Jews and other assumed enemies of the state. Gaining momentum after the Anschluss of May 1938, when Germany absorbed Austria,

Henri Matisse's 1908 *Bathers with a Turtle* is a large canvas depicting three women gathered around a small red turtle, an ancient sign of eternity. The Nazis seized the painting and sold it at the infamous 1939 auction of modern art.

Van Gogh's *Self-Portrait Dedicated to Paul Gauguin* (1888) was also auctioned off to raise foreign currency for the Third Reich. At the 1939 sale, held in Lucerne, Switzerland, it fetched $40,000 (more than $570,000 today).

they began targeting Austrian Jews. Though this was almost seventy years ago, Maria Altmann, born in 1916 in Vienna to a prosperous Jewish family, remembers the time very clearly. "They picked on old Jews and made them scrub the sidewalks," she recalls. "Friends of my parents, they were all in their sixties and seventies, they started to commit suicide because they saw there was no way out for them."

Maria and Fritz Altmann had just returned from their honeymoon when the Gestapo came to the door in April 1938, and relieved her of her diamond necklace. (She later learned that the family heirloom, which had been given to her as a wedding present, ended up around the neck of Hermann Goering's wife.) "Those things are totally, totally unimportant," she insists. "Material values never meant an awful lot. I just wanted to give everything away so they wouldn't find a reason to arrest my husband." Fritz was arrested all the same, and shipped off to the concentration camp at Dachau. His brother secured Fritz's release by signing over their thriving clothing factory in a process known as "Aryanization," by which Jewish-owned businesses were "cleansed" and handed over to Aryan, or German, control. In October 1938, Fritz and Maria escaped to England, but when war broke out, being citizens of an enemy country, they were forced out. They traveled to the United States, settling in California.

Maria's uncle, a sugar magnate by the name of Ferdinand Bloch-Bauer, was not as fortunate. He and his wife Adele had been members of Vienna's high society, regularly holding salons with the city's artists and intellectuals such as painter Gustav Klimt and composer Richard Strauss. Adele posed for two Klimt

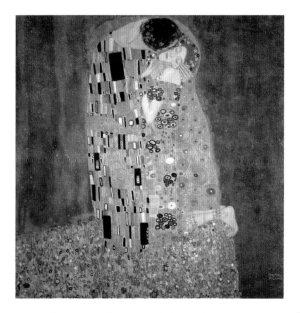

Gustav Klimt's 1908 *The Kiss* is probably his best-known work. The model is thought to have been his friend, Adele Bloch-Bauer.

portraits and a number of his other pieces, including the iconic painting of shimmering gold called *The Kiss*, which featured a strong and sexual woman who bore a striking resemblance to her. When Adele died of meningitis in 1925—she was just forty-two—her husband created a memorial room in his home with the portraits and other Klimt paintings. But when war broke out, he was forced to flee to Switzerland and

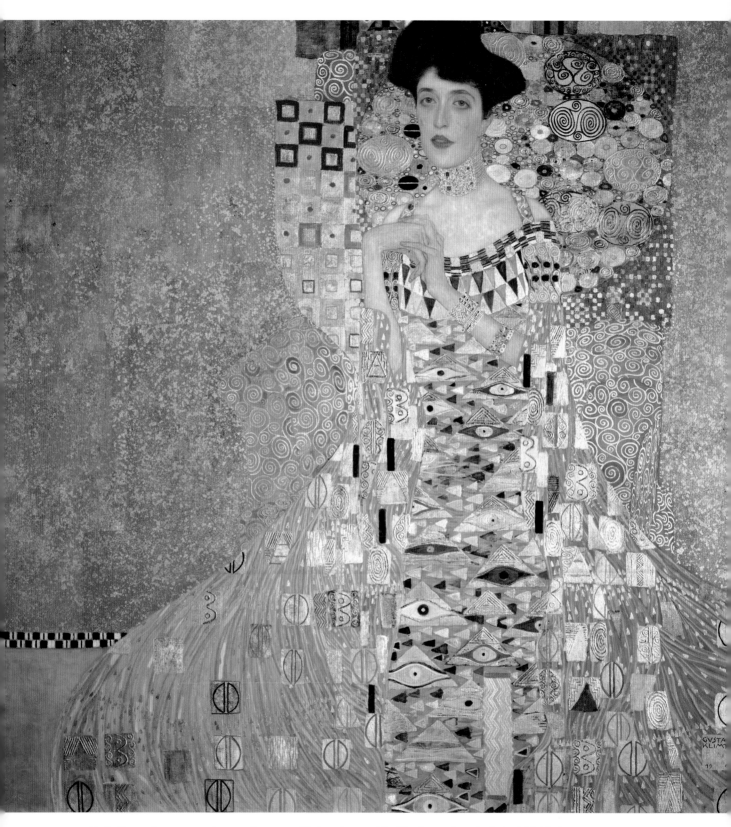

Maria Altmann's aunt was only twenty-four years old when she posed for Klimt's 1907 *Portrait of Mrs. Adele Bloch-Bauer I*.
He later featured her in a number of his other paintings.

abandon all of his property, including the paintings and a priceless collection of Vienna porcelain. The Nazis seized his possessions and sold them off to collect taxes they had levied against him because he was a Jew. They also enacted an "Aryanization" that forced the sale of his sugar factory, at a fraction of its real value. Ferdinand died alone, in exile, in November 1945, without ever seeing Vienna or the Klimt portraits again.

SUFFERING FROM ART SEIZURE

Similar stories, and worse, were repeated ad nauseam. With the start of war in September 1939, as Germany quickly conquered one country after another, the Nazis confiscated the property of Jews in the defeated territories, contending they were not genuine citizens. Sometimes, they would ship Jews out to concentration camps and then seize the "abandoned" or "ownerless" property left behind. At first they held the property for so-called safekeeping, but soon passed laws permitting its wholesale theft. Their attitude toward this looting varied by region: in Eastern Europe, the Nazis expanded their activities to the cultural holdings of the countries themselves, while in the West they mainly restricted themselves to private property and left state collections alone.

German forces looted art in almost all of the countries they occupied or invaded, including Austria, Poland, France, Czechoslovakia, Hungary, Belgium, Holland, Luxembourg, and Ukraine. Toward the end of the war, the Nazis even shipped holdings back to Germany from their former ally Italy, removing about half of Florence's Uffizi Gallery and Pitti Palace collections under the pretext of protecting them from attack by the rapidly advancing Allied armies. In Russia, a country with which they once had pledged nonaggression, German troops wantonly pillaged cultural centers, machine-gunned cathedrals and museums, and turned farm animals loose in palaces.

Being the center of the art world at the time, France suffered the most, though extensive planning initially helped keep many valuable pieces out of Nazi hands. In the late summer days of 1939, while most of their countrymen were still trying to enjoy their last vacation before imminent war, Paris museum administrators frantically packed up the nation's artistic treasures. Fearing damage from military attacks, they removed delicate, centuries-old paintings from their massive frames and gently rolled them

up for evacuation. On the evening of September 3, the day Britain declared war on Germany, the Louvre commandeered a convoy of scenery trucks from the nearby Comédie-Française theater, loaded them up, and sent them out into the countryside under cover of night. Over the next three months, thirty-seven additional shipments trickled out of the city and into safekeeping in more than a dozen chateaus. As well as national treasures, the shipments also included collections belonging to French Jews who had entrusted the Musées nationaux de France (the national museums board) with their possessions.

After the Germans invaded in 1940 and began to confiscate art, the puppet government in Vichy, France, which still oversaw some affairs of state, was occasionally able to divert German attention away from the nation's most prized artworks. Most individuals, however, had no such recourse when they faced off against the Einsatzstab Reichsleiter Rosenberg (ERR), the primary Nazi agency responsible for confiscation activities. Initially responsible for seizing Jewish artifacts for an anti-Semitic think tank, the ERR, which was overseen by the chief Nazi policymaker Alfred Rosenberg, quickly became the primary mechanism for all art seizures. The organization settled in comfortably at the Jeu de Paume museum in Paris. More than twenty-two thousand pieces eventually passed through the museum between 1940 and 1944. Over the course of the war, the Nazis seized or illegitimately acquired more than one-third of all the art in French private collections.

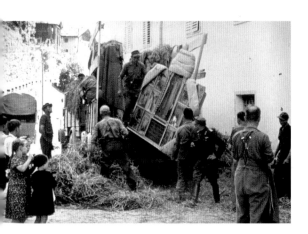

Germans unload masterpieces taken from the Uffizi Gallery to hide them for "safekeeping" during the war.

In 1939, the children of the late art aficionado Adolphe Schloss sent his collection into hiding in a chateau in Laguenne, near Tulle. Known for its breadth and quality, the collection numbered three hundred and thirty-three paintings, mainly of Dutch and Flemish origin. One of the most famous collections in private hands, it included works by Jan Brueghel, Rembrandt, Aert van der Neer, and Frans Hals. Alas, its fame was a double-edged sword: the Germans were on the lookout for it as soon as they set foot in France. In 1943, they finally sniffed out the collection at the chateau, seizing the paintings and splitting them up among

various agencies. Spending some of its political capital, the Louvre was able to hold on to forty-nine works, but the rest were taken by Germany, including two hundred and sixty-two for Hitler himself.

The legendary Rothschild collection, consisting of more than five thousand pieces, was also scattered among secret locations throughout the country, but that only foiled the Nazis for so long. A 1944 report by the ERR's Special Staff for Pictorial Art (in German, the Sonderstab Bildende Kunst) noted that the Staff had "brought into the Reich" twenty-nine shipments containing more than four thousand cases of artworks. "The Staff has not only seized great parts of the art treasures abandoned in the Paris city palaces of the Rothschilds, but it also systematically searched the country seats of the individual members of the Rothschild family, such as the famous Loire castles, for art treasures, thereby safeguarding for the Reich important parts of the world-famous Rothschild art collections," read the report.

The "safeguarded" Rothschild works tracked down by the Special Staff included Raphael's *Man with a Red Hat*, van Dyck's *Henriette of France as a Child*, *Baroness Betty de Rothschild* by Jean Ingres, and a number of Rembrandts and works by Jean-Honoré Fragonard. They also included Vermeer's *The Astronomer*, which was coveted by Hitler himself. The same February 1941 shipment from the Jeu de Paume that carried the Vermeer to the Führer included a couple of Jean-Antoine Watteaus, a pair of Francisco José de Goyas, and a trio of François Bouchers, all courtesy of the unlucky Rothschilds.

The 1653 canvas *Archduke Leopold Wilhelm and the Artist in the Archducal Picture Gallery in Brussels*, by David Teniers (the Younger), was one of the works confiscated from the Rothschild collection by the Nazis. It sold for $4.6 million at a 1999 auction.

Jews weren't the only individuals to lose treasures to the Nazis. In the Netherlands, the non-Jewish banker Franz Koenigs tried to save his collection of forty-six paintings, including twenty by Rubens and three by Hieronymus Bosch, and more than three thousand drawings from the Old Master hands of Dürer, Veronese, and Tiepolo, as well as the more modern artists Watteau, Delacroix, Corot, Manet, Degas, Pissarro, and Henri Toulouse-Lautrec. Under increasing financial pressure because of the war, Koenigs attempted to sell the paintings and drawings to a

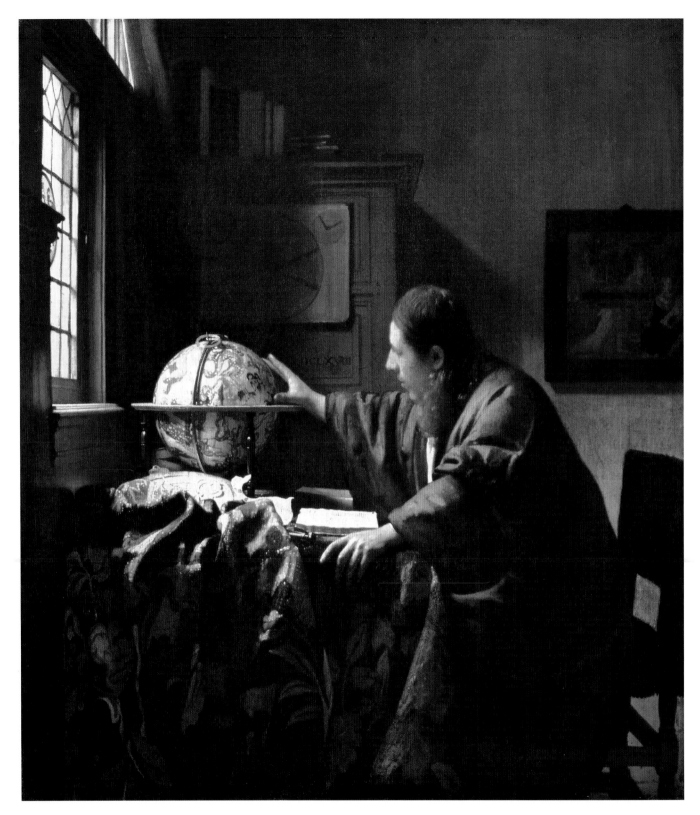

Hitler desired Vermeer's 1668 *The Astronomer*, part of the Rothschild collection, for himself. It was delivered to him in 1941. It now hangs in the Louvre.

Rotterdam museum at half their insured value, but couldn't secure a deal. Eventually, Koenigs had to hand over the collection to settle mounting bank debts. In the spring of 1940, the Nazis invaded the Netherlands and quickly split up the collection, plucking its finest plums for themselves.

Poland also endured enormous losses: the Nazis seized most of the state's collections, again under the pretext of "safeguarding" them. Hans Frank, the Nazi governor in Poland, appropriated for himself Leonardo da Vinci's *Portrait of a Lady with an Ermine*, as well as Raphael's oil-on-panel *Portrait of a Young Man*, both from the Czartoryski Museum in Cracow. The da Vinci was recovered after the war but the Raphael, last seen in Frank's possession in January 1945, now has the sad distinction of being the most important painting lost in World War II.

Portrait of a Young Man by Raphael was confiscated from a Cracow museum by the Nazi's Polish governor, who kept it. It has not been seen since.

HITLER'S DYING WISH

Revenge was one of the Third Reich's motivations. In 1940, Goebbels initiated a project known as the Repatriation of Cultural Goods from Enemy States, charging Otto Kümmel, the director of the Berlin State Museums, to compile a list of all artwork of German origin or provenance taken out of the country since 1500—either sold legally or stolen during the Napoleonic Wars—so they might be repatriated under a victorious Reich. In the end, only five copies of the Kümmel Report were made and the project never came to fruition, perhaps because the Nazi forces were so adept at seizing artworks that there was little time to distinguish between German and other works.

Still, the report influenced German policy toward the conquered countries. When the Wehrmacht stormed into Belgium in May 1940, they sought to reverse the Treaty of Versailles, the document that set out punishing conditions for German surrender at the end of World War I. One term of the treaty had given Belgium possession of the side panels of the Ghent Altarpiece, the multipaneled oil-on-wood masterpiece also known as

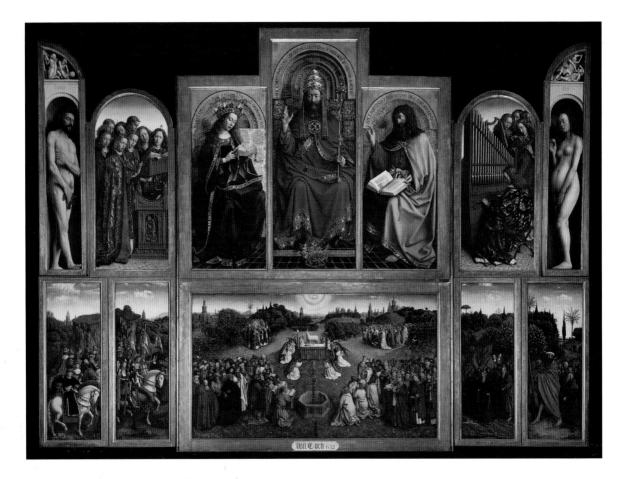

Hitler wanted the 1432 Ghent Altarpiece for the museum he was planning in his own honor. In 1944, the Nazis hid the altarpiece in a remote Austrian salt mine.

The Adoration of the Mystical Lamb that depicts various biblical scenes on both sides of hinged doors. Painted by the Flemish brothers Hubert and Jan van Eyck, the work was originally dedicated in 1432 in the Cathedral of Saint Bavo, in Ghent, Belgium, but it had resided in the Kaiser Friedrich Museum in Berlin since an Englishman had legally purchased it in 1816 and given it to the king of Prussia. In 1919, however, the altarpiece had been included in German war reparations. Still feeling the sting of the loss, the Nazis snatched it back in 1942, tracking it down at a chateau in Pau, France, where it had been placed for safekeeping. It was hustled back to Germany for Hitler, who envisioned it as a centerpiece of a museum planned in his honor. Troops also retrieved four side panels of the *Last Supper* by Dieric Bouts, which the Treaty of Versailles had also awarded to Belgium.

A report published shortly after the war by the Office of Strategic Services (OSS), the chief intelligence-gathering operation of the United

States, stated that the "German policy in regard to Monuments, Fine Arts, and Archives in the occupied territories seems to have been based on two principles: 1) Moral and material enrichment of the German nation. 2) Material enrichment of individual Nazis, predominantly Party bosses."

At least one Party boss would have begged to differ. The crowning vision of Hitler's intended Thousand-Year Reich was the establishment of a Führermuseum in his hometown of Linz, Austria, which would have brought together the greatest artworks in the world, according to his unfortunate tastes. Collecting for the museum was facilitated by the passage of the Führervorbehalt, a legal convention that gave Hitler first crack at any confiscated property. By 1945, more than eight thousand paintings had been accumulated for the planned museum, including more than five thousand Old Masters.

Like Napoleon, who depended on the sharp eye of Baron Denon, Hitler had a discerning curator for the Linz palace in Dr. Hans Posse, director of the Dresden Art Gallery. Posse was an intelligent curator who had built up the Dresden museum into a world-class institution, but he was also politically astute enough to indulge Hitler's provincial tastes in German art while still pursuing the genuinely fine work of Italian and Northern artists. And backed by the absolute power of the Führer, he could outmaneuver agents for the Reich's other main art collectors in securing the best works for Linz. More than once, he arranged exit visas for Jews who handed over their most prized paintings. Other times, a discreet phone call or cable got the bureaucratic wheels turning. The threat of tax assessment, for instance, would help convince reluctant sellers of the need to part with their collections. By this method, Posse was able to "rescue" the collection of French decorative art from the debt-ridden heirs of the German-Jewish banker Fritz Mannheimer, and set it on its way to Linz. He was waiting like a vulture when the Franz Koenigs collection was broken up, eager to take dozens of the Old Master drawings straight to Hitler's side.

Posse's greatest acquisition came in the fall of 1940 when he snatched up Vermeer's *The Art of Painting* (otherwise known as *Portrait of the Artist in His Studio*) on outrageously advantageous terms from Count

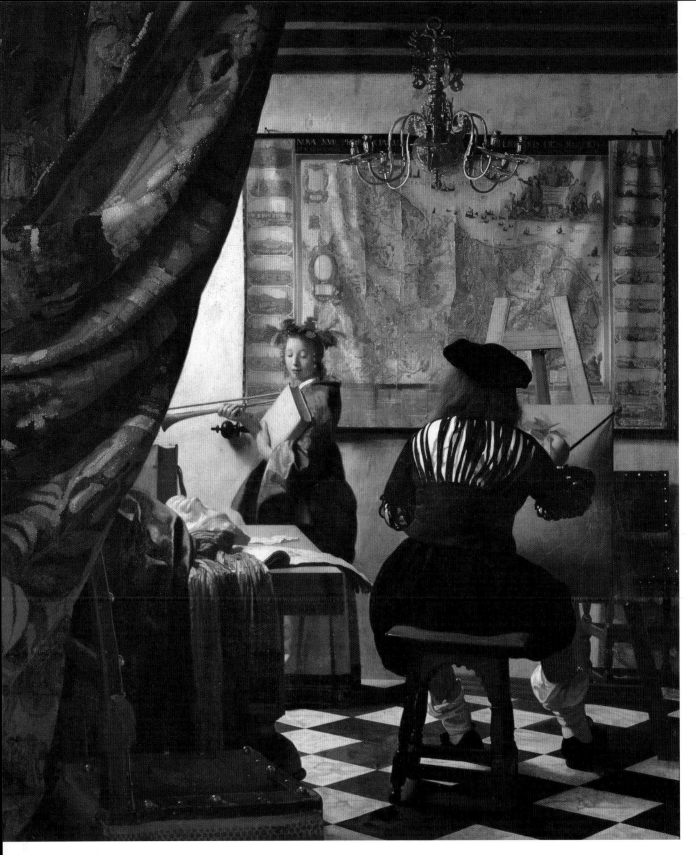

Vermeer's 1666 The Art of Painting is one of the largest of his works. Rather than selling the painting, he kept it with him until his death in 1675.

Jaromir Czernin. The count had received numerous offers to buy the painting, perhaps as high as $6 million from an American collector, but he was unable to obtain the necessary export permit that would have enabled him to cash in. Goering took a run at the painting but was thwarted by an Austrian politician close to Hitler who didn't want it falling into private hands. So when Posse offered 1.65 million reichsmarks ($660,000) on behalf of Hitler—who, the official line declared, didn't want the painting for himself, but for a museum dedicated to the glory of the German people—Czernin could only thank him profusely and bid the picture adieu.

After the war, Czernin tried numerous times to reclaim the painting by arguing that it was "spoliated," that he had been forced to sell it at a price far below its market value. But the Austrian government, which had been in favor of the Anschluss in the first place and therefore was unlikely to challenge German actions, had no interest in dredging up that particular chapter of the country's ugly past. They turned down his case, and since 1946, the painting has resided in Vienna's Kunsthistorisches Museum.

It may seem astonishing that in the midst of a financially taxing and physically grinding war that became thoroughly demoralizing, the Nazi elite could throw endless funds at the acquisition of art. But they'd found the cash by plundering the economies of the occupied countries: the profits from all of those Aryanized factories came in handy.

After hostilities ceased in 1945, Francis H. Taylor, the director of the Metropolitan Museum of Art in New York, estimated the value of all of the looted art to be a jaw-dropping $2 billion to $2.5 billion ($21.6 billion to $27 billion today). That figure exceeded the value of all the art in the United States at that time.

In Hitler's name alone, the German government had spent more than 183 million reichsmarks ($790 million today), making the Führer the greatest art collector of all time. The collection was so important to Hitler that it was one of the few elements in the last will and testament he dictated on April 29, 1945, the day before he killed himself. "My pictures in the collections, which I have bought in the course of years, have never been collected for private purposes, but only for the extension of a gallery in my hometown of Linz on Donau," read the will.

THE NAZI SATURNALIA

If Hitler had been collecting for himself, he wouldn't have been the only one. His deputies were frequently distracted from matters of war by their heated competition against each other and official state agencies for prized paintings, sculptures, prints, and tapestries. Goebbels reportedly paid $90,000 ($1.27 million today) for an El Greco. Goering instructed his agent to damn the expenses in pursuit of Picassos. Heinrich Himmler, the feared head of the SS; Kurt von Behr, the head of the ERR in France; the Nazi foreign minister Joachim von Ribbentrop, who laid his hands on two Monets, including one of the ethereal *Water Lilies*; the minister for economic affairs Walther Funk; Otto Abetz, the ambassador to France, who received dozens of paintings, including works by Monet, Pierre Bonnard, Braque, Maurice Utrillo, and Degas; and the labor leader Robert Ley all abused their positions to get their hands on art, each directing dealers to outbid their colleagues.

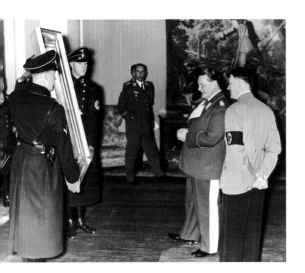

German Field-Marshal Hermann Goering admires a painting given to him by Hitler, right, for his forty-fifth birthday in 1938.

Goering was by far the most successful, accumulating over two thousand works, including more than thirteen hundred paintings, through frequent visits to the Jeu de Paume, where his de facto control of the ERR gave him the pick of the crop. Only Hitler's desires took a higher priority. Goering spread the artworks around his many homes, but most decorated the walls of his palace Karinhall, located near Berlin and named in memory of his first wife, who was buried on the grounds.

Initially, Goering merely "borrowed" works from German museums. But assisted by his primary agent Walter Andreas Hofer, the portly Reichsmarshall demonstrated an increasingly voracious appetite, using his unusual military and government position to force collectors throughout the German-occupied countries to part with their art. Various branches of the German government were also watching out on his behalf. When banks were seized and art was discovered in their vaults, Goering's underlings would get first crack at the prizes that arrived at the Jeu de Paume. In 1942, one hundred and sixty-three paintings belonging to the Paris-based Jewish art dealer Paul Rosenberg were discovered in a bank vault and shipped off to the Jeu de

Hitler's deputies competed for the best art plums. Foreign Minister Joachim von Ribbentrop appropriated two Monets, including a 1904 *Water Lilies*, which was recently returned to its rightful owners.

Paume. Many of the works were by Matisse, Degas, Picasso, and Renoir, modern artists who were officially derided, but Goering recognized their suitability for other purposes: he simply traded them for the German and Flemish Old Master works that were more to his liking.

But the saturnalia was destined to end, and as fortunes began to change in the winter of 1944, it was the Germans' turn to scramble to protect their collections.

Almost twenty thousand art objects came very close to being lost forever, including the Ghent Altarpiece and Bouts' *Last Supper*. In an echo of the massive game of hide-and-seek initiated by curators at the Louvre and other museums at the beginning of the war, the German army opened its own secret storage depots for art. The Ghent Altarpiece was hidden in the largest of these, a remote salt mine above the small Austrian town of Alt Aussee, about seventy-five miles southeast of Salzburg. Located more than a mile inside a mountain, the Alt Aussee site was chosen because the temperature and humidity remained low year-round. It was an extraordinary natural depository, a low-ceilinged and spooky rabbit's warren of interconnected chambers holding more than eighty carloads of treasures, including, according to one account, a copy of the *Mona Lisa* that the Louvre had put into circulation to throw the Nazis off the trail of da Vinci's genuine masterpiece.

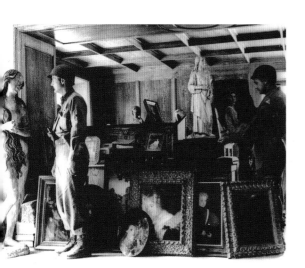

American GIs examine works discovered in the "collection" of Hermann Goering in 1945.

But the Nazis' benevolent attitude toward art ceased when they thought it might fall into enemy hands. Hitler had ordered the destruction of all infrastructure in the occupied countries as German troops retreated so that the Allies would find only a devastated wasteland. Some Nazis apparently felt the policy should extend to art, too. In April 1945, as the Allied forces advanced in Austria, local German brigades smuggled into the Alt Aussee mine eight crates marked "Marble—Don't Drop," which actually contained bombs they intended to set off in order to prevent the art from falling into Allied hands. At the last minute, though, resistance forces cut the long fuses leading to the bombs and instead set off a smattering of the explosives to

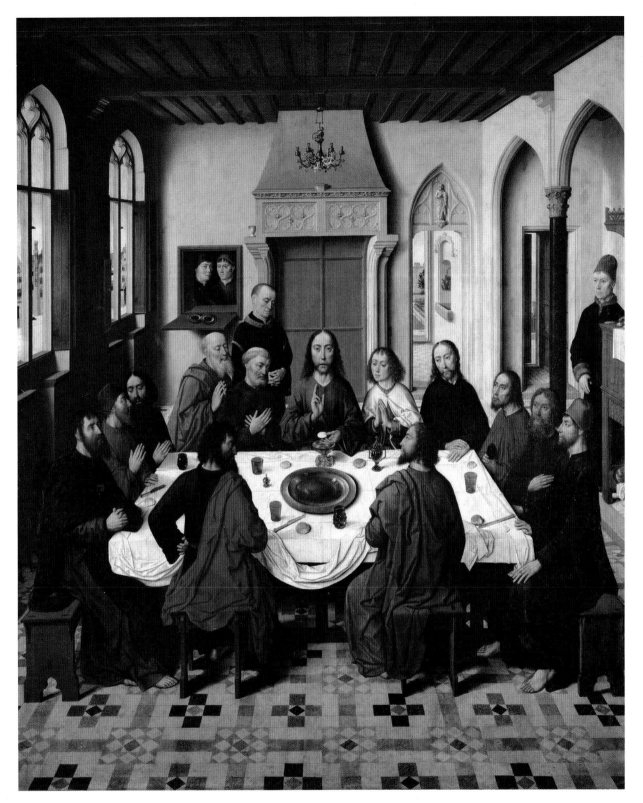

Dieric Bouts painted the fifteenth-century *Last Supper* while he was the official town painter for Louvain, which is now part of Belgium. The masterpiece was returned to St. Peter's Church after the war.

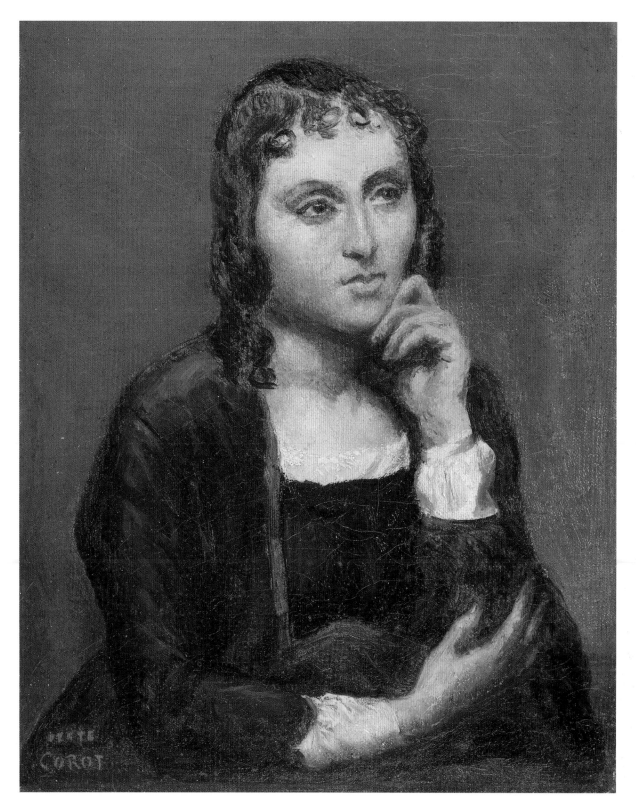

Jean-Baptiste-Camille Corot's *Pensive Young Brunette* (circa 1850) was confiscated by the Nazis from French collector Alphonse Kann and found in 1945 by the Allies in an Austrian salt mine. It was returned to its owner in 1946.

shut down the mine's entrance and preclude the possibility of further Nazi action.

Tragically, the fate of some works of art remains a mystery. One of the greatest treasures to be caught in the conflict was the famed Amber Room from the Catherine Palace at Pushkin (formerly known as Tsarskoye Selo), the summer home of Catherine the Great just outside St. Petersburg, Russia. Sometimes called the Eighth Wonder of the World, the room consisted of more than five hundred square feet of Baltic amber, weighing more than six tons, laid out in mosaics with gold and mirrors. It was commissioned by the king of Prussia and, in 1716, given to Peter the Great as an opulent gift cementing the friendship of the two leaders. (Its current value would be about $250 million.) But the room became a high-profile victim of the nations' enmity. In September 1941, the Germans took Pushkin and laid the Catherine Palace, as well as the Alexander Palace, to waste, destroying many of the treasures and looting the rest. They took apart the Amber Room and shipped it out in twenty-seven crates to Konigsberg Castle, where it was put on display. The panels were last seen intact in April of 1945.

A U.S. soldier inspects treasures confiscated from Jews and stashed in the Heilbron Salt Mines in 1945.

Their exact fate is unclear: the Russians initially suggested that bombing of the castle had destroyed the panels, but later withdrew that conclusion when they thought better of blaming themselves for the panels' destruction. Through the decades, enterprising investigators have turned up countless tantalizing leads, suggesting one moment that the amber panels are buried on the shores of the Baltic Sea and the next that they are in a silver mine about sixty-five miles south of Berlin. But if the panels were not destroyed, then they have stubbornly remained hidden, with the exception of one small section that the son of a German soldier tried to sell in 1997. The piece was confiscated and returned to Russia in an April 2000 state ceremony.

In 1979, Soviet officials finally gave up hope of ever recovering the treasure and set out to re-create the room's glory. Craftsmen toiled on the project for over twenty years. On May 31, 2003, during celebrations

German Chancellor Gerhard Schroeder and Russian President Vladimir Putin open the reconstructed Amber Room in St. Petersburg's Catherine Palace on May 31, 2003. The reproduction cost $8 million.

for the three-hundredth anniversary of the birth of St. Petersburg, thirty state and world leaders witnessed Russian President Vladimir Putin and German Chancellor Gerhard Schroeder officiate at ceremonies to open a new Amber Room in the Catherine Palace. Does the room have the same power as the original? Few would be able to say, as memories of its splendor continue to fade. But it is impossible to look at the re-creation and not muse on the missing treasure it symbolizes.

STALIN'S REPARATIONS

The Amber Room was magnificent, but it was only one of more than five hundred thousand artworks in Russia, worth upwards of $1.25 billion, that were reportedly taken, damaged, or destroyed by German troops during the conflict. So perhaps the Soviets can be forgiven for feeling a little uncharitable toward Germany at the end of the war.

A visitor examines details of one of the carved amber panels at the 2003 opening.

Still, most scholars, politicians, art lovers, and even casual observers condemn Russia for acting like a petty child in its desire to exact revenge from its former partner. When Germany fell to the Allies in May 1945, the country (which at that point included Austria) was divided into four zones administered separately by Soviet, American, British, and French troops. Faced with the nearly impossible task of finding the rightful owners of millions of works, the American, British, and French administrations simply repatriated the artworks that fell under their control to their countries of origin. (This laissez-faire approach led to countless court battles over the ensuing decades when some of those countries proved more interested in absorbing the treasures into national collections than in tracking down the rightful owners.) But Russia embraced the occupation as an opportunity to procure "reparations" for its wartime losses.

Like the Führermuseum initiative, the Soviet program of looting was championed by the head of state, empowered by law, and overseen by art experts. Josef Stalin himself harbored little-known plans to build a museum of world art like the one Hitler envisioned in Linz, and

Conventional Wisdom

The Hermitage Museum suffered damage from German bombing.

The horror of man's inhumanity to man in World War II shocked the world into revising the Geneva Conventions in 1949, under which countries engaging in war promised to treat enemy combatants and civilians with a measure of humanity. Surprisingly, cultural heritage and art caught up in war have been shielded from damage for even longer—at least theoretically.

The principle of protecting cultural property was discussed during the international peace conferences held in 1899 and 1907 in The Hague, Netherlands, and enshrined under the formal documents that emerged from the meetings, known as the Hague Conventions. The documents held little power, however, and demonstrably failed to prevent damage in either World War I or World War II.

The follow-up document, known as the Hague Convention for the Protection of Cultural Property in the Event of Armed Conflict, was signed in May 1954, and entered into force in August 1956. The convention commits signatories to do everything feasible to avoid attacking sites of cultural value, such as museums and archaeological digs. Occupying forces must not illicitly export cultural property, and must refrain from conducting archaeological excavations unless doing so would be the only way to safeguard such places.

Offenses against the convention can be tried under international law as war crimes—but that only applies to the citizens of signatory countries. Since 1956, the convention has been ratified by more than one hundred states around the world, including Iraq, Egypt, Italy, France, Liechtenstein, Canada, the Democratic Republic of Congo, and Niger. It is still awaiting passage by the United States and the United Kingdom.

he sent Trophy Brigades scouring the Soviet-administered zone to hunt down the greatest treasures to be found in stricken Germany.

Which is how it came to be that Schliemann's Gold ended up in Moscow. Discovered in Turkey in 1873 by Heinrich Schliemann, who is considered by some to be the first modern archaeologist, the cache consisted of more than nine thousand priceless gold artifacts found in the remains of Priam, the ancient city named after the one-time king of Troy. In 1881, amid accusations from the Turkish government that he had no right to the treasures, Schliemann donated them to Germany, where they resided until 1945. At the end of the war, however, the artifacts were shipped off to Moscow. For decades, many wondered if they had been destroyed, but in 1994, Russian officials finally admitted they had been stored at the State Pushkin Museum of Fine Arts. They were exhibited once by the Pushkin, in 1996, after which they were sent back into storage.

In 1958, the Soviet Union did return about 1.5 million items to what was then East Germany. But in February 2005, Anatoly Vilkov, the deputy chief of the Russian agency that oversees matters of cultural heritage, admitted that Russia still holds almost two hundred and fifty thousand works of art, as well as about one million books, taken from Germany. In the spring of 2005, as if to taunt Germany on the sixtieth anniversary of the end of the conflict, the Pushkin Museum displayed a selection of five hundred and twenty-two ancient works under the exhibition title Archaeology of War: The Return from Oblivion. Trumpeting the fine conservation work they had done, the Pushkin's staff made it clear that they would not entertain any discussions about Germany's claim to the pieces, which were considered under Russian law to be legally obtained reparations.

Russia also seemed little interested in returning the artworks that belonged to individuals, for in 1945, the Soviets had made no distinction between state-owned and private property that had been improperly seized by the Nazis. More than five hundred prints and drawings in the Franz Koenigs collection were taken back to Russia at the end of the war: three hundred and

Heinrich Schliemann, one of the first modern archaeologists, found thousands of gold artifacts, such as the circa 2300 BCE vessel below, in the remains of ancient Priam.

seven went to the Pushkin, and another one hundred and forty-two went to Kiev, where they were discovered in 1993. In December 2003, the post-Soviet government of Ukraine handed its one hundred and forty-two prints and drawings back to the Netherlands. To requests for a similar display of munificence, however, Russia offered a firm *nyet* and kept its three hundred and seven pieces.

PRIVATELY ENTERPRISING ART COLLECTORS

Taking their cue from the motherland, perhaps, some individual Red Army officers took advantage of the post-war chaos to enrich themselves. In 1945, someone removed Rubens' masterwork *Tarquinius and Lucretia* from the Sanssouci Palace in Potsdam, outside Berlin. Now valued at roughly $92 million, it recently surfaced in the hands of the Russian businessman Vladimir Logvinenko, a real estate developer who owned a strip club called Up & Down. Logvinenko offered to sell the Rubens back to the Sanssouci, but withdrew the offer when Germany replied that it would rather charge him with criminal possession. Eventually, he handed it over to the Hermitage, which restored the painting and hung it proudly in its own collection.

Russian troops weren't the only ones misappropriating artworks. Some U.S. soldiers and officers also had trouble resisting the temptation. In 1945, a Texan by the name of Joe Tom Meador lifted a dozen ancient and precious objects belonging to the church of Quedlinburg in Germany's Harz Mountains and spirited them back to the United States. Worth an estimated $200 million today, the pieces included reliquaries and a priceless ninth-century manuscript written entirely in gold ink. They only surfaced after Meador's death in 1980. His sister and brother circulated them for sale on the black market and managed to sell a couple of the lesser pieces for about $3 million before the rest were confiscated and returned to Germany in 1996.

Then there was the case of the former U.S. soldier who, one day in 1946, turned up at the home of Brooklyn lawyer Edward Elicofon and sold him a couple of paintings for about $450, no questions asked. Twenty years later, Elicofon claimed he had just learned that he'd actually purchased two original color portraits on wood done by Dürer in 1499, which meant he was now in possession of a windfall worth roughly

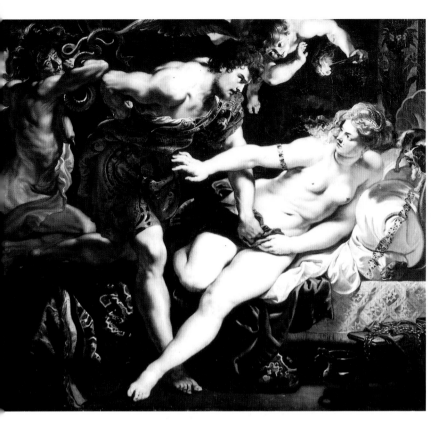

For his 1610 *Tarquinius and Lucretia*, pictured at left before it was stolen in 1945 and damaged, Peter Paul Rubens took as his subject the story from ancient Rome about the lustful Sextus, son of the tyrannical ruler Tarquinius the Proud, and his sexual conquest of the chaste Lucretia. In 2004 the damaged work, below, underwent extensive restoration at the Hermitage to remove the deformations seen here and mount it on a new canvas. Missing pigment was filled in and the yellowed and uneven varnish restored in the painstaking process.

Dishonest GI Joe

Precious stones, glass, pearls, corals, enamel, and mother-of-pearl decorate the gilt silver cover of the ninth-century Samuhel Gospels.

For almost a thousand years, the Church of St. Servatius, in the town of Quedlinburg, Germany, kept the world's darker forces at bay. Even as emperors rose and fell, the church sheltered a collection of priceless artifacts: reliquaries, illuminated manuscripts, coins, and objects of liturgical use. But at the end of World War II, an American lieutenant stationed in the town discovered the stash, which had been stored for safekeeping in a cave at Altenburg—and helped himself.

In April of 1945, Joe Tom Meador scooped up a dozen of the church's treasures and sent them home to Whitewright, Texas, using the U.S. military postal service. A gay man with a taste for aesthetic finery, Meador built a shrine to his prizes in a Dallas apartment, where he wooed other men by showing off the precious items as a way of demonstrating his own taste and supposed means. For who wouldn't be impressed with such prizes? There were centuries-old illuminated manuscripts; reliquaries of rock crystal, gilt silver, garnet, and colored glass; and one miniature casket with intricately carved panels of walrus and elephant ivory, decorated with strips of gilt silver and gilt copper inset with colored glass and semiprecious stones. Some of the reliquaries are said to contain sacred matter such as the dried blood of Christ or a hair of the Virgin Mary.

Meador's secret went undiscovered until after his death from cancer in 1980, when his sister and brother, who lacked his emotional attachment to the pieces, reached out to dealers to see what the hoard might fetch. They got about $3 million—officially labeled a "finder's fee"—when they returned to Germany the Samuhel Gospels, a ninth-century manuscript written in gold letters and bound with a jewel-encrusted cover. But they were thwarted in selling off the entire cache by the sharp investigative work of a German cultural official and a *New York Times* reporter. In all, ten objects were recovered. Alas, two treasures known to have been in Meador's possession are still missing: a crucifix and a rock-crystal reliquary.

$6 million. Unfortunately for Elicofon, the paintings had been stolen at the end of the war from Schwarzburg Castle in east-central Germany, where they'd been stored for safekeeping and which had been overseen by the U.S. military. Germany wanted them back. After years of litigation, Elicofon was forced to turn them over, and in 1981, they returned to the Weimar city museum, where they now hang.

In 1997, the same museum got back its portrait *Elizabeth Hervey Holding a Dove* by Johann Friedrich August Tischbein, when it surfaced for sale at Sotheby's. But about ten fifteenth- to eighteenth-century paintings believed to have been taken by American soldiers in 1945 are still missing from the museum.

All of these types of cases—state versus individual, state versus state, individual versus state, and individual versus individual—will likely continue to play out for years to come. With more attention being paid in the last decade toward the matter of art lost in World War II, justice is increasingly being served. Museums across the globe continue to investigate the provenance of pieces in their collections, reaching out to the world for information via their Web sites.

Even for some people who know where to find their long-lost artwork, the road to justice can be tortuous. At the end of World War II, the five Klimt paintings belonging to Ferdinand Bloch-Bauer were sent from Nazi hands to the Belvedere Gallery in Vienna. Over the decades that followed, they became synonymous with Viennese culture and Austrian pride, especially Klimt's *Portrait of Adele Bloch-Bauer I*, which has been reprinted endlessly on T-shirts, postcards, and dormitory room posters. It seemed fruitless to Maria Altmann and the other Bloch-Bauer heirs to put up a fight. But in 1998, the Austrian parliament passed a law requiring all federal museums to ensure their holdings were free of art illegally seized during the war. Beginning an odyssey that would last seven years, Altmann and her family convinced the U.S. Supreme Court that the federal government should let her sue Austria for the return of the paintings: a rare case of an individual taking on a foreign state.

In early 2006, at age eighty-nine, Maria Altmann got a long-awaited taste of victory when an Austrian arbitrator ruled in her favor, demanding that the Belvedere relinquish ownership of the Klimts to the family. Altmann insisted she didn't want the paintings to disappear from public

view, and the Austrian government briefly considered buying them before realizing it could never scrape together the $300 million it might take to keep them in their home country. "I grew up with those paintings," says a wistful Altmann, who saw the Klimt works every couple of weeks as a child. But she adds, "That was a long time ago."

Around the world, though, the wave of restitutions has been building. Only weeks after Altmann won her case, the Netherlands pledged to return more than two hundred Old Master paintings to the American heirs of Jacques Goudstikker, including works by Jan Steen, Filippo Lippi, van Dyck, Jan Mostaert, Jan van Goyen, and Salomon van Ruysdael. A wealthy Dutch Jewish art dealer and collector, Goudstikker died while fleeing the Nazis in May 1940, leaving behind more than eleven hundred paintings, many of which found their way into Goering's hands. After the war, about three hundred and thirty-five paintings were returned to the Dutch government, while the rest are believed to have filtered out to private collections and museums around the world. In the 1950s, the Netherlands sold sixty-five to seventy of them, placing the rest in museums and government buildings around the country.

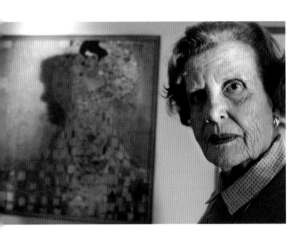

Maria Altmann stands beside a reproduction of Klimt's portrait of her aunt, Adele Bloch-Bauer.

It took eight years for the Goudstikker heirs to press their case with the Dutch government, but when the paintings were finally returned, it represented one of the largest cases of delayed Holocaust restitution in decades. Jacques Goudstikker's granddaughter, Charlène von Saher, declared, "It's about a historical injustice put right."

Such stories continue to surround us. In 2003, the American Association of Museums estimated that of the roughly 1.5 million artworks looted between 1932 and 1945, more than one hundred thousand pieces were still missing. Around the world, more of the rightful owners are passing away every day without ever seeing justice. Which means that until every one of those paintings, prints, sculptures, tapestries, and artifacts is returned, it will be impossible for us to walk through most of the world's museums and galleries without wondering if we are staring into the haunted face of the spoils of war.

It Isn't Always about the Art

Picasso's *Femme en blanc*, displayed here by FBI agents, is an example of his neoclassical work and has been the center of a complicated custody battle.

Art lost in the Holocaust that is restituted rarely finds a place in the homes of heirs. Often, the grandchildren and other relatives don't have the same collecting bug or love of art as their forebears, nor do they often have the financial wherewithal to keep it safe. In 2002, Tom Bennigson discovered that he was the sole heir of Picasso's 1922 painting *Femme en blanc*, which his grandmother Carlotta Landsberg had sent to a Parisian art dealer before she fled Berlin in the late 1930s. The dealer's collection had been looted and, after the war, scattered to the four winds. So when the painting showed up more than sixty years later in the possession of a Chicago woman who had bought it without knowing its seedy past, Bennigson filed suit. Three years later, he agreed to accept a payment of $6.5 million and forgo any further claim on the painting.

Sometimes, all that money at stake prompts unusual behavior. When journalist Hector Feliciano wrote *The Lost Museum*, a book about Nazi thefts, a few museums, galleries, and collectors realized they held art that had been looted or "spoliated," that is, taken without sufficient payment. The family of Paul Rosenberg, a Parisian art dealer, located paintings by Monet, Bonnard, and Léger, as well as Matisse's *Odalisque*, which was found at the Seattle Art Museum after one of its donors spotted a picture of it in Feliciano's book. All told, the family reclaimed about $39 million worth of art, and Feliciano, who said he had a verbal agreement with the daughter-in-law of the deceased art dealer for payment if his research turned up any missing work, sued for $6.8 million. There was no evidence to support his claim and the suit was dismissed.

Francisco José de Goya's portrait of Arthur Wellesley, the Duke of Wellington, which was missing for four years after being stolen from London's National Gallery in 1961, commemorates the British general who defeated Napoleon at Salamanca in 1812.

THE UNCOMMON CRIMINAL

French Impressionist Claude Monet's 1908 *San Giorgio Maggiore by Twilight* was stolen by Pierce Brosnan's character in the film *The Thomas Crown Affair*.

Pierce Brosnan certainly makes stealing art look like fun. In the 1999 remake of the heist caper *The Thomas Crown Affair*, Brosnan plays a bored billionaire who turns to art theft to spice up his life, waltzing into New York's Metropolitan Museum of Art in the middle of the day and strolling out a few minutes later with Monet's *San Giorgio Maggiore by Twilight* in his briefcase. Crown is just chasing thrills and doing what comes naturally to masters of the universe: making the world bend to his whims. He has no need to steal the painting. If he wanted it, he could probably buy it. In fact, unbeknownst to investigators, Crown returns the painting a few days later and sets up an elaborate, self-aggrandizing scheme for its discovery. Catherine Banning, the comely insurance investigator played by Rene Russo, declares the theft to be "an elegant crime done by an elegant person."

Thomas Crown wasn't the only elegant thief stealing into theaters that year. Only a few months earlier Sean Connery charmed his way through *Entrapment*, also playing a gentlemanly art lover and thief who is tailed by a ravishing insurance investigator (Catherine Zeta-Jones).

Is it a James Bond thing? Brosnan and Connery belong to that small fraternity of actors who have served on Her Majesty's Secret Service as special agent 007. As it happens, Bond first made an appearance

onscreen in the thriller *Dr. No*, a film that holds a special place in the thoughts of those who track art theft for a living because it suggested that stolen paintings end up in the private collections of well-heeled men. In the movie, Connery does a famous double-take in Dr. No's lair when he spots Goya's portrait *The Duke of Wellington* perched on an easel. When the film came out in late 1962, the Goya was in fact missing, snatched the previous year from the National Gallery in London. It turned up in 1965.

Officials at London's National Gallery discuss the condition of Goya's portrait of the Duke of Wellington after it had been returned to the gallery in 1965, four years after its theft.

But who really steals art? There may be as many different sorts of art "nappers" as there are schools of painting. Inside jobs are pulled off by resentful security guards trying to humiliate their bosses, poorly paid servants looking for a retirement nest egg, attention-seeking children of rich collectors, and museum staff who fall for a thing of beauty tucked away in storage and decide to take advantage of deficient record-keeping. The "perp" may be a mere street thug with a bad back who realizes that a couple of canvasses are easier to lift than a truckload of electronics. Insurance adjusters and authorities increasingly believe that underworld crime figures use art as collateral for drugs or other illicit goods.

"We haven't found a common thread at this point," says Robert K. Wittman, a special agent with the art crime team of the Federal Bureau of Investigation in the United States. "The only thing we haven't found a whole lot of is females. I'm not saying they're not stealing art, but we haven't arrested a whole lot."

UNLAWFUL GAINSBOROUGH

Still, the beguiling myth of Dr. No persists, even if there's precious little proof that captains of industry—legitimate or criminal—order up Old Masters for delivery like Chinese takeout. The story that inspires it stretches back to Victorian-era London, where Adam Worth was one of the most notorious heads of organized crime, a man who commanded dozens of foot soldiers in everything from burglary to safe-cracking, and

Damaged Goods

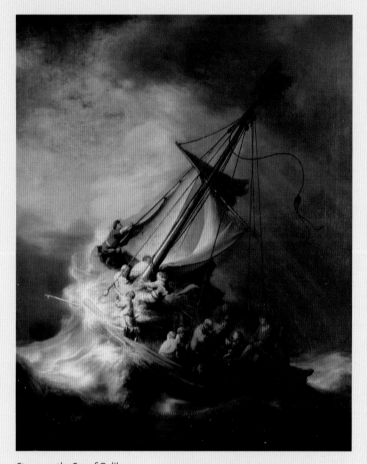

Storm on the Sea of Galilee (1633) is Rembrandt's only surviving seascape—if indeed, it hasn't been destroyed since its theft from the Isabella Stewart Gardner Museum.

Those who nab pieces of fine art would do well to brush up on their caretaking skills, if only for selfish reasons. Paintings especially can plummet in value if damaged, leaving the crooks with nothing to show for their enterprise. Contrary to popular belief, most paintings should never be rolled up.

Proper upkeep is so important that the Isabella Stewart Gardner Museum, on the fifteenth anniversary of the theft, issued a press release pleading with the paintings' guardians to keep the stolen works in the manner to which they had become accustomed. "[In] order to protect the artworks, they must be stored in conditions that do not allow for swings in temperature and humidity—ideally at 70 degrees Fahrenheit and 50% humidity." Unfortunately, the rumor from a number of corners is that Rembrandt's *Storm on the Sea of Galilee* has suffered grievously during its travels since the Gardner theft, and may be all but ruined. Experts also fear for *The Scream* stolen from the Munch Museum in August 2004.

In April 2003, somebody lifted three paintings worth more than £4 million ($6.5 million) from the Whitworth Art Gallery in Manchester, England: Picasso's Blue-period *Poverty*, van Gogh's *The Fortification of Paris with Houses*, and Gauguin's *Tahitian Landscape*. Acting on an anonymous tip, police found the paintings the next day rolled up in a tube near a disused public toilet. Alas, the thieves, who claimed in a note that they were only trying to highlight poor security at the gallery, hadn't counted on heavy overnight rain. One corner of the van Gogh was torn, and the other two paintings suffered from exposure to the weather.

Picasso was only twenty-four years old when he painted *Poverty* (1903), depicting a frail man walking with a small child.

mail heists to bank robbery. A German-born Jew who moved as a young boy with his family to America in the middle of the nineteenth century, Worth served in the Northern forces of the U.S. Civil War before turning to a more selfish and profitable career: picking the pockets of unsuspecting New Yorkers. As Ben Macintyre recounts in his splendid book *The Napoleon of Crime*, an early jail term inspired Worth to turn his attention to bigger scams. He traveled to London, where he reinvented himself as Henry Judson Raymond, a merchant banker, and insinuated himself into the upper crust.

It was a rigorously held cover, his real identity hidden from the society swells with whom he cavorted around Mayfair. The reach of Worth's criminal network was far greater than most of his upper-class friends' legitimate enterprises, extending beyond the natural limits of the English Channel to the Continent and, eventually, the West Indies. But if his means were disreputable, his appearance was refined. Dressed in bespoke suits, residing in luxurious apartments, accompanied by a heavyset butler, Worth gave every impression of being a gentleman to the manner born.

Except that most baronial gentlemen don't vault through second-story casement windows, and their butlers aren't actually bodyguards with a penchant for carrying bits and pieces of junk in their pockets. One evening in May 1876, Worth, his bodyguard "Junka" Phillips, and another accomplice waded through inky darkness to the art gallery of Thomas Agnew & Sons on Old Bond Street. Phillips cupped his hands together and hoisted up his boss, who pried open a window and slid silently into the gallery. Alone in the darkness, Worth removed a Gainsborough portrait of the Duchess of Devonshire from the wall. The painting had recently been sold at auction but had not yet been delivered to the American banker Junius Spencer Morgan, who had purchased it for his son J.P. At a hair over 10,000 guineas (equivalent to about $62,000 then and a little under $1.2 million today), the portrait was at the time the most expensive work of art in the world. Worth carefully cut it from its frame, rolled it up, and spirited it out into the night.

Why was it so entrancing? The British artist Sir Thomas Gainsborough (1727–1788) preferred to paint landscapes, but he had a wife and children to support and his pragmatic nature led him into commissioned

Adam Worth, head of a criminal network in Victorian London, wasn't the only man to fall for Georgiana, Duchess of Devonshire, whose portrait by Gainsborough (opposite) he cut from its frame and nabbed in 1876. Georgiana's husband apparently had the painting removed from their home when she became pregnant by another man.

A Different Sort of Art Theft

The legitimate version of Gauguin's *Vase de fleurs* fetched $310,000 for art dealer Ely Sakhai at a May 2000 auction, shortly before his scheme was discovered.

If there's no such thing as a perfect crime, Ely Sakhai's forgery scheme came pretty close. For almost two decades, Sakhai, a Manhattan art dealer, toured the major New York auction houses, buying paintings by Cézanne, Renoir, Chagall, Gauguin, Klee, Modigliani, and others. These were unspectacular, so-called mid-level works that didn't attract much attention because they usually fetched only a few hundred thousand dollars. He would then send out a painting to be forged, ensuring that the new painting was an exact replica of the original, right down to obscure markings on the back of the canvas. Sometimes, he'd direct the forger to apply a special coating atop the canvas to make it appear aged.

Allowing a respectable amount of time to pass after his purchase, he'd sell the forgery to an unsuspecting collector or dealer, usually accompanied by a bogus "certificate of authenticity" that carried the provenance of the authentic painting. Again he'd let some years pass before offering the original for sale in the marketplace, often at one of the major auction houses where he'd first purchased it.

Which is how his scheme eventually came crashing down. In the spring of 2000, Sakhai put his authentic Gauguin painting, *Vase de fleurs (Lilas)* up for auction at Sotheby's in New York. Bad luck for him. Years before, he'd commissioned a forgery of the painting that had subsequently passed through the hands of a series of collectors, the last of whom had chosen to put it up for auction only a couple of miles away, at Christie's, at the exact same time. When investigators started digging, they realized Sakhai was the source of the forged painting, and that he had pulled off the same stunt more than a dozen times over the years, often favoring Asian customers who might be less likely to press charges if they found they'd been duped because they would not want the public humiliation. In the summer of 2005, Sakhai was sentenced to forty-one months in prison and ordered to pay $12.5 million in restitution.

portraiture. His poetic sensibility was a hit with tastemakers such as King George III, and by the early 1780s, he was regularly painting the British Royal Family. Around 1787, he executed the portrait of Georgiana, Duchess of Devonshire, an ancestor of Princess Diana and a notorious vamp who shared a habit of immorality with her husband, the 5th Duke of Devonshire. Gainsborough's portrait captured Georgiana's inquisitive eyes and the baby-doll pout that ensnared many a man— including, decades after her death, Adam Worth.

When Worth snatched the painting, he'd intended merely to use it as a poker chip in a scheme to spring his younger brother, John, from the clink on a charge of check forging. More than a century later, this view of paintings as get-out-of-jail-free tokens would gain popularity among mobsters and small-time crooks alike. But shortly after Adam Worth grabbed the painting, John was sprung through entirely legal means, and Worth chose to keep Georgiana for himself. And like many men who begin as art thieves and find themselves captive to their own captures, Worth fell under the spell of the enchanting painting. He was unusually devoted: except for a crushing seven-year term in a Belgian prison, he carried the portrait with him for a quarter of a century, even on occasion sleeping with it under his bed. In 1901, in need of cash after prison, Worth finally arranged for Georgiana to be returned to her rightful owner. Some speculate that giving up the painting left him heartbroken. He died less than a year later.

Worth may be the only known high-society fixture to keep a stolen picture for his pleasure, but he has plenty of inept spiritual descendants in the common classes.

A SLAVE TO ART

For seven years beginning in the mid-1990s, Stephane Breitwieser strolled through castles, country homes, and the smaller museums and galleries of Europe scooping up loot. From afar, he must have looked like any passionate Frenchman in his twenties, albeit a shy and introverted sort, working as a waiter to support his hobbies of art appreciation and travel. But he appreciated the art just a little too ardently, blithely plucking paintings from the walls of poorly guarded museums and country houses during regular viewing hours, rolling up the canvasses and

tucking them into his long overcoat or knapsack. If he needed a little help, his girlfriend Anne-Catherine Kleinklauss sometimes acted as a lookout or distracted a guard.

Breitwieser's unparalleled art-theft spree began in March 1995, during a visit to the picturesque Gruyères Castle in Switzerland, where the French-born painter Corot was once an artist-in-residence. Corot's old room still boasts a number of his romantic landscapes, and the castle's other treasures include Flemish tapestries and heraldic stained glass. But it was a portrait of a woman by the little-known eighteenth-century German artist Christian Wilhelm Dietrich that seduced Breitwieser to the dark side. Its monetary value wasn't what stunned the small and fragile Frenchman: the painting was worth perhaps only $2,000.

"I was fascinated by the beauty, the qualities of the woman, by her eyes, which reminded me of my grandmother," he later recalled. "I thought it was an imitation of Rembrandt." He stared at the picture for almost ten minutes, drawn in by the life pulsating from its surface. Then he simply took it down from the wall of the Belle Luce room, gently removed the small canvas from the frame, rolled it up, and walked out of the castle.

Breitwieser was genuinely obsessed with art, and he tried to create a world that revolved around his obsession. He lied to strangers that his grandfather was the locally famous painter Robert Breitwieser. He tried channeling his passion into more traditional avenues, spending a year studying art history at the University of Strasbourg. In time, though, he began to grasp that a man of his meager means would never be able to possess works of the Old Masters. The realization helped justify in his mind an increasingly daring life of crime in pursuit of beauty.

He acquired paintings, drawings, silverware, ivory carvings, sculptures, and illuminated manuscripts, showing a catholic taste that led some experts to believe he was a kleptomaniac, thrilled by breaking the law rather than owning the art. Certainly Breitwieser was ill, according to a court-appointed psychiatrist at his trial. "It became a compulsion. I wanted more and more and I couldn't stop myself," Breitwieser explained. In the pages of a psychiatrist's report that held echoes of Adam Worth's obsession with the Gainsborough, Breitwieser elaborated: "I need these objects and they need me. I was nearly a slave."

François Boucher's eighteenth-century *Sleeping Shepherd*, which French waiter Stephane Breitwieser lifted from a Chartres museum in 1996, is believed to be among the paintings destroyed by the thief's mother.

Breitwieser had each painting framed by a local craftsman who, proving supremely incurious, apparently never wondered how this diminutive waiter was acquiring million-dollar masterpieces. He would then hide away the art in his bedroom in the small Alsatian home he shared with his mother, first in the tiny village of Ensisheim and, later, the nearby village of Eschentzwiller. When his hoard outgrew the walls of his tiny bedroom and a sitting room, he organized a series of revolving shows for himself, putting some pieces on display and storing others around the room.

In all, Breitwieser admitted to acquiring two hundred and thirty-two items from one hundred and thirty-nine museums and galleries in Belgium, Denmark, Netherlands, Germany, Austria, France, and Switzerland. The biggest plum of all was a $9-million painting by Lucas Cranach (the Elder) depicting a sly Sybille, Princess of Cleves. Other treasures included *Cheat Profiting from His Master*, by Pieter Brueghel (the Younger), stolen in May 1997, in Antwerp; Corneille de la Haye's *Madeleine of France, Queen of Scotland*; François Boucher's *Sleeping Shepherd*, stolen from a museum in Chartres in August 1996; David Teniers' *The Monkey's Ball*; and a red chalk drawing by Watteau entitled *A Study of Two Men*, stolen in June 1999, from Montpellier Museum.

French gendarmes and soldiers search for art objects in the Rhine-Rhone canal. Breitwieser lived with his mother, who, when he was under suspicion, allegedly destroyed some of the paintings and threw many artifacts into the canal. Some were recovered.

In November 2001, Breitwieser pushed his luck just a little too far when he snatched a hunting bugle from the Richard Wagner Museum in Lucerne, Switzerland. It was fairly easy to pin the theft on him since he was one of only three visitors that day. When he returned two days later, the museum director had no trouble picking him out and called the police. At first, the authorities thought they were dealing with another petty thief. But over the next few months, as various Swiss cantons came forward with stories of their losses, and the French police added their own files to the investigation, the full scope of Breitwieser's pathological enthusiasm came into focus. Alas, by that point, his mother, Mireille Stengel, had allegedly destroyed dozens of the canvasses—to punish her son, she explained, though authorities figured she was

Lucas Cranach (the Elder), whose sixteenth-century painting *Sybille, Princess of Cleves* was the most valuable work stolen by Stephane Breitwieser, is believed by some to have been the inventor of the full-length independent portrait.

The *Mona Lisa* of Sculpture

Benvenuto Cellini, who crafted the *Saliera*, was considered one of the finest Italian artists of the generation to follow Michelangelo.

Security specialists are supposed to help the art stay where it is. But when they cross to the other side, they can leave the authorities tied up in knots. In the spring of 2003, a fifty-year-old security alarm expert by the name of Robert Mang paid a visit to the Kunsthistorisches Museum in Vienna, where his eyes alighted upon one of the world's most valuable works of art, the *Saliera*, or royal saltcellar, which King François I of France had commissioned from Benvenuto Cellini (1500–1571). Known as the *Mona Lisa* of sculptures, it depicts an intertwined man and woman in an allegorical representation of the Earth's relationship with the sea, executed in intricately carved gold and inlaid with ebony and enamel. Valued at $60 million but considered priceless for its rarity, it is the only gold sculpture of Cellini's known to exist.

Mang returned to the museum in the pre-dawn inkiness of May 11, scaling an exterior scaffolding rig, breaking a second-floor window, slipping inside, shattering a glass case holding Cellini's masterpiece, and retreating less than sixty seconds later. "The alarm system went off, but as an alarms expert, he knew he had time to get out," Ernst Geiger, a chief of the local criminal police, explained later. Indeed, the guard on duty simply reset the alarm. It was more than four hours before a porter noticed the damage and called in police.

Mang, who authorities said had no criminal record and was in no financial trouble, quietly held on to the sculpture for more than two years while police tracked down leads across the globe. In the fall of 2005, he suddenly demanded a ransom of 10 million Euros ($11.9 million). But if he was an expert in security systems, he wasn't as adept at other technology: a cell phone he used to contact police was traced back to the store where he bought it. In January 2006, police released a videotape of Mang in the store. He quickly turned himself in and led police to a snowy forest about fifty miles northeast of Vienna, where they recovered the *Saliera* buried in a box. Other than a few scratches, the sculpture was none the worse for its adventure, and a week later it was back on display—after the museum's director vowed to house it in a shatter-resistant glass case.

merely getting rid of the evidence—and thrown closetfuls of the other artifacts and relics into the Rhine-Rhone canal, about sixty miles from her home. Many of the artifacts were pulled from the canal. Some investigators think she may have sold some of the paintings, though none has yet turned up. In any case, Stengel received only eighteen months in jail for her collaboration. Breitwieser's by-then-ex-girlfriend also received a light sentence, only six months. Breitwieser himself was given a twenty-six-month jail term.

ART FOR THE TAKING

History is sprinkled with the broken hearts of art lovers whose unbridled and unbalanced ardor compelled them to break the law. One Monday morning in August 1911, an Italian carpenter named Vincenzo Peruggia stepped out of a storage closet in the Louvre, where he had been hiding, and pulled the *Mona Lisa* off the wall of the Salon Carré. The museum was shut for the day and Peruggia, who had been working on a display cabinet for the *Mona Lisa*, was able to escape without drawing notice from the thin security staff. He held on to the painting in his tiny Parisian flat until he was arrested two years later while trying to sell it to the director of the Uffizi in Florence.

Italian carpenter Vincenzo Peruggia stole da Vinci's *Mona Lisa* from the Louvre in 1911. Officials did not report the painting missing until the day after the theft.

At his trial, Peruggia declared that he was merely performing his patriotic duty by trying to return the work by the Italian-born da Vinci to its home and native land. He apparently believed that all of the Louvre's Italian masterpieces had been stolen by Napoleon. (Never mind that da Vinci had happily sold the *Mona Lisa* to his patron François I, the king of France, around 1514.) But if Peruggia's nationalistic stance was merely a cynical ploy to appeal to the court, as some people speculated, the strategy worked: he received only one year in prison, and his sentence was eventually commuted to a mere seven months.

In recent years, Peruggia's story has received a sinister twist that suggests his motivations weren't as pure as selfless patriotism. Some

historians have theorized that Eduardo de Valfierno, an Argentine con man, hired Peruggia to steal the painting. De Valfierno allegedly planned to sell six forged copies to wealthy collectors scattered around the world who, knowing the *Mona Lisa* had been stolen, could have been easily convinced they were buying the real thing. The story goes that Peruggia wasn't told that part of the plan and that when he didn't hear from de Valfierno after the theft, he figured he might as well try to sell it.

In any case, the Louvre was hit again in 1939, by another aesthete with a very particular aesthetic, an art student who snatched Watteau's *L'Indifférent* and returned the painting a short time later, after removing the varnish. Someone who stole a Harold Betts painting from a storage facility in West Los Angeles in 1994 restored the picture and had the canvas restretched before selling it again. Another art student who swiped an Auguste Rodin bronze from London's Victoria & Albert Museum in 1953 returned it after explaining he merely wanted to live with it for a while.

In June 2005, a twenty-year-old Chilean art student stole Rodin's bronze *The Trunk of Adele* from the National Museum of Fine Arts in Santiago and then turned himself and the sculpture in to authorities. He said he was trying to "prove the vulnerability of the museum." Red-faced administrators had to admit he was right. But just because it looks easy is no guarantee that anyone can steal art and get away with it.

Rare books are less popular targets than rare art, but that doesn't mean they're any less valuable, beautiful, or culturally significant. In 1994, Microsoft founder Bill Gates paid just over $30 million for a da Vinci notebook known as *Codex Leicester*. Written between 1506 and 1510, the book contained da Vinci's thoughts on all manner of scientific subjects—from astronomy to geology, paleontology to hydrodynamics—and its sale set a world record for a manuscript sold at auction.

That kind of money could certainly motivate a college dropout to walk through the door of a university library. Which is why a twenty-year-old man calling himself Walter Beckman came to call at the Farris

Vincenzo Peruggia, seen here in his mug shot, had snuck out of the Louvre with the *Mona Lisa* tucked under his shirt. He kept the painting in his Paris flat for two years before trying to sell it to the Uffizi Gallery in Florence.

Luis Onfray, a student at the University of Arts and Social Science, snatched Rodin's *The Trunk of Adele*, part of a sixty-two-piece exhibit at Santiago's Museum of Fine Arts. He returned the bronze sculpture the next day.

Rare Books Room at Transylvania University in Lexington, Kentucky, on December 17, 2004, with a stun gun in his pocket.

The room has a separate stairway that is not visible from the rest of the library and is locked at all times, for its treasures include the *Book of St. Albans* (printed in 1486), Charles Lucien Bonaparte's *American Ornithology* (1833), and the first five editions of Izaak Walton's *Compleat Angler* (1653–1676). Visitors are urged to make appointments, which Beckman had done by e-mail.

Shortly after Special Collections librarian B.J. Gooch opened the door, Beckman called an associate on his cell phone. When the friend showed up, he grabbed Gooch, and Beckman zapped her with the stun gun. The two men bound her hands and feet and snatched three rare books, twenty sketches by the naturalist John James Audubon made in preparation for his 1856–1857 edition of *Birds of America*, and two Audubon books: a folio edition of *Viviparous Quadrupeds of North America* (1845–1848) and a double elephant folio of *Birds of America* (1826–1838), measuring about twenty-six and a half inches by thirty-nine inches. In 2000, a similar first edition of *Birds of America* sold at Christie's for $8.8 million, setting a record for any printed book sold at auction.

They didn't get very far with their booty. It's not easy to run with books that large, and as the two men rushed out, Susan Brown, the library director, spotted them and yelled for them to stop. In a panic, they dropped the Audubon books—the heart of their prize—but kept running until they reached a gray minivan, where they joined two more accomplices and sped off. Police estimated the value of their haul at upwards of $500,000.

Four days later, Beckman, now calling himself Mr. Williams, walked through the Rockefeller Plaza entrance of Christie's auction house in New York City with a man who gave his name as Mr. Stephens. Meeting with printed books specialist Melanie Halloran, the two said they were representing a very private individual, a Mr. Beckman, who wished to unload some valuable

Leonardo da Vinci's seventy-two-page notebook, known as the *Codex Leicester*, covers a range of scientific subjects, including astronomy, hydraulics, and optics. It is encased in a tooled and embossed clamshell box and leather binding.

possessions through Christie's private treaty service, whereby the house sells goods without an auction. They opened up a suitcase and showed Halloran an 1859 edition of Charles Darwin's *On the Origin of Species*; an illuminated manuscript written in 1425; the *Hortus Sanitatis* ("Garden of Health"), a two-volume natural history with hand-painted gold-illuminated woodcuts; and the twenty Audubon sketches.

Halloran said she believed she'd be able to accommodate them, and got a cell-phone number from Mr. Stephens for a follow-up. But the next day she told her boss about the encounter, saying she felt there was something suspicious about the men.

Indeed there was. Mr. Williams, a.k.a. Mr. Beckman, was in fact Walter C. Lipka, a former University of Kentucky student who had been attending school on a partial soccer scholarship before he stopped going to classes because of payment issues. Mr. Stephens was Spencer Reinhard, a promising artist and student at Transylvania University who had taken the semester off. He should have changed the voice mail on his cell phone before giving the number to Christie's, however. When an FBI agent posing undercover as a broker handling Christie's private treaty service called the number, the outgoing message said, "This is Spence, leave a message."

It wasn't the only flaw in their plan: Lipka had used the same e-mail address to set up his appointments both with B.J. Gooch at the Farris Rare Books Room and with Melanie Halloran at Christie's; it was only a matter of time before authorities put it all together. On February 11, 2005, Lipka and Reinhard were arrested along with Eric Borsuk, who had helped Lipka subdue Gooch, and Charles T. Allen II. Both Borsuk and Allen were University of Kentucky students taking a semester off from school. Their botched theft and resale of the books and sketches ensured that it would be a long while before any of them saw the inside of a university library again. The four men were each sentenced to seven years in jail.

PICASSO TRIGGERS A FRAUD

Sometimes people steal from themselves. Insurance fraud is a popular tactic among collectors looking for some extra cash, since it enables them to liquidate their own property and take the cash while still holding on to

This hand-painted and illuminated woodcut from the fifteenth-century *Hortus Sanitatis* shows the creator, Verard, presenting the book to King Henry VII. The *Hortus Sanitatis* was one of the rare works stolen from Transylvania University in Kentucky.

Heavy Lifting Required

Henry Moore used reclining figures throughout his career, initially inspired by pre-Colombian sculptures. His two-ton bronze work, simply titled *Reclining Figure*, was stolen in late 2005.

When police and the press talk about a big art theft, they're usually referring to the high monetary value of what's been taken. But on rare occasions, they're also talking about the sheer physical size of the art.

In March 2005, three sections of Philip Pavia's four-part, ten foot tall, three thousand pound bronze piece, *The Ides of March*, were removed from a loading dock in midtown Manhattan, where they had been awaiting shipment to Hofstra University in Hempstead, Long Island. A few days after the theft was discovered, a man representing a Bronx scrap-metal dealer showed up at the loading dock, saying he'd come for the fourth piece. Police called on the dealer, who said he had no idea he was in possession of stolen property and promptly returned the first three sections. He also handed over the name of the man who'd sold them to him.

One of the biggest thefts in recent years—in both value and weight—involved the eleven-foot-long, two-ton bronze Henry Moore sculpture *Reclining Figure*, valued at £3 million ($5.2 million), swiped from the grounds of the late artist's home in Much Hadham, Hertfordshire, in December 2005. Police were astonished to view the closed-circuit television recording of the nighttime burglary, which showed a team of thieves driving onto the grounds of the Henry Moore Foundation in an old-style Austin Mini Cooper car and a red flatbed Mercedes truck that was fitted with a crane. A British police inspector declared the operation to be a "very, very audacious theft," but just because the thieves were bold and ingenious doesn't necessarily mean they'll be able to cash in on their hard work. With the Moore's unique combination of fame, market value, and size, police know it would be all but impossible to fence. Their real fear? That another scrap-metal dealer who has never heard of Moore might melt down the bronze.

In January 2006, seven years after Picasso's *Nude Before a Mirror* was recovered from an insurance scam, Lloyd's of London sued the insurance broker that accepted an exaggerated appraisal.

the artwork: to have their cake, and eat it too, as it were. And with theft being so common, suspicion rarely fall first upon owners.

In the mid-1980s, Dr. Steven Cooperman, a Beverly Hills ophthalmologist with a taste for the French Impressionists, purchased two paintings: Monet's *Customs Officer's Cabin at Pourville*, for about $800,000, and Picasso's *Nude Before a Mirror*, for $957,000. In 1991, he loaned them to the Los Angeles County Museum of Art for an exhibition. For the museum's insurance purposes, he estimated their value at a staggering $12.5 million, but nobody at LACMA bothered to question the figure.

After the show, Cooperman took his paintings and the loan receipt—with its outrageous estimate, ostensibly approved by the museum—and presented it as proof of their value for an updated insurance policy underwritten by Lloyd's of London and the German insurer Nordstern Allgemeine Versicherungs. The policy should never have been written at that level, but fine-art insurance brokers aren't naturally predisposed to suspecting their clients of fraudulent intent, and they'd rather take the business than let it go to another company.

Monet painted many works of Pourville, on the rough northern coast of France, not far from his childhood home in Le Havre, including *Customs Officer's Cabin at Pourville*. The 1882 work was falsely reported stolen in an insurance scam.

One weekend in July 1992, when Cooperman was away on vacation, his housekeeper called to tell him the paintings had been snatched. Oddly, the burglar alarm had not been tripped and the police found no signs of a forced entry, but investigators treated the paintings as stolen. When Cooperman filed for the insurance money, Lloyd's and Nordstern, disgruntled at the extraordinary valuation, refused to pay out the claim. As it happens, Cooperman had a long resumé of legal imbroglios that encompassed an apparent enthusiasm for spurious class-action suits, as well as allegations of health insurance fraud. In addition, at the time his paintings disappeared, he was also in some financial distress, with more than $6 million in outstanding loans.

But Cooperman sued his insurers and won—not only the $12.5 million, but also an additional $5 million in punitive damages. A few years later, debts paid and in possession of a sizable nest egg, he moved to Connecticut to enjoy a very comfortable retirement. In the end, he was brought down by that age-old story, a spurned lover out for revenge. To add to the indignity, it wasn't even his own lover who brought him to heel.

In early 1997, FBI agents received a tip that they might find some stolen art in a storage locker just outside Cleveland, Ohio, being rented by James Little, a lawyer whose former partner represented Cooperman. Little's ex-wife, Roberta Vasquez, had been talking to the feds, partly inspired by a $250,000 reward. Vasquez is famous in some circles as the first California Highway Patrolwoman to land a position as *Playboy*'s Playmate of the Month (November 1984). She's also in the 1988 B-movie thriller *Picasso Trigger*, which happens to be about a devious art collector. But she had some competition for the reward money from Little's girlfriend Pamela Davis, who at the time was beginning to find her affair with Little less than enchanting.

In the end, it was Cooperman's own lawyer, James Tierney, who served him up to the feds, participating in a series of tape-recorded phone conversations in which the ophthalmologist urged Tierney to chop up the paintings with gardening tools so as to get rid of the evidence. Eligible for a jail sentence of up to one hundred and eighty-three years for his fraud, Cooperman walked away with a sentence of only thirty-seven months after he cooperated with a separate federal investigation into dubious dealings at a law firm.

After Marc Chagall's *Study for Over Vitebsk* turned up in Kansas, Bella Meyer, the artist's granddaughter, authenticated the work by noting a group of numbers on the back of the canvas, put there by Chagall.

ART AND POLITICS

Sometimes, thieves have higher ideals than mere personal gain. In the spring of 2001, the Jewish Museum in New York faced an impossible demand. The small oil-on-canvas *Study for Over Vitebsk*, painted in 1914 by Chagall, disappeared during a cocktail reception. A few days later, the museum received a letter from an organization no one had ever heard of called the International Committee for Art and Peace. Their demand? That peace must be achieved between Israel and the Palestinians before the painting would be returned. Alas, peace was a long way off, which someone in the shadowy organization apparently came to realize. The following January, the painting, which is worth more than $1 million, turned up in a postal sorting station in Topeka, Kansas, none the worse for wear.

The Thomas Alcock Collection

Jonathan Tokeley-Parry, posing beside replicas of pieces he smuggled out of Egypt by disguising the real artifacts as tourist souvenirs.

One of the more popular art-world ruses involves touching up a cheap plastic or wooden statue and presenting it to a gullible neophyte collector as a priceless artifact that has been spirited out of the bosom of an ancient civilization. But one famous smuggler turned that trick on its head, and for many years got away with it.

During the early 1990s, the former British cavalry officer Jonathan Tokeley-Parry bought numerous items, including statuary, from Egyptians he later identified obliquely as "farmers and builders." A master restorer, he would dip the stone statues in clear plastic and then cover them in black and gold paint to make them look like gaudy tourist souvenirs. Customs officials, who routinely ignored anything that looked cheap, didn't catch on. Tokeley-Parry, thus, successfully transported many artifacts, including a $1.2-million sculptured head of the Egyptian pharaoh Amenhotep III (circa 1403–1354 BCE), to a Manhattan dealer via Switzerland.

Tokeley-Parry created a false provenance for many of his stolen artifacts by claiming that they came from the nonexistent Thomas Alcock Collection—named after his real-life great uncle. He made convincing labels for the old pieces, too, by copying old pharmaceutical labels onto rough paper, baking the labels, and daubing them with tea bags to make them look aged.

In the late 1990s, Tokeley-Parry was caught and tried in England, where he received a three-year prison sentence. He was also tried in absentia in Egypt and sentenced to fifteen years' hard labor, to be served in the event that he ever returns to that country.

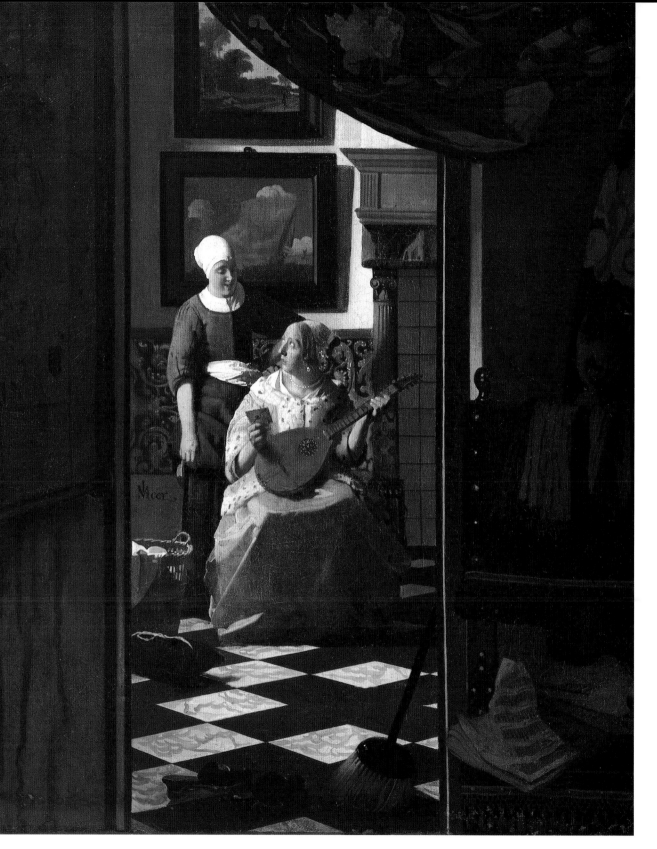

Vermeer's *The Love Letter* (1667–1668) suffered damage during its theft and the time it was held for ransom, when it was stored under a bed. It is one of four Vermeers owned by Amsterdam's Rijksmuseum. The others are *The Milkmaid*, *Woman in Blue Reading a Letter*, and *The Little Street*.

The demand was not without precedent. After the September 1971 theft of Vermeer's *The Love Letter* from the Fine Arts Museum in Brussels, where it was on loan, thieves demanded a ransom of 200 million Belgian francs ($19.5 million today) on behalf of Bengali refugees. No ransom was paid. The painting was recovered and now hangs in its usual spot in the Rijksmuseum in Amsterdam. In February 1994, when a version of Edvard Munch's *The Scream* was stolen from the National Gallery in Oslo, suspicion fell upon two local antiabortion activists, ex-priests who had been promising to pull off a spectacular publicity stunt during the Winter Olympics, which had just opened there. They suggested that the painting might be returned if Norwegian television would show a pro-life film. Broadcasters demurred and the activists' demand was revealed to be a mere bluff: they'd had nothing to do with the theft. The real thieves were arrested and the painting was recovered.

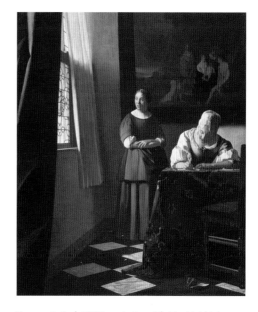

Vermeer's *Lady Writing a Letter with Her Maid* (circa 1670) was stolen from a British diamond heir in 1974. The painting was recovered and now hangs in the National Gallery of Ireland in Dublin.

Perhaps the most outrageous politically motivated theft involved Rose Dugdale, an English, Oxford-educated, spoiled little rich girl who fell from favor with her establishment father and crossed both the law and the Irish Sea to aid the Irish Republican Army. Supporting the cause with her inheritance, Dugdale quickly ran out of cash and decided to return to the source for more. One night in June 1973, Dugdale and three accomplices ransacked her parents' country estate, taking paintings, silver, and porcelain. But Dugdale was double-crossed by one of her accomplices and ended up facing off against her angry and disbelieving father in court.

The suspended sentence she received obviously had little effect. Less than one year later, in April 1974, Dugdale and another three accomplices were back in the game, hurtling through the Irish night to Russborough House in County Wicklow, south of Dublin. The house is a massive seven hundred feet across at its front entrance and is surrounded by five hundred acres of lawns and forest. The British diamond heir Sir

Alfred Beit and his wife, Lady Clementine Beit, had bought the estate in 1951, the better to show off their magnificent art collection. But they'd caught the attention of the wrong folks, and Dugdale and her mates burst in violently, tied up the Beits and their servants, and fled ten minutes later with nineteen pictures, including two oils and a sketch by Rubens, a Goya, Gainsborough's *Portrait of Madame Bacelli*, and Vermeer's extraordinary *Lady Writing a Letter with Her Maid*. Shortly thereafter, authorities received a note demanding ransom and the transfer to Belfast of four Irish political prisoners who were on a hunger strike in British jails.

The ransom for the £8-million ($40.2-million today) theft was neither paid, nor ever seriously contemplated. Instead, just over one week later, Dugdale was found alone in a cottage near the Atlantic coast, still in possession of the paintings. She was sentenced to nine years and proved defiant to the end, even giving a forceful courtroom soliloquy denying the legal right of the authorities to try her for the crimes.

THE PRICE OF ADMISSION

Dugdale and her gang were only the first of many to hit Russborough House. Over the next thirty years, the place would be robbed another three times. The most infamous thug to steal from the Beits was Martin Cahill. Cahill was a nasty piece of work, an Irish gangster whose contempt for authority and social convention stretched into every aspect of his life. Born in 1949 to a poverty-stricken Dublin drunk who had eleven other surviving children, Cahill was involved in crime by the age of twelve. In his mid-twenties, he turned professional, leading a growing army of men on a string of burglaries that the police were invariably unable to pin on him.

Paranoid and vicious, Cahill regarded everyone who stood in his way as an enemy. His lieutenants once strapped a radio-controlled bomb to a man's chest to force him to carry out an illicit errand, and had the terrified fellow bring along his eighteen-month-old daughter for the ride, lest he get any funny ideas. When Cahill suspected a gang member of having his hand in the till, he nailed both of the man's hands to the floor in an attempt to extract an admission of guilt. (None was forthcoming: the poor crucified fellow was innocent.) As his fame

Opposite: Gainsborough's delicate portrait of the famous ballet dancer Giovanna Bacelli was another of the works stolen to obtain the release of Irish political prisoners. The paintings were found a week after the theft.

and reputation grew, the Dublin crime press lionized him with the moniker "The General."

Cahill was untouchable, even in his personal life. He openly practiced an unofficial bigamy, maintaining a romantic relationship with his wife's sister, whom he supported until his death. He held all agents and expressions of authority in contempt, thumbing his nose at the state with mischievous and brazen expressions of his own lawlessness. Though he could afford to buy two homes with cash—one each for his wife and her sister—the residences were never registered in his name. That left him free to continue collecting a welfare check from the state.

In *Madonna with the Yarnwinder*, Jesus clings to a cross-shaped yarnwinder that refers both to Mary's domesticity and Christ's eventual crucifixion. The work dates from between 1500 and 1520. It is still missing.

In 1985, an aspiring associate brought Cahill the idea of hitting Rose Dugdale's target, Russborough House, where the Beits were still living and which they were about to open for public tours. The practice of offering public access to country estates was growing in popularity among the gentry, driven as much by a growing sense of noblesse oblige—if the Queen could open the grounds of Windsor Castle to the public, surely the merely rich could do so as well—as it was by the tax incentives and cash that helped pay the cost of maintenance. But it had a downside: For the price of admission, usually a couple of pounds, thieves received a guided tour of the property, complete with advice from solicitous volunteers who cheerily indicated the best and most expensive artworks. The fact that art-rich country homes are often miles from the nearest town, and the corresponding police station, makes them especially attractive for thieves.

As recently as the summer of 2003, for example, two men took the tour at Drumlanrig Castle in Scotland and set their eyes upon *Madonna with the Yarnwinder*, a sixteenth-century painting believed to be by da Vinci that depicts the Madonna pulling the infant Jesus away from a stick used to wind yarn. The painting was valued at $65 million, but at Drumlanrig it did not have any heavy security. The men simply snatched the picture, vaulted over a wall surrounding the grounds, and ran.

Cahill was bold, but not that bold, and in any case he preferred to operate in the dark of night. In May 1986, he and a gang of fifteen associates stole a handful of cars and headed through the post-midnight blackness to the back of Russborough House. There, they hid in the darkness as one man cut a small hole in a windowpane and tripped an alarm. While they waited a few minutes for the police to arrive, they disarmed the alarm. Sure enough, just as the thieves had anticipated, after conducting an inspection and finding nothing awry, the police retreated back to their station. When the coast was clear, Cahill and his gang entered the house, swiped eighteen paintings, and slipped back into the darkness. They made off with two Rubenses, a Goya, a Gainsborough, and the biggest prize of all: Vermeer's *Lady Writing a Letter with Her Maid.*

Richard Dalkieth, son of the Duke of Buccleuch, stands in the entrance hall to Drumlanrig Castle in Scotland, the day after da Vinci's *Madonna with the Yarnwinder* was stolen.

Missing Madonna

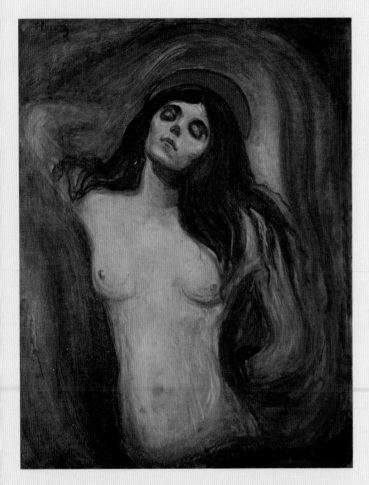

Edvard Munch was renowned for returning to subjects in his paintings. Though one of his *Madonnas* was stolen in 2004, there are another four versions in existence.

The upside of recent improvements in museum security is that art thieves may think twice before trying to penetrate the elaborate web of high-tech, nighttime alarm systems now in place at some of the world's major museums. The downside is that thieves are quite happy to walk through the front door during regular business hours and flee with their loot while everyone stands aghast, doing nothing at all.

So it was that two men wearing black ski masks and carrying pistols burst into the Munch Museum in Oslo shortly after the doors opened on the morning of August 22, 2004, in Norway's first-ever armed art robbery. Speaking Norwegian, one man forced about seventy visitors to lie on the floor, holding a gun on two security guards—neither of whom was armed—while the other snipped the thin wires holding Edvard Munch's iconic *The Scream* and his *Madonna* in place on the wall.

The thieves proved that you don't need to be either graceful or well-informed to carry off a successful heist. They crashed into a glass door on their way into the museum, seemed to be uncertain about the exact location of the paintings they were looking for, and then dropped their booty twice while making their escape. But they were swift and armed, and they had an accomplice waiting for them in an Audi station wagon as they dashed across the museum grounds. The paintings' broken frames were found two hours later, surrounded by shattered glass, leading art experts to fear the worst. A stolen painting is bad news; a stolen and damaged painting is a tragedy.

The total haul was estimated conservatively at $44 million, but it might have been five times that, since there's no legitimate way to estimate any painting's true price without putting it up for sale. It would be another seven years before the world would see all of the Russborough paintings again.

When the police finally did track them down, they discovered that Cahill had used the Vermeer as collateral to buy drugs. The development was a troubling one for investigators, who had previously operated on the assumption that stolen art could only be converted into cash by either ransoming it or selling it at a heavy discount to a shady broker. Indeed, Cahill himself had unsuccessfully attempted to ransom the paintings. But the notion that drug traffickers or gun runners might accept fine art as collateral meant a picture might circulate for years in the underworld, just like cash, before rising again to the surface. Most of the time, fame and a high valuation push down the worth of a painting in the illegitimate market, since they make it harder to fence. (No one could possibly sell the *Mona Lisa.*) But the renown of a painting like the Vermeer, and its attendant publicity when it is stolen, mean that even criminals who have never stepped into an auction house would be aware of its value, making it easier for the person holding the work to use it as collateral. A Titian painting was once put up by a criminal in the north of England to secure a £50,000 ($87,000 today) bail bond.

THE CONNOR ARTIST

That is one plausible explanation for why a gang of armed and black-clad hoodlums bothered to barge their way into the Munch Museum in Oslo, Norway, in August 2004, point a gun at the head of an unarmed guard, and snatch one of the world's most famous paintings, one they could never hope to sell even to an unscrupulous collector. If it were put up for sale in the legitimate art market, Munch's *The Scream* might fetch $100 million—or more, now that its fame has been boosted by the publicity surrounding the theft.

The thieves who took Isabella Stewart Gardner's prized possessions may have had a similar purpose in mind. Certainly, the absence of those paintings from public view for more than fifteen years suggests they

were either snatched by a rare breed of thieves who excelled at long-term planning, or that they are currently floating around the underworld as collateral in an endless series of drug and other deals.

For many years, suspicion for the Gardner theft centered on Myles Connor Jr. Son of a Boston cop and the alleged descendant of a *Mayflower* pilgrim, Connor is an unusual convict, a certifiably brilliant man who made a career out of snatching art at least partly because he had a genuine appreciation for it. During one prison stretch in the early 1980s, Connor instructed his girlfriend on the outside on what to buy for a successful art-collecting enterprise. But too many of his activities were illegitimate. Over the course of thirty-odd years beginning in the mid-1960s, Connor stole Tiffany lamps, a Rembrandt, an Andrew Wyeth, and scores of other paintings and artifacts.

In fact, Connor admitted planning a Gardner heist, making a wish list of pieces on a stroll through the building with an associate years before the museum was actually hit. But he couldn't have pulled off the March 1990 robbery by himself because he was in an Illinois prison at the time for selling a couple of paintings that had been stolen from Amherst College in Massachusetts. Still, he was known to have directed heists while in jail before, so the notion that he'd orchestrated the Gardner theft was within the realm of possibility. Indeed, he toyed with authorities, telling them that he knew who had pulled off the job and that he could arrange for the artworks' return in exchange for a reduced prison sentence and a hefty reward. In 1998, however, while still in prison, Connor suffered a massive heart attack that he maintains briefly cut off the oxygen to his brain and thus wiped out any memory of the heist. Still, he was able to remember enough of his past life to cooperate with a fawning profile a few years later in *People* magazine.

Which points up an odd and disturbing dissonance at play. We know art thieves can be dangerous, murderously so. Yet we continue to make heroes out of villains, to think of them as mere roustabouts. Television networks create reality series duplicating the most brazen heists in the art-theft canon. Hollywood keeps churning out breathtaking capers. In fact, in 2003, Myles Connor Jr. sold his life story to a leading Hollywood producer for development as a feature film. At last check, there was no word on whether Pierce Brosnan might play the part of Connor.

True or False

An Italian paramilitary police officer points out details on the terracotta vase decorated by the Greek painter Asteas, returned to Italy in November 2005 by the J. Paul Getty Museum.

In late 2005, Italian prosecutors placed Marion True, the longtime curator of antiquities at the J. Paul Getty Museum in Los Angeles, on trial for knowingly receiving stolen artifacts. Authorities charged that more than forty pieces in the Getty's collection, including an ancient Greek statue of Aphrodite and a twenty-five-hundred-year-old terracotta vase depicting the Greek hero Perseus rescuing Andromeda from a sea monster, had been either illegally excavated or stolen and then smuggled out of Italy.

The Getty maintained that True was innocent.

The trial capped a tortuous investigation that began in 1995, when Swiss authorities seized four thousand stolen artifacts, along with thousands of documents and instant photographs that outlined how traffickers took pieces from Tuscany and Lazio, laundered them through neutral countries such as Switzerland, and sold them on to museums around the world. In 2000, after Italian art dealer Giacomo Medici was sentenced to ten years for trafficking on the strength of the Swiss evidence, authorities turned their attention to True, who had acquired pieces from Medici and the Paris-based dealer Emanuel Robert Hecht. Shortly before the trial, True resigned her post after the museum revealed she had improperly borrowed money from a Getty board member who herself had purchased dirty pieces from Medici that had to be returned to Italy.

As of this writing, the True case is unfinished but still shaking the museum world to its core. The Italian government, emboldened by its earlier victories, alleged that the Getty was not alone in owning illicitly obtained antiquities. Authorities charged that the Boston Museum of Fine Arts had twenty-two, and one each could be found in the Princeton University Art Museum and the Cleveland Museum of Art. When they pressed the Metropolitan Museum of Art in New York about its ownership of a krater painted by the fifth-century BCE Greek artist Euphronios, bought from Hecht in 1972 for $1 million, the Met stunned the antiquities world in early 2006 by pledging to return the piece to Italy, along with a selection of silver also in dispute. Many observers whispered that it was just the tip of the iceberg, and that the world's major museums would be spending the next decade investigating the provenance of all of their holdings.

THE LOST ART DETECTIVE AGENCY

In August 2005, on the second anniversary of the stunning daylight theft of da Vinci's *Madonna with the Yarnwinder* from Drumlanrig Castle, two professional art hunters made wildly different predictions about when the painting would resurface. "There are definite cycles in the way things move in the world of stolen artworks," said Dick Ellis, the former head of the Art and Antiques Unit at Scotland Yard in London. Suggesting that "seven years after the date of a theft" is a significant moment in the cycle, he calculated it would therefore likely be 2010 before the da Vinci reappeared. Meanwhile, on the other side of the Atlantic, Robert Wittman, the FBI's senior art crimes investigator based in Philadelphia, said he thought it could be another twenty years before the painting showed up.

Which expert is right? Probably neither. There is no evidence whatsoever that there are any such cycles in the underground circulation of stolen art. A stolen work is most likely to surface when, and only when, the person holding it gets brazen or desperate enough to try to cash it in. One man with knowledge of the Drumlanrig investigation suggested that both Ellis and Wittman were using the media to bluff during a hand of high-stakes poker, trying to dupe the thieves into believing the heat was off and that the authorities

Above: Police stand outside the Duke of Buccleuch's Drumlanrig Castle in Scotland after the August 2003 theft of da Vinci's *Madonna with the Yarnwinder*, valued at $65 million.
Opposite: Of Rembrandt's approximately three thousand paintings, drawings, and etchings that still exist, almost one hundred of them are self-portraits, executed over the long course of his career. This self-portrait on copper was stolen in late 2000.

LAPD Web Site

"El" Lazar Markovich Lissitzky was a Russian artist and designer who began experimenting in photography in the early 1920s. This rare, untitled Lissitzky photograph, valued at $200,000, was missing for four years and presumed stolen when it turned up in 2002.

If the Internet has made it easier to sell off stolen art and antiques (criminals salivate at the don't-ask-don't-tell policies of auction Web sites), it's also very helpful in throwing up red flags for members of the public who stumble upon or are offered art they think might have been boosted or lost.

Buried deep in the more than three thousand pages of the Los Angeles Police Department Web site (www.lapdonline.org) is a special section devoted to the initiatives of its one-man Art Theft Detail. Hundreds of pictures and descriptions of artworks are posted there in the hopes that prospective buyers will search the site before putting down good money for stolen property, and rightful owners will end up with their long-lost treasures.

In 1998, a New York art dealer driving south from San Francisco became frantic when he realized that a rare photograph by the Russian artist "El" Lazar Markovich Lissitzky (1891–1941), valued at $200,000, that he'd intended to show a client in Los Angeles had gone missing. He called the LAPD Art Theft Detail and suggested that a prostitute he'd hired in Santa Monica had lifted the piece, but admitted he couldn't prove anything. When the owner of the photograph heard about the lurid hotel-room detour, the dealer's career was ruined.

Four years later, though, the manager of a hotel in Oakland, California, was going through a luggage storage room when he noticed a museum label on the back of an old photograph that included the photographer's name. (Apparently, the hapless dealer had left a portfolio containing the photograph leaning up against his car, and had driven away without it.) The manager hit the Internet, searched for "Lissitzky," and found a bulletin on the LAPD Web site about the photo. Moments later, he was on the phone to the department's Art Theft Detail, telling them that he thought he'd found that missing photograph.

had given up hope of finding the da Vinci anytime soon. The investigators wanted the crooks to drop their guard, to relax a little and try—as the authorities say—selling the painting on.

That's because, when a work of art changes hands, its movement can send ripples through the nerves of the underground information network that is poised for such an event. There is a loose but hungry network of mercenaries, security experts, private investigators, multinational police organizations, undercover informants, insurance company functionaries, and local lawmen—most of them fiercely competitive, but all of them gunning for the same goal: to recover art and bring it back into the cleansing light of day.

MR. PRICE IS RIGHT

Only a few weeks after Wittman outlined his scenario of how long it might take for the da Vinci to be found, the FBI man found himself standing in the washroom of a ritzy Copenhagen hotel room, staring under black light at a tiny painting bearing the twenty-four-year-old face of Rembrandt, while an Iraqi with alleged ties to organized crime nervously waited for him to hand over a suitcase full of cash. Wittman had been looking for the picture for five years.

J.P. Weiss, an FBI special agent in Los Angeles, outlines the September 16, 2005, recovery of Renoir's *Young Parisian*, on the easel behind him. Worth about $10 million, it was stolen, along with his *Conversation* and Rembrandt's *Self-portrait*, copies of which are also displayed here, from the National Museum in Stockholm.

The story begins one late afternoon in December 2000, when three armed and masked men carried off one of the most spectacular thefts ever to take place in Sweden. A few minutes before closing time, the three strolled into the lobby of the National Museum in Stockholm, where one of the men pulled out a submachine gun and ordered the guards to the floor. His two partners split up and stormed off, returning moments later with three rare paintings: an eight-by-four-inch Rembrandt self-portrait on copper worth an estimated $36 million and two Renoirs, *Conversation* and *Young Parisian*, each valued at a few million dollars. The trio raced out, spreading nails behind them to thwart emergency vehicles, and jumped into a motorboat waiting by the museum's riverfront entrance. While they made their getaway in the dark, accomplices set off diversionary car bombs in

other parts of the city. The boat was found a few hours later, abandoned on the banks of Malar Lake in suburban Stockholm.

Police were thoroughly vexed. But when art is stolen, law enforcement has one big advantage: as smart as the crooks may be in the execution of their thefts, they usually have no idea how to unload their prize catches. "The real art in art theft is not stealing, but selling," explains Robert Wittman.

Here's why. If you're a run-of-the-mill thief who's come into possession of a truckload of DVD players, you can parcel them out to an army of associates with street-level distribution channels. Just about anyone can afford a DVD player these days, especially a heavily discounted one, so nobody asks any questions and in a day or two the merchandise evaporates into the ether. But the profits aren't great—all of those associates want a cut—and it takes an awful lot of effort to snatch, fence, and retail all that merchandise.

Paintings, you tell yourself, are compact and easy to steal. So you find yourself a speedboat and snatch a $36-million Rembrandt with a couple of buddies. Within a day, images of the painting appear in police and private databases. The theft makes headlines around the world, from *The New York Times* to the *Bangladesh Times*, which is great if all you want is fame, but not so promising if you want to flip the piece for some actual cash. And in the only market where a $36-million Rembrandt would actually fetch $36 million, no one is going to touch the property.

That's why Swedish investigators figured that one of Dr. No's spiritual heirs had to be behind the Stockholm hit. "It looks like a case where someone ordered them to steal the paintings, a contract job," suggested Police Inspector Thomas Johansson. "It's not going to be easy to sell these paintings on the open market, so it must have been someone who just wanted the paintings for their own sake."

Well, he was half right: it was impossible to sell the paintings on the open market. As it turns out, the thieves quickly realized their foolishness and tried to ransom the paintings back to the museum. The authorities didn't bite, and a few months later they arrested and convicted eight men on theft charges in the case, with sentences ranging up to six years. They recovered Renoir's *Conversation* in Stockholm, but the other two paintings stayed stubbornly hidden. Still, they had promising

Renoir's *Conversation* was valued at several million when machinegun-toting thieves stole it, along with another Renoir and Rembrandt's *Self-portrait*, from the National Museum in Stockholm. It was the first of the paintings to be recovered by police, in July 2001.

leads in two additional men, Iraqi nationals by the name of Baha Kadhum and his brother Dieya, who had been arrested in the dragnet but who had managed to beat the rap. For four years, Swedish investigators nursed the leads, sharing information with United States and other international authorities, until the FBI discovered the second Renoir while looking into drug dealing by an organized crime group in Los Angeles. They connected the dots, realizing that one of the men affiliated with that organization was also connected to the Kadhum brothers, who had been acquitted in 2001.

This was exactly the sort of case for which the FBI had, in early 2005, created its Rapid Deployment Art Crime Team (ACT) with Wittman as lead investigator. In September 2005, with a Los Angeles member of the unit at his side, Wittman flew off to Sweden to play the undercover role of an American looking to broker a purchase of the Rembrandt on behalf of a European organized crime group. Under an assumed name, Wittman met the Kadhum brothers and their two associates in Stockholm, where they all agreed to regroup later for the exchange in Copenhagen: neutral territory.

But the territory wasn't as neutral as the gang had thought, because Danish police had outfitted the Scandic Hotel with video and audio surveillance equipment and scores of personnel. On the appointed day, Wittman met Baha Kadhum in the hotel lobby, took him up to his room, frisked him, and went to another room to get the sum they had agreed upon: $250,000 in U.S. currency. That may seem to have been a careless mistake on Kadhum's part, to allow the exchange to happen under circumstances he didn't control—the infamous Martin Cahill, for one, was an expert at drawing the Irish police out of their familiar surroundings and into his own web of bars and rooming houses, which is why he was so successful for so long. But most sellers need to take a chance if they're going to get rid of their merchandise.

After Renoir's *Young Parisian* turned up in the possession of a gang in Los Angeles in 2005, a California law enforcement official observed that organized crime activities "defy international borders and reach into the hearts of our local communities."

"The guy with the money's got the upper hand," explains one long-time investigator. "It's his money. If you want the money, you need to play the game, and if you don't play the game, you're not gonna get the money. And why'd you take the paintings? Because you want money." In the murky underworld where such deals are made, the sellers understand the need to make buyers comfortable. Because the buyer knows if he comes back to his own boss with a forgery, or an inferior painting, he won't be alive for very long.

Wittman brought the bag of cash into the room, and watched for almost ten minutes as Baha Kadhum nervously went through each and every bundle of hundred-dollar bills, twenty-five hundred bills in all, to ensure he wasn't being ripped off. Satisfied, he left the room, and reappeared about ten minutes later with a bag of his own that contained a painting wrapped in heavy blue felt cloth. Twine tightly bound the cloth, but since both men had frisked each other to make sure neither had a weapon, there was no knife to cut the painting loose. For more than five minutes, with Danish SWAT teams watching via a surveillance camera from the room next door, Wittman grunted and groaned trying to stretch the tightly wound twine without exerting so much pressure that he'd damage the frame within the heavy fabric.

Finally, the twine came free. Wittman opened up the package and knew immediately from his years of working on the case that the painting was real. He could also see that the painting had been treated well during its five-year underworld sojourn—the clips that held the painting inside the frame were still in the same position they were in when it was snatched. But if Kadhum and his gang had respect for the Rembrandt, their admiration only went so far. "I look at him, I say, 'Are you an art lover, is this why you take these?'" Wittman later recalled. "He says, 'No, I'm just in it for the money.'"

There was one more procedure for Wittman to execute before he could bring down the hammer. The Rembrandt had been painted on copper and had never been retouched. So if it was real, it would give no luminescence when exposed to black light. He took it into the bathroom to view it under a portable black light he'd brought along. Kadhum followed, his curiosity piqued. "I think he was actually interested in the identification technique," said Wittman. "Everybody's a human being,

and they have interest in the mystique of these things as well. They were awestruck to have a Rembrandt in their hands." Turning on the black light, the FBI agent knew it was real.

As the two men emerged from the bathroom, Wittman told the other, "This is a done deal." That was the signal for the Danish SWAT team to storm the room. They appeared in a flash, and Wittman jumped back into the bathroom, where he hid from the melee in the cast-iron bathtub—structurally, the strongest area in the entire hotel room—and protected the painting with his body in case gunfire erupted. At that very moment, another SWAT team descended on Kadhum's three accomplices, who were waiting outside the hotel: Dieya Kadhum, a Gambian, and a Swede. After Kadhum was subdued, a SWAT team member brought Wittman out of the bathtub, and he ran the painting to his associate in a safe room.

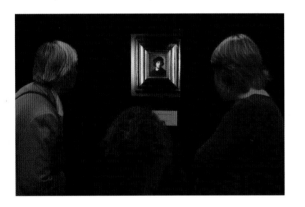

Visitors inspect the tiny Rembrandt self-portrait on September 22, 2005, the day after it was returned to the Swedish National Museum.

"At that point, there's exhilaration," recalled Wittman. "I mean, it's amazing to have a Rembrandt in your hands that was missing for five years, and to know that it's going to go back to the Swedish National Museum. It's like finding a lost child." A short time later, that lost child returned to its museum home in Stockholm, where it took pride of place in a long-planned exhibition on art of the Dutch Golden Age. With the Rembrandt, Wittman could claim more than $150 million in recoveries since 1999.

THE CRACKS IN THE PAINT

The adrenaline rush of that sort of operation can be addictive. Charley Hill is a former Scotland Yard investigator who thrives on the thrill of the sting. With more than $100 million in recoveries, Hill is the second-most successful art cop in the world, and its single most famous one. He's the subject of an entire book, as well as countless magazine and newspaper articles. Big and blustery, he revels in the attention his exploits attract, and he happily spends long hours retailing war stories of his undercover work, even as colleagues scoff at his lack of discretion. "I don't understand an undercover officer showing his face to the public,"

Art Loss Register

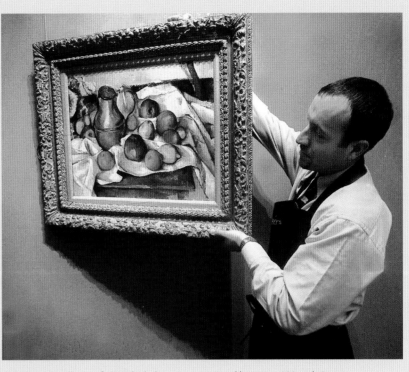

Cézanne's *Bouilloire et fruits*, which the painter executed between 1888 and 1890, is one of the first works in which Cubism can be identified. It was stolen from a private home in 1978 and resurfaced in 1999.

When a work surfaces under mysterious circumstances —say, an unknown collector shows up at an auction house with a multimillion-dollar painting under his arm—the Art Loss Register (ALR) is one of the first places to receive a phone call. Established in 1991 by major auction houses, insurance companies, and other industry players, the London-based ALR maintains a database of more than two hundred thousand items known to be stolen or whose ownership is under dispute.

In October 1999, a Lloyd's of London underwriter inspecting a Cézanne masterwork dating from 1888–1890, *Bouilloire et fruits*, became suspicious about its provenance. He contacted the ALR, which informed him that the Cézanne had, in fact, been stolen in 1978, along with six other paintings, from collector Michael Bakwin in what was then the largest unsolved art theft from a private residence in Massachusetts.

With the assistance of the ALR, Bakwin sued Erie International, a shadowy, Panamanian-registered com-

pany that had possession of the painting, which it was trying to sell. Bakwin recovered his Cézanne and, months later, when he realized he could not provide sufficient security to prevent another theft, put the painting up for auction at Sotheby's, where it sold for almost $30 million. Seven years later, after the ALR pressed the case further, it recovered four of the other six paintings from Erie International. Two of Bakwin's paintings remain missing.

The ALR has been responsible for many such happy endings, including the 1999 return of one of Monet's resplendently moody *Water Lilies*. Stolen by the Nazis from art dealer Paul Rosenberg in 1940 after he fled Paris, the painting had spent more than fifty years in the possession of the French government, which had shown little interest in exploring its provenance until Rosenberg's American descendants spotted it on loan to Boston's Museum of Fine Arts and asked the ALR to help out.

said Mark Dalrymple, a London-based loss adjuster who is often called in to advise a museum on how to respond to a theft. "Because of the undercover-type operations revealed through the press, criminals become more and more worried about who they're dealing with."

Born in World War II England to an American father and an English mother, Hill moved with his family to the United States when he was seven years old. The cross-cultural upbringing served him well. He developed an ability to take on a sort of social camouflage, blending in wherever his father's assignments with the U.S. Air Force, and then the National Security Agency, would take the family. The younger Hill volunteered to fight in Vietnam for his adopted country, then moved back to Britain as a Fulbright scholar at Trinity College, Dublin. After his studies, he joined up with the Metropolitan Police in London (also known as Scotland Yard), where he discovered a knack for undercover work.

His first such operation set the template for many of his successful stings over the next twenty years. In 1982, a gang in south London floated the news that it was looking for a buyer for a painting, estimated to be worth millions of pounds, by the sixteenth-century Italian Mannerist Francesco Mazzola, who was also known as Parmigianino. Hill had been languishing at a desk job, so when a couple of detectives responsible for bringing down the gang thought his background might give him an edge (the theory being that crooks would be less likely to suspect that someone with an American accent was a British cop), he jumped at the chance.

He adopted the role of a crooked American art dealer, embracing it with a trademark combination of physical gusto and keen intelligence. He studied Parmigianino and a variety of schools of painting, including Mannerism, in case the gang members decided to quiz him. When the time came to be introduced to the underworld figures, he set himself up at an expensive London hotel, which suggested that he had very deep pockets. The charade worked. One of the thieves took an immediate liking to the hard-drinking, heavy-spending character portrayed by Hill.

On the night of the arranged exchange, Hill and another undercover cop met their criminal contact at a train station southeast of London. The thief drove Hill to a large house where an older member of the gang was waiting. Over a long evening lubricated by much alcohol, Hill managed to convince the men of his bona fides, talking up his Vietnam War

Stop the Presses

Sir Kenneth Thomson examines the miniature ivory reliefs recovered a week after they were stolen while on loan to the Art Gallery of Ontario.

On a quiet Saturday afternoon in January 2004, someone pried open a wooden display case at Toronto's Art Gallery of Ontario and made off with five ivory reliefs worth approximately $1.2 million. The pieces by the renowned eighteenth-century French-born sculptor David Le Marchand, which included a portrait of Sir Isaac Newton, were on long-term loan to the Toronto institution from Sir Kenneth Thomson, a local billionaire collector.

To publicize or not? That was the question. Museums are reluctant to announce losses because they fear it makes their security look shoddy and endangers future loans. In 1989, forty-five drawings belonging to the Andy Warhol Foundation went missing while in the care of the Museum of Modern Art in New York. Wondering why you hadn't heard? The museum's insurance adjuster quietly cut a check for more than $1 million and no one ever said anything about it. Most thefts aren't reported to the press; sometimes even the police aren't notified.

The AGO handled things differently. It issued a news release the morning after the theft. "That made the ivories more difficult to sell," explained Mike Ferguson, the gallery's deputy director of operations. "Any buyer would be aware that they were stolen merchandise. This bought us some time. We'd effectively made the ivories hotter than hot by making the news public."

The strategy paid off. With intense media coverage and a series of press conferences highlighting a $120,000 reward that could prove tempting even for friends of the thieves, the heat proved too much for the crooks. One week after the ivories vanished, they resurfaced at the office of a lawyer, acting as a middleman for the thieves, and then were passed on to Thomson himself.

Sir Ken obviously had no hard feelings over the incident. He pledged to give the ivories back to the AGO as soon as a massive renovation was completed—paid for in part by his own $60-million gift.

stories. But when they rolled out the Parmigianino, Hill took it from the men, studied the canvas from front to back, and determined that the painting was a fake: he realized the base frame holding the canvas wasn't four hundred years old, and there was something wrong with the paint's spidery web of cracks, known as *craquelure*. Grimly, he told them as much, and asked to be driven back to the train station. The thieves were agitated by the news—after all, they'd stolen the painting in good faith, thinking it was real—but they knew there was nothing they could say to convince Hill to buy the canvas.

Though Hill was sure of his diagnosis, his supervisors didn't believe him, and the next day they ordered a takedown of the gang. Alas, after appraisers at Christie's got a look at the painting, all the police had to show for their efforts were a couple of frustrated thieves and an impressive hundred-year-old forgery of a four-hundred-year-old painting.

A GOYA IN THE TRUNK

From Hill's perspective, the operation wasn't a total failure: He'd pulled off the role of the rich, swaggering American with aplomb. He managed to prove to himself, his supervisors, and a few incredulous armed thieves that he could stay in control and in character under dangerous circumstances. Furthermore, he had discovered, almost accidentally, an affinity for fine art that was unusual among working cops.

Indeed, one of the difficulties of cracking art-crime cases is that few police forces around the world have officers who take an interest in art. An Australian detective with the Queensland Police Service once noted ruefully that a thief had stripped a private home of works by Pissarro, Chagall, and the nationally famous painters Arthur Boyd and Grace Cossington Smith, but when six of the pieces turned up in the bell tower of a church, the local police thought the paintings were student projects. In early 2004, after an art restorer in New South Wales reported the theft from his home of an A$50-million ($37-million) painting known as Paul Cézanne's *Son in a High Chair*, it took more than a year for experts to determine that no such original Cézanne painting existed.

Because it is one of the centers of the art world, and the place where a majority of stolen paintings are believed to end up, London has the benefit of a national government that recognizes the importance of

maintaining a knowledgeable force of experts in such matters. The four-man Art and Antiques Unit at Scotland Yard regularly cracks large and small cases, and is credited with significantly reducing the amount of art theft across the United Kingdom. In 1993, Charley Hill was with the unit when he scored his first major success, helping to rescue four paintings stolen by Martin Cahill from Russborough House in 1986: Goya's *Portrait of Doña Antonia Zárate*, Gabriel Metsu's masterpiece *Man Writing a Letter*, an Antoine Vestier portrait, and Vermeer's priceless *Lady Writing a Letter with Her Maid*.

He had come close to them before, when an associate of Cahill, taking Hill for a crooked American named Charley Berman, called him shortly after the Russborough theft to see if he might be interested in helping to move some of the bounty. In February of 1987, Hill brought in an FBI agent who used the alias Tom Bishop to play a big-time gangster who was looking to acquire some high-class pictures for his walls. Hill and Bishop went to Dublin to meet Cahill's men, and all was progressing merrily until Bishop passed around some doctored photos of himself and top American mobsters to seal the deal. The show-and-tell would have been convincing, were it not for a piece of paper that slipped out from the stack of photos and fell with a sickening swish to the table. It was a note written on FBI stationery that read: "Tom, don't forget these." Cahill's men excused themselves, and Hill, his cover blown too, had to retire the fake identity of Charley Berman.

Six years later, though, Hill got another shot at the Russborough House cache. Word filtered up from the street that Cahill had exchanged the paintings for $1 million, which he'd plowed into the drug trade, and that they were now in a bank vault in Luxembourg. Playing another rich American, this time named Chris Roberts, Hill put feelers out through a crooked lawyer. Which is how, in August 1993, he found himself in the company of Niall Mulvihill, a Dublin operator who said he'd sell the paintings for $1.25 million. Chris Roberts agreed to the price and told Mulvihill that he wanted to make the exchange in Antwerp, Belgium, because it would be more convenient to travel on from there to meet with his own buyers in the Middle East. (In reality, Hill couldn't make the exchange in Luxembourg because the laws there prevented undercover operations.)

Like his contemporary Vermeer, Gabriel Metsu (1629–1667), whose *Man Writing a Letter* was stolen in 1986, excelled at capturing scenes of the Dutch middle class.

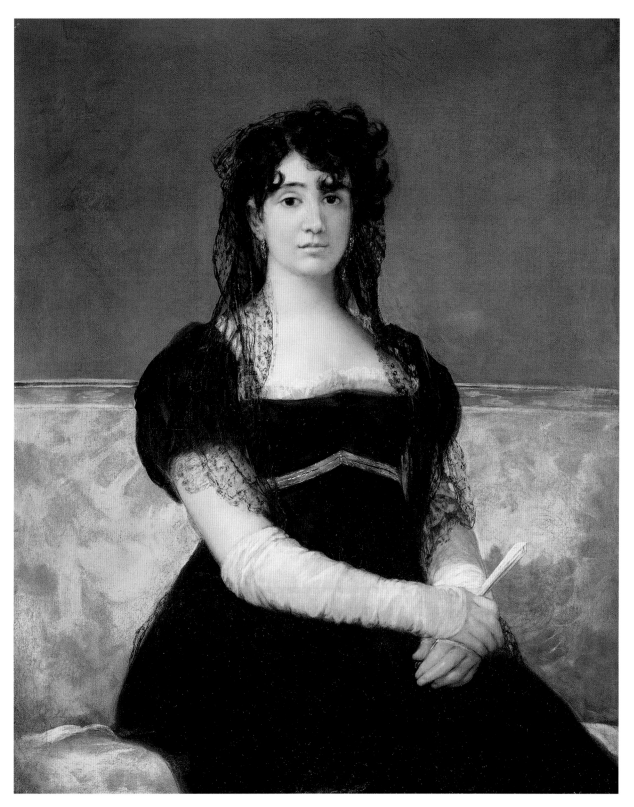

With his body of work, including *Portrait of Doña Antonia Zárate,* encompassing Impressionism, Surrealism, Expressionism, and Romanticism, Goya (1746–1828) is considered a father of modern art.

On the day of the sale, Hill and Mulvihill met at the Antwerp airport, each with a bodyguard in tow. After some preliminaries in which each side made sure the other wasn't carrying a weapon and had brought what each had promised to exchange, Hill walked to the parking garage with Mulvihill's bodyguard. There, in the trunk of a rented Peugeot, Hill spotted the Goya, rolled up like a child's homework assignment. As he reached into the trunk to grab a garbage bag that contained the Vermeer, two cars sped onto the scene and disgorged eight cops who were suddenly screaming in Flemish for everyone to hit the ground. All four men were handcuffed and taken to the station house, at which point Hill and his associate were let go. In time, Mulvihill, too, was let go, acquitted of possession of stolen property; evidently, he had friends in high places.

AFTER THE DELUGE

Charley Hill's most celebrated recovery came the following year, in 1994, when Norwegian authorities turned to Scotland Yard for help in solving *The Scream* theft that had caused them so much embarrassment during the Winter Olympics. The Antwerp sting, which involved English detectives working with Belgian police to solve an Irish theft, had demonstrated that art crime had gone global. Once again, the name Chris Roberts was put into play, this time as a man working for the ultra-rich J. Paul Getty Museum in Los Angeles who wanted to buy back the painting from the criminals in order to help out the Norwegian government. The Getty itself cooperated, putting Hill's false identity into its personnel files, in case the crooks tried to check up on him. Hill's offer of £500,000 ($770,000) was enough to draw out the men who held *The Scream*, and three months after its pre-dawn theft, Hill and an assortment of his British colleagues brought the trap down on the bad guys.

The notion of a man from the Getty paying a ransom on behalf of the Norwegian government is not as far-fetched as it sounds. As a rule, governments do not participate in ransom schemes; indeed, in some areas it is illegal to do so. "As a matter of principle and as a matter of fact, ransoms aren't paid," says insurance adjuster Mark Dalrymple. The reasoning is simple: "However dear and precious and wonderful the object may be, you cannot give in to that pressure. The minute you do so, it will unleash a torrent of criminals who will all imagine they can get away

with it because of the fear that the property will be destroyed unless you pay money. It's extortion. It's what the Mafia grew rich on."

At least, that's the party line. What actually transpires in the real world is a little morally muddier. In July of 1994, a pair of exquisite paintings by J.M.W. Turner, on loan to the Schirn Gallery in Frankfurt from London's Tate Gallery, were lifted in a lightning-quick nighttime operation in which two men jumped a guard at closing time, just before he turned on the gallery's alarm system. They tied up the guard and slipped away in minutes, taking *Waft of Mist*—a landscape by the German master Caspar David Friedrich—along with Turner's studies of light and color: *Shade and Darkness—The Evening of the Deluge*; and *Light and Colour—The Morning After the Deluge*. The value of the two Turners, which were insured, was estimated at more than £24 million ($32 million).

Friedrich's *Waft of Mist* (1818–1820) was snatched, along with Turner's two light-and-color studies. The Friedrich was recovered in August 2003.

Five years later, the two thieves and their getaway driver were caught and given sentences ranging from three to eleven years. But the mastermind behind the theft, believed to be a leader of Frankfurt's Balkan mafia, was not caught, and the pictures stayed missing. In the summer of 1999, a Frankfurt lawyer named Edgar Liebrucks contacted the Tate with the news that he could negotiate the Turners' safe return. The Tate reportedly placed £3.3 million (more than $5.3 million) in a bank account he controlled. Two private eyes who had worked on the case when they had been with Scotland Yard, Detective-superintendent Mike Lawrence and Detective Jurek "Rocky" Rokoszynski, came on board to help. Over the next three years, the crooks demanded one payment after another through Liebrucks—first for photographs proving they had stolen the paintings, then for more information on the whereabouts of the art, then in exchange for the first Turner itself, etc.—until the scheme culminated in a reported £2.5 million (almost $4 million) payment that netted the second painting.

The senior Tate executive who had been responsible for organizing the paintings' retrieval insisted that the museum had done nothing wrong. "It was absolutely not a ransom," Sandy Nairne said years later.

J.M.W. Turner (1775–1851) painted *Shade and Darkness—The Evening of the Deluge*, above, and *Light and Colour—The Morning After the Deluge*, opposite, partly in response to theories about color espoused by the German philosopher J.W. Goethe. The paintings, which belong to the Tate in London, were stolen in 1994 while on loan in Frankfurt.

The Tate turned an unintentional profit when their two Turner paintings were stolen. Three years after insurers paid out £24 million ($39 million), the Tate bought back the right to the missing works for £8 million ($13 million), which left them £16 million ($26 million) in the black when the paintings were recovered.

"A ransom is where somebody is threatening something. It may sound like splitting hairs, but we paid for information leading to the recovery of the paintings."

In most cases, there isn't anywhere near that sort of money available to kick-start a recovery, which is why rescuing art doesn't actually pay very well. Despite the popular image, it's just not a glamorous business. When the Hollywood screenwriter for *The Thomas Crown Affair* went looking for true-life details to help create the character of the sultry, jet-setting insurance adjuster played by Rene Russo, he spent hours with Mark Dalrymple—and then embellished the real-life research. For if you want to see how the business of art-loss adjustment really works, you can find Dalrymple holed up in a bunker of a building in a seedy part of London just east of the City, in an office groaning with paperwork and without benefit of modern air conditioning. Half a block away, homeless people gather in a small park strewn with litter.

Not even Charley Hill can make a living purely as an art hunter. He now runs an art security consultancy business not far from where his undercover life began, in Kent, southeast of London. But there's one prize that could turn it all around for him: the published $5-million reward for solving the Isabella Stewart Gardner Museum thefts. He claims to have good information on the case. He speculates that the paintings are in Ireland, moved there by the infamous Boston crook Whitey Bulger, who was known to have had a guardian angel in at least one FBI agent. And Hill isn't afraid to share his theories, especially if they will tweak the noses of his competitors in the trade. "It's awful for the FBI," Hill told a reporter in 2005. "When the paintings are found here, it is going to be another terrible embarrassment for them."

You might think he'd avoid upsetting the FBI, but Hill's competitive and boastful attitude is a hallmark of private investigators, who attract business by building themselves up in the press. Some law enforcement officials complain because they're prevented by the strictures of the job from speaking on the record about active cases. They find it galling when Hill talks up his game because it has the dual effect of making him look as if he's got the inside scoop and making everyone else look clueless.

A Private Investigator's Private Obsession

Some men spend their retirement playing poker. Some travel around the world. You might say Harold J. Smith did both. After spending his career as an independent art investigator for companies like Christie's and Lloyd's of London, uncovering fake Michelangelos and Picassos and cracking a spectacular Florida gold robbery, Smith obsessed for nearly fifteen years over the March 1990 theft from the Isabella Stewart Gardner Museum in Boston.

He was a former merchant marine from the Bronx with a rakish appearance: he habitually wore a bowler hat, an eye-patch, and a prosthetic nose to cover the ravages of a decades-long battle with skin cancer.

Immortalized in the 2005 documentary film *Stolen*, by Rebecca Dreyfus, Smith put the Gardner case above all else in the last years of his life. One Christmas, he spent half the day on the phone trying to negotiate with someone who said he could produce the Vermeer. The next day, his wedding anniversary, he awoke at two o'clock in the morning to go to New York for a meeting outside the Museum of Modern Art with an informant who never materialized. "That doesn't make you feel like a million dollars," he said grimly to Dreyfus's cameras. But even into his seventies, when he was playing high-stakes games with notoriously violent underworld figures, Smith possessed boundless enthusiasm. He was convinced he would solve the riddle. "This art is going to be found. I'm not going to give up," he said.

In February 2005, at the age of seventy-eight, cancer beat Smith before he managed to locate the Gardner cache. Nowadays, his son and grandson carry on the family trade—they are both art investigators.

Art detective Harold J. Smith as he appears in Rebecca Dreyfus's documentary *Stolen*.

"Look, it's been fifteen years since the Gardner paintings were stolen, and there's a five-million-dollar reward offered, but they're not back yet, so that shows you what anybody knows," says Robert Wittman. "There are these aficionados out there who create these scenarios, and they don't know anything more than you do, they're just making this stuff up. But people put these ideas out so they can get publicity." Hill isn't the only one. Michel van Rijn, a former convict turned fickle police informant, raises the hackles of many in the industry. Even Dick Ellis, the go-to guy for the British TV news shows whenever art goes missing, is the subject of jealous sniping for all the press he attracts.

COPS ON THE ART BEAT

Meanwhile, law enforcement officials keep plugging away. In the mid-1980s, a police officer named Don Hrycyk took a position solving art crimes to get away from the gruesome realities of inner-city police work. He'd been with the homicide squad in the south end of Los Angeles for a few years, dealing on a depressing everyday basis with the violent, often senseless crimes of that beat: kids killing each other for wearing the wrong color of shoelaces; muggers blowing away an immigrant ice-cream vendor for not handing over his cash fast enough, and not realizing they were dealing with someone who didn't speak English. After that, being surrounded by art—even photocopies of art illustrating a police bulletin—can feel like heaven.

"If you look at what is usually stolen," he says, referring to everyday property crimes, "people can go to the neighborhood department store and get the new and improved version of what they lost. But this cultural property, these antiques, these collectibles, this art—by definition they're unique and usually handmade and irreplaceable, so this really does deserve government and law enforcement's extra effort, in order to maintain and preserve it, just to make sure that street thugs don't get hold of it, because they have no respect for this type of property."

European countries have long understood this. In Italy, three separate police forces have hundreds of personnel dedicated to solving art-and-antiquities crimes. But Hrycyk, who was born in 1950, is the only man on a local police force in North America with the full-time job of cracking art crimes. Because he knows that it won't be much longer before he

Manet's *Chez Tortoni*, painted between 1878 and 1880, portrays a stylish patron of a Parisian café and was one of the paintings stolen from Boston's Isabella Stewart Gardner Museum in 1990.

retires, he shares his accumulated wisdom twice a year with other police officers from around the United States who travel to Los Angeles for a primer on the subject. "If you're a burglary detective or a homicide detective, you have associations you belong to, conferences you attend," he explains. No such organizations or events exist for art-crime detectives looking to share trade secrets.

In some ways, though, Hrycyk says that solving an art theft is like cracking any other property case. You scour the site for clues, probe the vulnerabilities, and draw up a list of the likely suspects. You might as well begin with what's right under your nose. According to statistics gathered by the FBI, more than eighty percent of art heists are inside jobs. Hrycyk notes the number of wealthy and status-conscious art collectors in Los Angeles. Such people may be vulnerable because they employ domestic and maintenance staff who have easy access to their possessions.

Just being near the art every day can sometimes prove too tempting. In January 2004, a security guard at the Georgia O'Keeffe Museum in Santa Fe, New Mexico, removed the painter's slyly erotic *Red Canna* (1919) from its spot on a gallery wall and hid it inside a storage closet. Oddly, he called police to report a burglary in progress and was found out in short order. He convinced the court that he'd taken the painting not to sell but, rather, to punish his employers for treating him harshly. He was sentenced to time served.

One year before that, in March 2003, at least three employees of the famous Riker's Island prison got it into their heads to snatch an original Salvador Dalí from the people of New York State. The four-by-three-foot pencil-and-ink drawing, which depicted the crucifixion, had hung in a glass-enclosed case in the prison since 1965 when the artist, on a visit to New York City, had sent it along as a consolation offering after an illness prevented him from making a trek to the island to spend time with inmates. After seeing it every working day and figuring its beauty was lost on the inmates, an assistant deputy warden and two guards arranged a fire drill in the middle of a winter's night to provide cover as one of them removed the Dalí and replaced it with a laughably poor forgery. After a long investigation and a series of trials, the three were convicted and given light sentences. The Dalí, which was valued at about $275,000, is thought to have been destroyed.

Freud Looks for His Bacon

The British Council's director of the arts, Andrea Rose, described Lucian Freud's painting of his friend Francis Bacon as "a portrait of one national icon by another."

Police agencies and private detectives aren't the only ones who hunt art; sometimes artists pick up their paintbrushes to help the cause, too. In 1952, the German-born British artist Lucian Freud executed a tiny five-by-seven-inch portrait on copper plate of his friend, the artist Francis Bacon. Though the thirty-year-old Freud was a little-known artist who was just then beginning to make waves, the Tate Gallery in London showed impressive foresight and purchased the work for its permanent collection.

In May 1988, the portrait was on loan to the Neue Nationalgalerie in West Berlin as part of a Freud retrospective when someone took advantage of the lax security to help himself. Organizers immediately closed the show, but the portrait never turned up.

In the spring of 2001, as preparations were under way for another Freud retrospective on the occasion of his eightieth birthday the following year, the British Council put up a reward of £100,000 ($151,000) for return of the work, then valued at more than $1.4 million. Freud himself designed the publicity materials for the effort, an Old West-style WANTED poster showing the missing portrait of a downcast Bacon. Neither artist is mentioned on the poster. The only text, in German, read: "Would the person who holds the painting kindly consider allowing me to show it in my exhibition at the Tate next June?"

More than two thousand of the posters were put up around Berlin, but the effort came to naught. In a show of Freud's continuing popularity, however, a number of the posters were stolen by souvenir hunters.

That's unusual. Most experts believe any work of art will resurface in time, even if it takes a generation or two. Indeed, the files are full of stories about art that eventually slides back into view. In 1967, someone nabbed a $30,000 Andrew Wyeth watercolor, *The Studio*, from the front room of the Sears–Vincent Price Gallery in Chicago (a joint venture between the department store and the iconic horror-film actor that was closed in 1971). More than thirty-three years later, in late 2000, the painting turned up at Christie's auction house, where a researcher investigating its provenance realized it was still officially considered stolen. *Portrait of a Rabbi*, a painting attributed to Rembrandt that had been stolen from the M.H. de Young Museum in San Francisco in 1978, was dropped off anonymously at a private gallery in New York City twenty-two years later.

Portrait of a Rabbi, which turned up twenty-two years after being stolen, was renamed *Portrait of a Man with Red Cap and Gold Chain* when the Netherlands-based Rembrandt Committee couldn't be certain the subject was a rabbi.

That sort of development cheers people like Don Hrycyk. He sees a moral element to the never-ending hunt for stolen art and the criminals who would deprive the world of its sublime pleasures. "The overwhelming feeling I have is that, in a world that has so much violence, these artworks are testaments to our better nature," he explains. "These are the things we would want to trot out if there was an Armageddon and somebody said, 'Hey, you guys don't deserve to go on.' There is so much out there that has tremendous beauty that we could actually point to and say, 'No, this is our finer nature, this is what we strive for here.'"

Valued at $30,000 when it was stolen in 1967 from a Chicago gallery, Andrew Wyeth's 1966 watercolor *The Studio* was appraised at $500,000 after it turned up in late 2000.

THE SPACE ON THE WALL

Bulletproof glass can make it awfully difficult to appreciate a painting. But after the brazen August 2004 thefts of *The Scream* and *Madonna* during opening hours, directors at Oslo's Munch Museum felt they had no choice but to undertake an extensive security overhaul. When the museum reopened after a ten-month, $5-million systems upgrade overseen by a consulting firm that handles security for airports, Norwegian journalists dubbed the place Fortress Munch. Indeed, visitors might reasonably think they have wandered into an airport. At the entrance, they are confronted by metal detectors and an X-ray machine, not to mention a high-tech optical ticket reader and a double set of one-way security doors. Further on, stepping into the galleries themselves brings perhaps the greatest shock, for Munch's best works are now protected behind panels of unbreakable glass that sit about eight inches away from the wall. The paintings are safer than ever from theft and vandalism, but the solution brings to mind an old and not-very-funny joke. "The operation was a success," goes the punch line, "but the patient died."

"You can't see all of the brushstrokes," sighed Iris Müller-Westermann, a curator who put together the first show to open at the

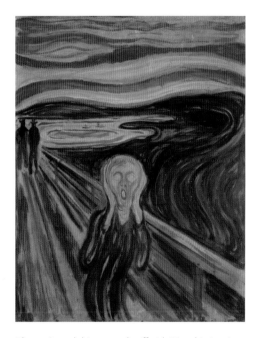

Above: Armed thieves made off with Munch's iconic *The Scream* in 2004. It has not been recovered.
Opposite: In the Dutch Room at Boston's Isabella Stewart Gardner Museum, an empty frame bears silent testimony to the heartbreaking loss of the thirteen priceless works in a 1990 theft. The paintings have never been recovered.

Munch Museum after its renovation. "No matter how much they polish the glass, you can see little dust particles, and there are thick lines where the panels come together."

There are no such forbidding glass panels at the Isabella Stewart Gardner Museum, but if you drop by there for a visit, don't bother trying to do a pen-and-ink sketch while relaxing in the manicured courtyard. Pens are forbidden. (If you ask nicely, one of the volunteers at the desk on the first floor will kindly provide you with a stubby pencil for your sketching.) Cameras, cell phones, and backpacks are also forbidden, as is the practice of carrying a coat in front of the body. All are potential security threats.

Museums and galleries have had to change their access policies in light of the daring thefts of their holdings. Students, such as this one in London's National Gallery in the 1930s, used to be able to sit for hours, studying and copying masterworks. These days, only pencils and paper are allowed in most major institutions.

The fact is, museums around the world have had to overhaul their welcoming attitudes as much as they've had to overhaul their surveillance technologies. Mindful of what security specialists call "social engineering," which refers to the ability of con men and women to extract valuable information without anyone realizing it, museums are putting more emphasis on the need to train staff not to get too friendly with visitors. Art has been moved farther away from entrances, bags are now regularly banned, and the number of exits has been reduced in many buildings to make fast getaways more difficult.

All of which, unfortunately, feeds a vicious cycle. The new security measures make it more expensive to run a museum; at the same time, they also make it tougher to raise the cash to pay for such measures. A few years ago the American Association of Museums passed new security guidelines that called for an end to special tours of collections in storage. Allowing people behind the scenes, where the public is not regularly permitted, too often exposed the vulnerable areas in a museum's protective system. Museum directors and curators dissented ferociously when the new rules were introduced. Storage collection tours are often arranged for VIPs, potential board members, the press, and student groups. They are at the very heart of a museum's primary missions of education, public relations, and fundraising.

Steal Me, Please

The *Mona Lisa*, seen here being hung in a new room at the Louvre in April 2005, became a popular subject of public affection after her theft in 1911.

Like a movie star who becomes a legend by dying too young, a painting can get a huge boost in value by being yanked out of the public eye. Images of stolen artworks now flash around the world after a theft, ironically making them more desirable to the public because of their sudden absence.

In late 2004, a trio of artists in Seattle took this dynamic to an absurd extreme, stealing about a dozen paintings by other artists in order to make them famous. "The idea was to take the worst crap we could find and give it value," admitted one of the pranksters.

In his book *Stealing the Mona Lisa: What Art Stops Us from Seeing*, the British psychoanalyst Darian Leader notes that da Vinci's masterpiece really only became famous after Vincenzo Peruggia lifted it from the Louvre in 1911. In the ensuing months, composers wrote tunes about the *Mona Lisa* and its subject's beauty;

editorial cartoonists mocked police efforts to find her; and cabaret singers appeared as topless versions of her. For two years, until the *Mona Lisa* was located in Florence, crowds flooded the Louvre to stare at the empty space on the wall. They actually showed up in far greater numbers than they had before, when the painting was there for them to see. "Might this give us a clue as to why we look at visual art?" asks Leader. "Are we looking for something that we have lost?"

Certainly, that's true of some visitors to the Isabella Stewart Gardner Museum who stand flat-footed before the empty frames. And in Oslo, Norway, in the immediate days after *The Scream* and the *Madonna* were lifted in August 2004, attendance at the Munch Museum shot up. But the place didn't feel much like a gallery anymore; it was more like a funeral home.

In this context, it's best to be the sort of person who sees the glass half full instead of half empty. Talk to some security people and they'll tell you, only half jokingly, that if it were up to them, they'd bury all of a museum's treasures in a highly fortified basement and never let any member of the public in at all.

To be sure, in art-rich, old-world countries like Italy, the artwork can seem far too accessible. It's hard to quarrel with the description of his country offered by the head of the carabiniere's art theft unit as an "open-air museum." Indeed, some people are agitating for the Italian government to move more of its statues and other public artworks indoors, which would help protect the cultural patrimony from the elements, as well as from vandalism and theft. But there is enormous pride among Italians over objects like the statues of the country's forefathers that decorate city squares. Making them less accessible would diminish something in the Italian sense of self.

So security experts plow ahead to develop new technologies that might enable art to remain accessible to all. In the fall of 2005, a British engineer pursuing his Ph.D. at Bath University won an international scientific and engineering award for creating a unique locking system for paintings that uses a mechanically coded plastic chip as a key. In the event of fire, the locks can be opened quickly by a special pass card, but the system is difficult enough to duplicate that thieves cannot just go to their corner locksmith for assistance. Best of all, the system can be installed inside a frame, allowing visitors an unobstructed view of the artwork.

Above: Mounting security concerns have led to scenes such as this, at the reopening of Oslo's Munch Museum, where visitors must pass through airport-type screening procedures as they enter.
Opposite: The accessibility of public art leaves it vulnerable to theft and vandalism. The Renaissance sculpture of Neptune in Florence had its hand broken off by vandals in 2005.

Perhaps the very first step that many museums need to undertake is a simple inventory of their holdings. The storage areas of the Victoria & Albert Museum in London are crammed with curios and artifacts collected over the centuries, and administrators still don't have a complete catalog of the institution's possessions. In late 2005, the National Art Gallery in Malaysia suddenly discovered that eighty-nine of one hundred and twenty-seven paintings that had been reported missing were actually in other parts of their

museum. The discovery prompted outrage, but it's not unusual: Short-staffed and underfunded institutions necessarily focus on the pieces put on exhibit for the public and not on the overflowing cupboards in their basements. The danger, of course, is that if something disappears without ever being cataloged, it might as well not exist. Certainly, it would be extremely difficult to retrieve.

For the sake of efficiency, museums might be able to combine the task of cataloging their holdings with that of marking them using identification tags. A number of government and private industry teams are working on systems that employ nanotechnology so that if a work is ever snatched it can be identified. Staff members at the National Physical Laboratory near London, England, are developing a three-dimensional barcode made of coated silicon that can be applied to a hard surface with an adhesive, or even woven into fabric. In the United States, the California company Applied DNA Sciences has come up with an identification system based on plant DNA. Both mechanisms are so small it's unlikely that thieves would be able to find them on a work of art.

Many pieces held in museum storage areas never see the light of day in display galleries, and increased security has meant that educational and fundraising tours of collections in storage have ceased. At the Brooklyn Museum's Luce Center for American Art above, the storage area is visible to the public.

These systems are not expensive—the three-dimensional barcode will probably cost less than $2—so they may just be able to help the tens of thousands of unguarded churches, private galleries, and private homes around the world, where pieces often seem ripe for the plucking. Something must be done. Thefts from French churches are at record levels, with thousands of artifacts disappearing every year, by some estimates putting France ahead of Italy in the illicit-trade game. In 2004, the Office Central de lutte contre le trafic des Biens Culturels (OCBC), which oversees cultural trade in France, reported that more than twenty thousand artworks and artifacts had been snatched from the country's private homes and churches. That year alone, some four hundred and fifty chateaus and two hundred and twenty-five religious places had been hit. The haul was more than double that of 2003, suggesting the development of a very worrisome trend.

Easy Pickings

Expulsion from the Garden of Eden is considered a significant Spanish colonial work, likely painted by a self-taught artist. The large canvas was cut from its frame and was the third work stolen from the small Mexican church that was its home.

As many museums tighten security, crooks are increasingly turning to softer targets. Hundreds of churches across Europe are hit every year; France recently surpassed Italy in annual losses.

In Mexico, organized gangs have been hitting village churches, taking anything they can get their hands on: paintings, statuaries, even robes and historical documents. In the village of San Miguel Atlautla, citizens raised money for a motion detector to protect a wooden statue of San Miguel, their patron saint. When a young man set off the alarm while trying to pry gold chains out of the statue's hands, villagers rang the church bells and tied up the thief until police arrived.

The government is now building an art-theft database, but with roughly four million uncataloged artworks in the country's churches, it's difficult even to be certain that something really has gone missing.

Mexico's predicament is worse than that of European countries, since its relatively poor economic status means most stolen art is smuggled to deep-pocketed foreign buyers. Sometimes that leads to unlikely happy endings. In 2000, thieves struck a small church in San Juan Tepemazalco, in the Mexican state of Hidalgo, taking three items including a 1728 painting, *Expulsion from the Garden of Eden*. Later that year, an art gallery based in Mexico City sold the painting to the San Diego Museum of Art, accompanied by what seemed like a legitimate provenance. But a few years later, when a researcher at the museum looked more closely at the documentation, he found a number of unanswerable questions about its provenance. After speaking with Mexican authorities, museum directors realized they had purchased stolen property, and in the late fall of 2004 agreed to return the painting.

THE GOVERNING OF ART

Not all of the focus is on prevention of theft. Museums, government authorities, and insurance companies are trying to educate the public about the need to help stop thefts by simply refusing to purchase stolen or looted art, thereby sapping the market of its lifeblood. They're trying to get the message out that collectors who buy art without being absolutely certain of its provenance risk losing it at some point, along with the purchase price. Certainly, many of those collectors who have acquired art looted in the Holocaust have paid a painful price for that lesson, as have museums.

The illicit trade in antiquities is a thornier issue than stolen art. There is widespread sympathy in the West toward those in the world's less economically advanced regions who make a meager living by selling out their country's cultural birthright. "The peasants who dig the objects out of the ground because there are people who pay good money for them, they are the innocent wrongdoers," said the British archaeologist Colin Renfrew. "Curators, museum directors who willingly purchase or accept as bequests material they know they have no provenance for, they're the real villains, the real pushers who drive this trade."

Some governments, prompted by the United Nations Educational, Scientific, and Cultural Organization (UNESCO), which oversees cultural issues, are getting more serious about prosecuting the trade in illicit art. Italy is striking bilateral deals with countries as varied as the United States and China to prevent its antiquities from finding legal buyers abroad. Freed from Taliban rule, Afghanistan is pleading with the international community not to buy the country's historic treasures. Though it is now mired in conflict, Iraq is also reaching out to the West in an effort to close off a potential market for its art and antiquities.

Above: Pakistani customs officers in Karachi foiled a June 2005 attempt to smuggle a large number of antique sculptures worth millions of dollars out of the country. Almost fifteen hundred pieces had been concealed in a container bound for Dubai.

Opposite: The trade in illegal antiquities poses a major problem. In 1999, Thai plainclothes police raided a sculptor's home north of Bangkok and seized a large number of artifacts, believed to have been stolen from ancient temples in Thailand and Cambodia. Prosecutors are increasingly pursuing those who trade in illicit antiquities.

Perhaps the best thing for everybody would be if a major American museum were robbed in spectacular style. How so? The assault on the Isabella Stewart Gardner Museum shocked the American public with its audaciousness and the headline-grabbing value of the missing paintings. Politicians even got in on the act. Senator Edward Kennedy sponsored legislation making art theft a federal crime if it involved a piece of art worth at least $100,000, or worth $5,000 and more than one hundred years old.

After Corot's *Le chemin de Sèvres* was cut from its frame and secreted out of the Louvre in 1998, an independent commission decreed that security was so poor at the museum it would be easier to steal a work of art there than to shoplift at a department store.

Legislation designed to stop money laundering in North America is now tougher than ever. Recent legislation passed by the European Parliament also puts up significant roadblocks for those seeking to hide illicit cash. Still, in too many countries it remains too easy to gain legal title to an illicit work of art. In the United States and Canada, a stolen piece of property will never be cleansed. But in the United Kingdom, six years after you've bought a stolen painting, it's all yours. In Switzerland, the owner of a work of art that has been stolen has five years to find and lay claim to it in a court of law; otherwise ownership is cemented with the new possessor, even if the new owner is the thief. In France, it takes only three years for ownership tainted by theft to be cleansed. In Japan, the window is a mere two years. In Italy, a purchaser in good faith automatically acquires title. That can prompt the exploitation of some bizarre legal loopholes. Courts in Britain, for example, have supported the notion that the country in which a property transfer takes place shall have its laws apply, so stolen art is often sent to Italy to be sold, and then shipped back to its original country. Indeed, one of the major unspoken fears among those hunting the Isabella Stewart Gardner Museum treasures is that they may have been sold on to buyers in countries where legal title to a stolen painting is easily obtained.

Governments certainly give mixed signals on the matter of art theft. The culture budgets of governments in North America and across Europe are being slashed, making it more difficult for museums and galleries to invest in promising but expensive new technologies. In the United Kingdom, the government was cheered for finally passing the

More Security than a Bank

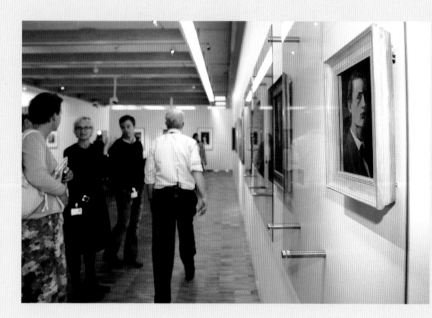

Bulletproof glass now protects the art at Oslo's Munch Museum, which underwent an almost year-long $6.5-million security overhaul after being robbed in August 2004.

Once upon a time, if a light-fingered visitor helped himself to a piece of art at a large museum in the middle of the night, it might take half an hour or more before the guards knew exactly what had happened. An alarm would go off in the monitoring station (often a bunker in the basement, far from the galleries), but the staff wouldn't necessarily know whether they were staring at a burglar alarm, a smoke alarm, or an air-conditioning system malfunction until they consulted a thick manual. Computers have changed all that, but even the most hi-tech security systems still depend on alert responses from staff. Too many times, thefts succeed because guards assume an alarm that has been activated is simply faulty.

The most visible element in any comprehensive security system is usually an array of closed-circuit video cameras placed at the entrances and exits of galleries. If the funding is available, cameras are also sometimes placed within the galleries themselves. But there are dozens of other devices that can help foil theft: alarms on windows to prevent burglars staying behind until after closing time and then busting their way out; infrared sensors that pick up temperature changes; motion detectors; and microwave sensors that can be hidden in walls, where they pick up any unusual sound waves.

Motion-detection systems are sometimes placed right above a particularly precious painting; if a visitor gets too close, a low chirping sound alerts both the visitor and security staff. Steve Keller, a Florida security consultant, favors an approach he calls "saturation motion detection," which refers to multiple devices that track visitors on parallel systems. It's an expensive strategy, but the most effective.

The next time you're in a museum, take a look at how the paintings are hung and the sculptures are fixed in place, and see if you can figure out all of the security precautions. Just don't get too close—you might set off an alarm.

Dealing in Cultural Objects Act, which came into effect in 2004. The legislation called for up to seven years in prison for anyone who is found trafficking in illicit antiquities, which would seem to indicate the government was taking the issue seriously. A special panel had recommended the government set up a database of stolen art and antiquities. Dealers buying or selling cultural artifacts would have been required to consult the database as part of their due diligence. But after almost five years of negotiations and political pussy-footing, the government quietly dropped the proposal, saying it was unable to ensure it would have been used and that, in any case, perhaps it wasn't appropriate for the government to be giving financial support for such a project. The British Art Market Federation was aghast, noting that a federally funded database would have been "a major deterrent against art crime."

This muddled approach to the problem shouldn't surprise anyone. Art-theft cases in general are politically unpopular. Many museums and institutions in the West, filled with ancient treasures from faraway lands, have proved unenthusiastic about legislation or mechanisms that could curb their ability to collect. And if the authorities throw too many resources at stolen art or artifacts belonging to collectors, the public sees it as taxpayer-supported private-detective work. Certainly, from the perspective of the police, the work hardly ever pays off, since the focus is and must be on reclaiming the art rather than putting somebody away. It's nice to be able to pose next to a pretty picture for the newspapers, but for a police officer the brief fame is small consolation.

At the end of that 1999 remake of *The Thomas Crown Affair*, the police detective played by Denis Leary puts the situation in plain terms. "The week before I met you," he explains to the ravishing insurance adjuster played by Rene Russo, "I nailed two crooked real estate agents and a guy who was beating his kids to death. So if some Houdini wants to snatch a couple swirls of paint that are really only important to some very silly rich people, I don't really give a damn."

But with all due respect to jaded police detectives and Hollywood screenwriters everywhere, it's not just silly rich people who care about those swirls of paint. Tens of millions of regular people pack museums around the world every year to bask in the transcendent creativity of men and women throughout history, to linger for a while among the paintings,

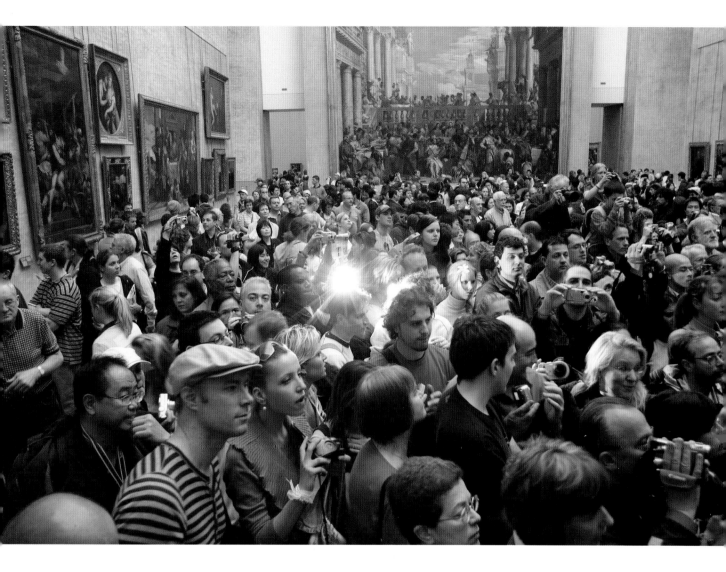

Thousands flocked to the April 2005 opening of the Louvre's newly restored Salle des Etats to see the five-hundred-year-old *Mona Lisa* in her new home.

sculptures, and other treasures that form our collective birthright. Museum and gallery attendance is skyrocketing. Previous generations of artists dedicated their lives to capturing profound truths for us to appreciate; their patrons and collectors handed over their fortunes so that our lives might be enriched, and so that new generations of artists and thinkers might learn from their predecessors. Must we respond with fear, by closing down our museums and galleries, and putting these treasures where only the elite might enjoy them? What will it take before the world gets serious about our bewildering, collective losses? How many more empty frames must we contemplate in sorrow and despair and frustration?

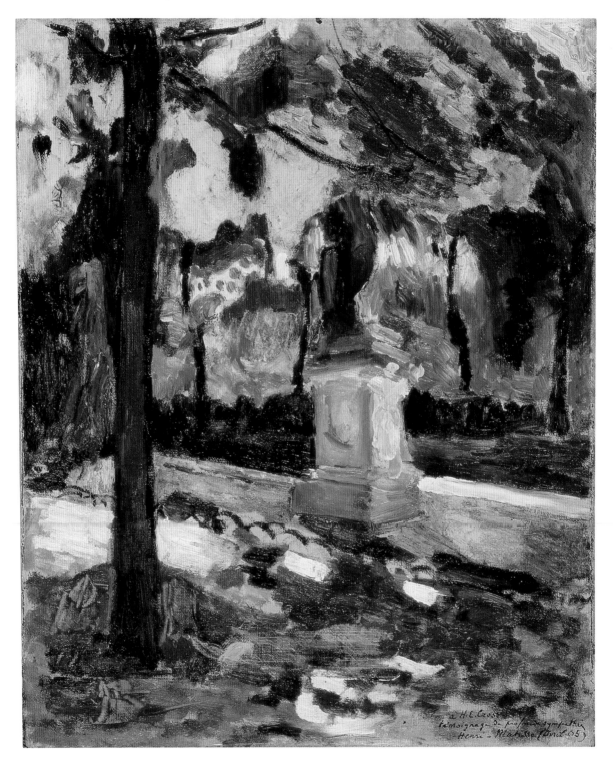

Henri Matisse, *Luxembourg Gardens* (see entry, facing page)

GALLERY OF MISSING ART

In the following pages, you will find Pollocks and Parrishes, Corots and Caravaggios, Monets and Manets and Matisses, all of them tinged in tragedy. Gazing at this diverse collection is an ambivalent experience, for here are gathered some of the finest paintings and sculptures the world has ever seen. Some of these masterpieces are considered priceless—their values are so high that they have not been determined. Some values are unknown because this information has not been made public. Revel in the beauty of these artworks, and study them closely, too, for they will only find their way back home if people keep their eyes open for these unique missing pieces.

HENRI MATISSE
(1869–1954)

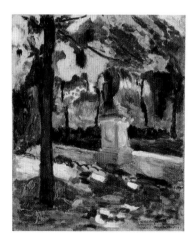

Luxembourg Gardens
1904, oil on canvas, 15.75 x 12.6 inches (40 x 32 cm)

Missing since February 24, 2006
from the Chácara do Céu Museum, Rio de Janeiro, Brazil
Estimated current value: unknown

Four heavily armed men overpowered the security guards and forced them to shut down the surveillance cameras in the museum before making off with this painting, as well as Pablo Picasso's *Dance*, Salvador Dalí's *Two Balconies*, and Claude Monet's *Marine*. The thieves took advantage of the carnival celebrations and parade to disappear into the large crowd of revelers.

CLAUDE MONET
(1840–1926)

Marine
1880–1890, oil on canvas, 25.5 x 35.8 inches (65 x 91 cm)

Missing since February 24, 2006
from the Chácara do Céu Museum, Rio de Janeiro, Brazil
Estimated current value: unknown

This seascape by French Impressionist Claude Monet was one of four paintings stolen during carnival festivities in Rio. Monet is considered one of the founding fathers of Impressionism, along with Renoir, Alfred Sisley, and Frédéric Bazille—all of whom excelled at capturing on canvas the impression of the moment and the effect of light on a subject.

AUGUST STRINDBERG
(1849–1912)

Night of Jealousy
1893, oil on canvas, 16 x 12.6 inches (41 x 32 cm)

Missing since February 15, 2006
from the Strindberg Museum in Stockholm, Sweden
Estimated current value: $1.3 million

On the afternoon of February 15, three thieves entered the museum and while two distracted the staff, the third took *Night of Jealousy* off the wall. Strindberg, a Swedish novelist and playwright as well as a painter, depicted violent scenes of nature in many of his paintings, particularly in his seascapes.

PABLO PICASSO
(1881–1973)

Femme regardant par la fenêtre
1959, linoleum-cut graphic, 21 x 25 inches (53.3 x 64.5 cm)

Missing since December 22, 2005
from the Modern Masters Fine Art Gallery, Palm Desert, California
Estimated current value: $53,000

Using a crowbar, two men broke into the gallery through the back entrance shortly after 11:00 PM and took very little time (about thirty seconds) to steal the Picasso as well as a lithograph by Marc Chagall entitled *The Tribe of Dan*. The theft was captured on surveillance videotape.

August Strindberg, *Night of Jealousy* (see entry, facing page)

MARC CHAGALL
(1887–1985)

The Tribe of Dan
1964, lithograph, 24 x 18 inches (61 x 46 cm)

Missing since December 22, 2005
from the Modern Masters Fine Art Gallery, Palm Desert, California
Estimated current value: $35,000

Marc Chagall, whose given name was Moses, was one of eight children born to Russian-Jewish parents in Vitebsk, Russia, now Belarus. In Paris, Chagall experimented with Fauvism and Cubism, but soon developed his own style. He left Nazi-occupied France for the United States in 1941, but returned in 1947. Chagall created stained-glass windows for churches, synagogues, and hospitals. This lithograph mirrors one of the twelve windows he created for Hadassah Hospital in Beit-ul-Moqaddas, each one representing a tribe of Israel.

HENRY MOORE
(1898–1986)

Reclining Figure
1970, bronze sculpture, 8.8 x 11.5 feet, 2.7 tons (270 x 350 cm, 2.5 tonnes)

Missing since December 15, 2005
from the Henry Moore Foundation, Much Hadham, Hertfordshire, England
Estimated current value: approx. $5.2 million

Reclining Figure had been temporarily moved to a yard in preparation for repositioning elsewhere on the foundation's grounds. Using a crane and a stolen flatbed truck, three thieves were able to hoist the sculpture and drive away with it at about 10:00 PM. A few days later, police found the abandoned truck. It is feared that the bronze masterpiece may have been melted down for scrap metal. Henry Moore is critically regarded as Britain's foremost sculptor of the twentieth century.

JACOB WABEN
(1580–1634)

Vanitas
1622, oil on canvas, 51.5 x 59.5 inches (131 x 151 cm)

Missing since January 9, 2005
from the Westfries Museum, Hoorn, the Netherlands
Estimated current value: entire theft $13 million

The Westfries, one of the oldest museums in Holland, was robbed on the eve of its 125th anniversary. The heist occurred on a Sunday night, and on Monday morning employees discovered smashed display cases, broken doors, and empty frames. The thieves made off with twenty-one paintings—the heart of this small museum's collection—as well as three drawings, a print, and a silver collection.

Matthias Withoos

(1627–1703)

Harbour in Hoorn (1)

Late 17th century, oil on canvas, 25 x 39 inches (63.5 x 100 cm)

Missing since January 9, 2005

from the Westfries Museum, Hoorn, the Netherlands
Estimated current value: entire theft $13 million

Dutch painter Matthias Withoos created two versions of the same painting (see below). Both pieces were part of the "Sights of North Holland" exhibition and both were stolen in the January 2005 robbery at the Westfries Museum. Withoos, who painted landscapes and still lifes, was also the teacher of another famous Dutch landscape artist, Caspar van Wittel.

Matthias Withoos

(1627–1703)

Harbour in Hoorn (2)

Late 17th century, oil on canvas, 25.5 x 39.7 inches (65 x 101 cm)

Missing since January 9, 2005

from the Westfries Museum, Hoorn, the Netherlands
Estimated current value: entire theft $13 million

This is Matthias Withoos's second version of the the harbor in Hoorn.

Jan Claesz Rietschoof

(1652–1719)

View on the Oostereiland (Hoorn)

Late 17th century, oil on canvas, 37 x 50 inches (93.5 x 127.5 cm)

Missing since January 9, 2005

from the Westfries Museum, Hoorn, the Netherlands
Estimated current value: entire theft $13 million

Dutch artist Jan Rietschoof was skilled in capturing the details of seascapes that included men-of-war ships, galleons, whaling ships, stormy seas, and harbor activities. His son and pupil, Hendrik Rietschoof, was also a painter of seascapes.

HERMAN HENSTENBURGH
(1667–1726)

Still life, Memento Mori
1698, watercolor, 12 x 10 inches (31 x 26.4 cm)

Missing since January 9, 2005
from the Westfries Museum, Hoorn, the Netherlands
Estimated current value: $96,000

This still life was one of two taken in the museum robbery.
Henstenburgh was a master of botanical painting, and
the palette of his watercolors was extraordinarily rich. He
began by depicting birds and landscapes and later included
flowers and fruit.

HERMAN HENSTENBURGH
(1667–1726)

Untitled
1698, watercolor, 15 x 11.6 inches (38.7 x 29.5 cm)

Missing since January 9, 2005
from the Westfries Museum, Hoorn, the Netherlands
Estimated current value: $122,000

This is the second missing Henstenburgh watercolor still life.
In addition to being a talented painter, Henstenburgh was also
an accomplished baker.

WORKSHOP OF DONATELLO
(1386–1466)

The Virgin and Child in a Niche
c. 1440s, bronze

Missing since December 29, 2004
from the Victoria & Albert Museum, London, England
Estimated current value: approx. $260,000

This is one of the eight bronze plaquettes stolen from the
Victoria & Albert Museum. Donatello (Donato di Niccolò
di Betto Bardi), a master of marble and bronze sculpture, is
considered one of the greatest of all Italian Renaissance artists.
Almost all of the small-scale reliefs and plaquettes produced by
Donatello and his followers are religious in subject matter and
usually depict the Virgin and Child.

EMILE GALLÉ
(1846–1904)

Dragonfly Bowl
1904, cased glass, 7.5 inches high (19 cm high)

Missing since October 27, 2004
from the Neumann Foundation, Gingins, Switzerland
Estimated current value: $3.3 million (12 items)

Thieves broke into the museum, housed in the village castle of Gingins overlooking Lake Geneva, and stole a dozen glass artworks made by French artisan Emile Gallé. They had disabled the building's security alarm and used a ladder to reach a second-story window. A second alarm woke the resident curator, but the thieves escaped before the police arrived. Among the stolen glassworks were Gallé's dragonfly pieces, made just before he died.

EDVARD MUNCH
(1863–1944)

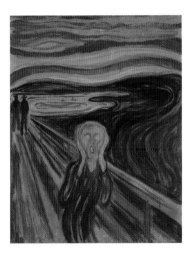

The Scream
1893, oil on board, 32.8 x 26 inches (83.5 x 66 cm)

Missing since August 22, 2004
from the Munch Museum, Oslo, Norway
Estimated current value: more than $100 million with *Madonna* (below)

Two masked thieves stole *The Scream* and *Madonna* in a bold daylight heist that was witnessed by many museum patrons. After threatening the museum staff at gunpoint, the thieves made their escape in a black Audi. *The Scream* is Munch's best-known work and has become symbolic of the modern human condition. There is another version in the National Gallery in Oslo.

EDVARD MUNCH
(1863–1944)

Madonna
1893–1894, oil on canvas, 35.4 x 27 inches (90 x 68.5 cm)

Missing since August 22, 2004
from the Munch Museum, Oslo, Norway
Estimated current value: more than $100 million with *The Scream* (above)

Munch created four other versions of this dramatic image. The red color of the Madonna's halo is associated with both love and blood. *Madonna* and *The Scream* were in Munch's possession when he died in 1944 and were part of his bequest to the city of Oslo. Both paintings are also central in the cycle of images that Munch called "The Frieze of Life," which he described as "a poem about life, love, and death."

PARMIGIANINO
(FRANCESCO MAZZOLA)
(1503–1540)

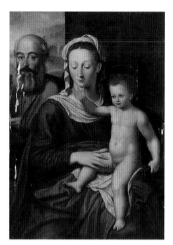

The Holy Family
16th century

Missing since July 31, 2004
from the Santo Spirito in Sassia Hospital, Rome, Italy
Estimated current value: $5 million (10 paintings)

The historic Santo Spirito Hospital houses a rich art collection. Apparently, thieves chose this particular night for the robbery because a huge Simon and Garfunkel concert was going on in the city. Normally the works would have been on display in a room protected by an alarm system. However, a month before the theft, they had been moved to a restoration room that lacked an alarm. Francesco Mazzola, or Parmigianino as he came to be called, was a painter, draftsman, and etcher born into a family of artists in Parma, Italy.

GIUSEPPE CESARI
(CAVALIER D'ARPINO)
(1568–1640)

Flagellazione

Missing since July 31, 2004
from the Santo Spirito in Sassia Hospital, Rome, Italy
Estimated current value: $5 million (10 paintings)

Italian Mannerist painter Giuseppe Cesari, also known as Cavalier D'Arpino, established a huge reputation in the first two decades of the seventeenth century, when he gained some of the most prestigious commissions of the day, most notably the designing of the mosaics for the dome of St. Peter's Basilica (1603–1612) in Rome. At one point in his career, Cesari was a mentor of Caravaggio.

LEONARDO DA VINCI
(1452–1519)

Madonna with the Yarnwinder
1501, oil on wood, 19.6 x 14 inches (50 x 36 cm)

Missing since August 27, 2003
from Drumlanrig Castle, Dumfries, Scotland
Estimated current value: $65 million

Two men dressed as tourists taking a public tour of Drumlanrig Castle overpowered a young tour guide and stole this masterpiece. Aided by two accomplices, the men escaped in a white Volkswagen Golf, which they abandoned nearby. The winder that the infant Jesus is holding is shaped like a cross, perhaps symbolizing the eventual crucifixion. The painting is sometimes called *Madonna of the Spindle* or *Madonna with the Distaff*.

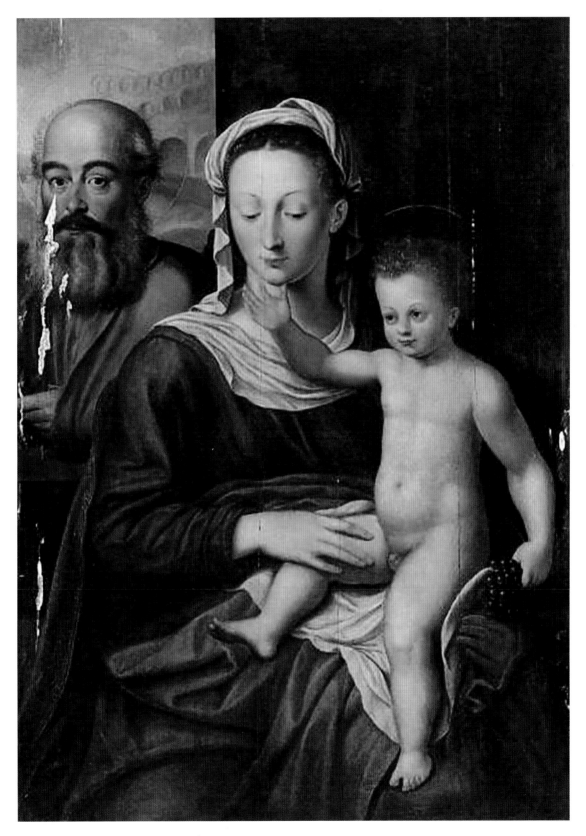

Parmigianino, *The Holy Family* (see entry, facing page)

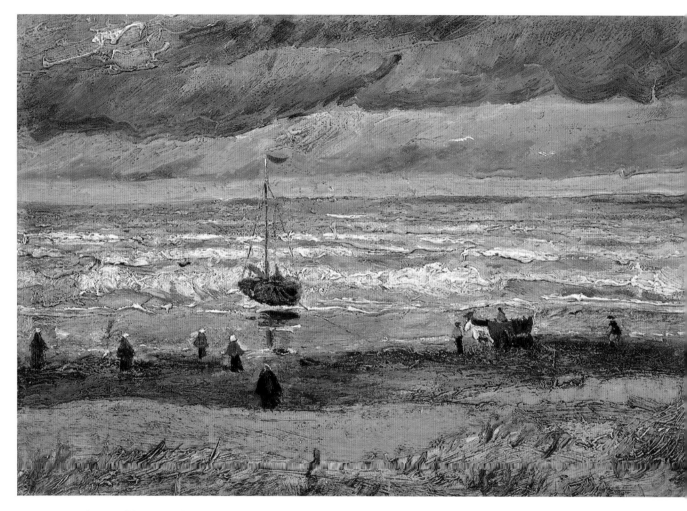

Vincent van Gogh, *View of the Sea at Scheveningen* (see entry, facing page)

UNKNOWN

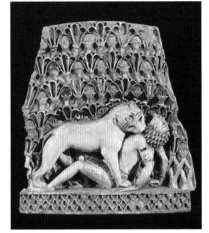

The Lion of Nimrud
c. 720 BCE, wood and ivory, 3.8 inches high (9.8 cm high)

Missing since April 2003
from the Iraq National Museum, Baghdad
Estimated current value: priceless

This ivory relief of a lion attacking a Nubian was one of approximately fourteen thousand objects looted from the museum by citizens and soldiers following the U.S. invasion of Baghdad in 2003. About five thousand artifacts have since been recovered. *The Lion of Nimrud*, one of the museum's most prized objects, has been called an icon of Phoenician art.

VINCENT VAN GOGH
(1853–1890)

View of the Sea at Scheveningen
1882, oil on canvas, 13.5 x 20 inches (34.5 x 51 cm)

Missing since December 7, 2002
from the Van Gogh Museum, Amsterdam, the Netherlands
Estimated current value: $30 million with *Congregation* (below)

Two thieves used a ladder to climb to the roof and break into the museum. In a matter of minutes, they stole this painting and *Congregation Leaving the Reformed Church in Nuenen*. A Dutch court convicted two men a year later, but did not recover the paintings. Van Gogh painted this view of the sea at a beach resort near The Hague. The weather was very stormy and bits of sand stuck to the wet paint. A few grains can still be found in some of the paint layers.

VINCENT VAN GOGH
(1853–1890)

Congregation Leaving the Reformed Church in Nuenen
1884–1885, oil on canvas, 16 x 12.5 inches (41 x 32 cm)

Missing since December 7, 2002
from the Van Gogh Museum, Amsterdam, the Netherlands
Estimated current value: $30 million with *View of the Sea* (above)

This small canvas was originally painted in early 1884 for van Gogh's mother, who had broken her leg. The church is the one where his father had become pastor in 1882. X-rays show that the members of the congregation and the autumn leaves were added to the painting composition at a later date (probably in late 1885).

Henri Matisse
(1869–1954)

Odalisque in Red Pants
1925, oil on canvas, 23.6 x 28.7 inches (60 x 73 cm)

Missing since some time between 2000 and late 2002
from the Sofia Imber Contemporary Art Museum, Caracas, Venezuela
Estimated current value: $3 million

The museum purchased the painting from the Marlborough Gallery in New York in 1981 for $400,000. It was on display there ever since, except for a brief period in 1997, when it was on loan for a Spanish exhibition. In late 2002, it was discovered that the original had been replaced with a forgery perhaps as far back as 2000. French artist Henri Matisse painted several "odalisques," or depictions of Arab dancers, which reflect his fascination with North Africa and his interest in the female form.

Maxfield Parrish
(1870–1966)

Gertrude Vanderbilt Whitney Mansion Murals, Panel 3A
1912–1916, oil on canvas, 64 x 74 inches (162 x 188 cm)

Missing since July 28, 2002
from the Edenhurst Gallery, West Hollywood, California
Estimated current value: $2 million

The theft of two valuable Maxfield Parrish murals (see also below) occurred some time between the close of business on July 28 and the opening of the gallery the next day. The thieves, who gained entry through the roof, cut the panels from their custom frames.

Maxfield Parrish
(1870–1966)

Gertrude Vanderbilt Whitney Mansion Murals, Panel 3B
1912–1916, oil on canvas, 64 x 74 inches (162 x 188 cm)

Missing since July 28, 2002
from the Edenhurst Gallery, West Hollywood, California
Estimated current value: $2 million each

This panel and the one above are from a series of six that were commissioned for Gertrude Vanderbilt Whitney's Fifth Avenue mansion in New York. Parrish was an American illustrator and artist and these two murals are considered among his finest creations. All six panels were on display at the Edenhurst Gallery.

ALBERTO GIACOMETTI
(1901–1966)

Figurine (sans bras)
1956, bronze, 12.6 inches high (32 cm high)

Missing since May 25, 2002
from the Hamburg Museum, Germany
Estimated current value: approx. $500,000

This small bronze statue by the Swiss sculptor was reported stolen June 3, when a museum worker noticed that the statue behind the plexiglass was a wooden copy. The theft likely took place during Hamburg's "Long Night of the Museums" on May 25, when cultural attractions in the city stayed open until 3:00 AM. More than sixteen thousand people visited the museum that night. The small figurine is the second of six identical bronze pieces created in 1956. Giacometti was part of the Surrealist Movement.

CORNELIUS DUSART
(1660–1704)

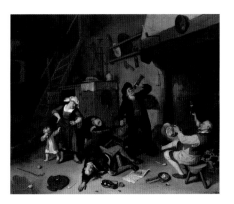

Drinking Bout
c. 1700, oil on panel, 18.8 x 22 inches (48 x 56 cm)

Missing since March 25, 2002
from the Frans Hals Museum, Haarlem, the Netherlands
Estimated current value: $220,000

Five seventeenth-century paintings were stolen on a Sunday night from one of the country's most famous museums, located in a converted historical almshouse. The thieves forced open a window and triggered the alarm, but when police arrived, they were already gone—although they left behind a valuable sixth canvas. Investigators believe the burglars were acting on behalf of a collector because they stole small-sized paintings with a common theme: everyday scenes of peasant drinking and fighting.

ADRIAEN VAN OSTADE
(1610–1685)

Drinking Peasant in an Inn
c. 1655, oil on panel, 18.5 x 15.7 inches (47 x 40 cm)

Missing since March 25, 2002
from the Frans Hals Museum, Haarlem, the Netherlands
Estimated current value: $550,000

Dutch painter Adriaen van Ostade specialized in depicting scenes of carousing peasants and merriment. Another of his paintings, *The Quack* (c. 1648), was also stolen during this robbery.

Cornelius Bega
(1631–1664)

Festive Company before an Inn
c. 1655, oil on panel, 13.7 x 12.7 inches (35 x 32.5 cm)

Missing since March 25, 2002
from the Frans Hals Museum, Haarlem, the Netherlands
Estimated current value: $275,000

Cornelius Bega came from a prosperous Dutch family. His father was a silversmith and woodcutter and his grandfather was the Dutch Mannerist painter Cornelius Cornesz van Haarlem. Bega studied under another famous Dutch artist, van Ostade. Like van Ostade, Bega's principal subjects were peasants going about their daily lives at home, in taverns, and in villages.

Jean-Léon Gérôme
(1824–1904)

Pool in the Harem
1876, oil on canvas, 28.9 x 24.5 inches (73.5 x 62 cm)

Missing since March 22, 2001
from the Hermitage Museum, St. Petersburg, Russia
Estimated current value: $1 million

This painting was on display in the museum's French wing, where there are also priceless works by Monet, Renoir, Gauguin, Manet, Picasso, and Matisse. With such pickings to choose from, the theft puzzled investigators. The heist took place in broad daylight, when only one person was guarding the whole floor, and may have been an inside job. There are fears that the artwork could have ended up in the hands of the Russian mafia. Gérôme's travels inspired him to depict life in the Muslim world.

Howard Pyle
(1853–1911)

The Battle of Bunker Hill
1898, oil on canvas, 23.25 x 35.5 inches (59 x 90 cm)

Missing since August 2001
from the Delaware Art Museum, Wilmington, Delaware
Estimated current value: $250,000

In August 2001, museum workers planning to display this work in a fall exhibition discovered that it was missing. Staff had thought the work, part of the museum's permanent collection since 1912, had been stored in the basement. American author and artist Howard Pyle painted this piece as an illustration for "The Story of the American Revolution," by Henry Cabot Lodge, which appeared in the February 1898 issue of *Scribner's* magazine.

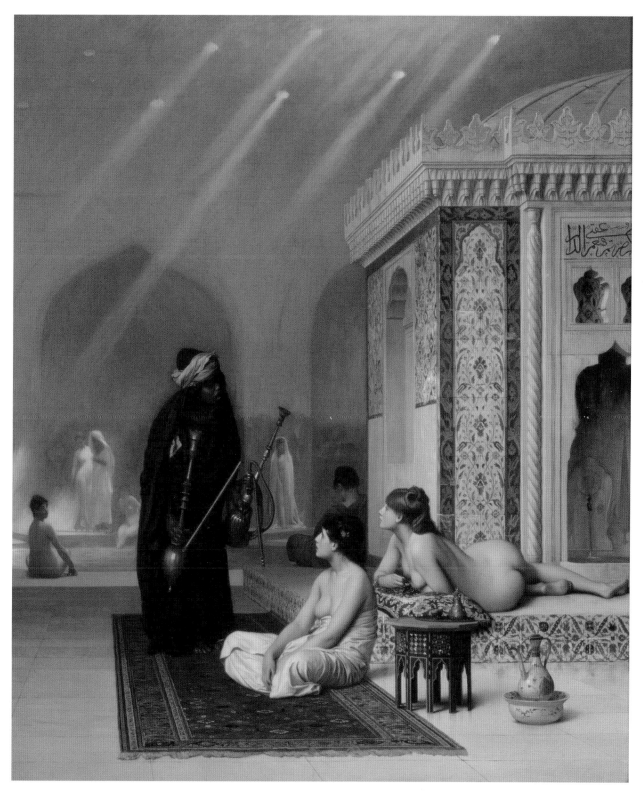

Jean-Léon Gérôme, *Pool in the Harem* (see entry, facing page)

Claude Monet, *Beach in Pourville* (see entry, facing page)

CLAUDE MONET
(1840–1926)

Beach in Pourville
1882, oil on canvas, 23.6 x 28.7 inches (60 x 73 cm)

Missing since September 19, 2000
from the Polish National Museum, Poznań, Poland
Estimated current value: $7 million

This Monet masterpiece was purchased by the museum in 1906 when the city of Poznań was part of Germany. It was not insured because the museum simply could not afford the insurance. Thieves cut the painting out of its frame and replaced it with a badly printed copy on cardboard. It is not certain when the theft took place, since it was reported only after the museum staff noticed the forgery.

THOMAS SULLY
(1783–1872)

Portrait of Frances Keeling Valentine Allan
c. 1800–1815, oil on tin mounted on oak, 10 x 8.5 inches (25.4 x 21.5 cm)

Missing since February 2000
from the Valentine Museum, Richmond, Virginia
Estimated current value: unknown

This portrait by the English-born American painter Thomas Sully is of Edgar Allan Poe's stepmother. Sully was famous for his portraiture, especially his studies of women. His *Queen Victoria* (1838), in particular, is a stunning full-length rendering of the young queen in her coronation year.

PAUL CÉZANNE
(1839–1906)

Near Auvers-sur-Oise
1879–1882, oil on canvas, 18 x 21.6 inches (46 x 55 cm)

Missing since January 1, 2000
from the Ashmolean Museum, Oxford, England
Estimated current value: $3 million

Thieves broke into Britain's oldest public museum through the glass roof on the eve of the new millennium and lowered rope ladders into the gallery. This landscape painting is an important example of late-nineteenth-century art and represents Cézanne's transition from Impressionism to his later, more mature work. It is said to depict a small town in which Cézanne once lived and worked.

Jean-Baptiste-Camille Corot
(1796–1875)

Le chemin de Sèvres
1855, oil on canvas, 13.3 x 19.2 inches (34 x 49 cm)

Missing since May 3, 1998
from the Louvre Museum, Paris, France
Estimated current value: $1.3 million

Le chemin de Sèvres was removed from its frame despite the presence of a protective glass case. The theft occurred around noon on a busy Sunday and even though the police blocked the exit doors and searched thousands of visitors, the thief managed to escape with the small painting. As a result, security measures at the Louvre had to be critically reassessed. Corot painted more than three thousand works in his lifetime and is best known for his landscapes.

Gustav Klimt
(1862–1918)

Portrait of a Woman
c. 1916–1917, oil on canvas, 32.6 x 21.6 inches (60 x 55 cm)

Missing since February 18, 1997
from the Galleria Ricci Oddi, Piacenza, Italy
Estimated current value: $4 million

Although the painting was stolen on February 18, the theft was not discovered until the 22nd. The gallery was closed for renovations and some paintings had been removed, so guards assumed the Klimt had been put in storage. Investigations revealed that the thief had climbed onto the roof, opened a skylight, and then used a fishing line to hook the painting off the wall! The frame was found abandoned on the roof.

Georges Braque
(1882–1963)

Still Life
1928, oil on canvas, 20 x 26 inches (51 x 66 cm)

Missing since November 8, 1993
from the Moderna Museet, Stockholm, Sweden
Estimated current value: unknown

Georges Braque and Pablo Picasso were leading proponents of Cubism, a revolutionary modern-art movement. Works by both artists were stolen in a huge $53-million art theft in 1993. In 1995, three Swedes were sentenced to prison in this theft, but Braque's painting remains missing.

Gustav Klimt, *Portrait of a Woman* (see entry, facing page)

Narcisse Garnier, *Portrait of Regnerus de Kempenaer* (see entry, facing page)

LOUIS-BERNARD COCLERS
(1741–1817)

Portrait of Jan van Loon Jr.
1779, oil on canvas, 13.7 x 11.8 inches (35 x 30 cm)

Missing since October 3, 1993
from the Museum Van Loon, Amsterdam, the Netherlands
Estimated current value: approx. $6,000

Four portraits were stolen from the museum during this heist.
Two of the paintings are attributed to Louis-Bernard Coclers and
the other two are by Narcisse Garnier. Investigators believe that
the portraits were lowered out of a second-floor window.
The van Loons were an old Amsterdam family. The museum's
collection consists of some 150 van Loon family portraits from
1600 to the present day, along with antique furniture, silverware,
and porcelain.

LOUIS-BERNARD COCLERS
(1741–1817)

Portrait of Maria Backer
1779, oil on canvas, 13.7 x 11.8 inches (35 x 30 cm)

Missing since October 3, 1993
from the Museum Van Loon, Amsterdam, the Netherlands
Estimated current value: approx. $6,000

Louis-Bernard Coclers, the son of artist Jean-Baptiste-Pierre
Coclers (1692–1772), began his training in his father's workshop.
He painted portraits, landscapes, and interiors and was also
known for his engravings and art restorations. Maria Backer
(1758–1801) was the wife of Jan van Loon Jr.

NARCISSE GARNIER

Portrait of Regnerus de Kempenaer
1805, oil on canvas, 17.3 x 15.3 inches (44 x 39 cm)

Missing since October 3, 1993
from the Museum Van Loon, Amsterdam, the Netherlands
Estimated current value: approx. $6,000

Narcisse Garnier was a portrait artist from the late eighteenth
and early nineteenth centuries. Both this and his portrait at the
top of page 168 were still in their heavy gilt frames when stolen.

NARCISSE GARNIER

Portrait of Tjallinga thoe Schwarzenberg
1805, oil on canvas, 17.3 x 15.3 inches (44 x 39 cm)

Missing since October 3, 1993
from the Museum Van Loon, Amsterdam, the Netherlands
Estimated current value: approx. $6,000

The Museum Van Loon, from which this portrait and the one of Regenerus de Kempenaer were stolen, is housed in a double canal house, built in 1672 by well-known Dutch architect Adriaan Dortsman.

JEAN-BAPTISTE OUDRY
(1668–1755)

The White Duck
1753, oil on canvas, 38.5 x 25 inches (98 x 64 cm)

Missing since September 30, 1992
from Houghton Hall, Norfolk, England
Estimated current value: $8.8 million

This work by the French painter, tapestry designer, and illustrator was stolen from Houghton Hall, an estate in Norfolk. Oudry is famous for his paintings of animals, hunt scenes, and landscapes and for his attention to detail and his interest in light and its reflection.

THOMAS GAINSBOROUGH
(1727–1788)

Portrait of William Pitt the Younger
c. 1787, oil on canvas, 30 x 25 inches (76 x 63.5 cm)

Missing since September 16, 1990
from Lincoln's Inn, London, England
Estimated current value: $380,000

The theft took place on a Sunday. The culprits tied up the security guards and cut three paintings from their frames: this portrait; Gainsborough's *Sir John Skynner*; and a portrait by Joshua Reynolds, *Francis Hargrave*. Two of the paintings were recovered some years later, but this one is still missing. Sixteen British prime ministers, including Pitt, Margaret Thatcher, and Tony Blair, were, or are still, members of Lincoln's Inn, a famous law school and society.

Jean-Baptiste Oudry, *The White Duck* (see entry, facing page)

REMBRANDT HARMENSZ VAN RIJN
(1606–1669)

Storm on the Sea of Galilee
1633, oil on canvas, 63.3 x 51 inches (161 x 129.8 cm)

Missing since March 18, 1990
from the Isabella Stewart Gardner Museum, Boston, Massachusetts
Estimated current value: priceless

This was one of eleven paintings, including two other pieces by the Dutch master (the oil-on-canvas *A Lady and Gentleman in Black* and the small etching *Self-portrait*), stolen in the biggest art theft in U.S. history, perpetrated on St. Patrick's Day in 1990. The FBI has posted a $5-million reward for the safe recovery of all of the stolen pieces in good condition.

REMBRANDT HARMENSZ VAN RIJN
(1606–1669)

A Lady and Gentleman in Black
1633, oil on canvas, 51.8 x 43 inches (131.6 x 109 cm)

Missing since March 18, 1990
from the Isabella Stewart Gardner Museum, Boston, Massachusetts
Estimated current value: priceless

A Lady and Gentleman in Black, one of eleven paintings stolen during the 1990 Gardner Museum theft, was taken from the Dutch Room Gallery. Rembrandt's mastery is evident in the fine detail of the costumes and the effect of light in this work.

JOHANNES VERMEER
(1632–1675)

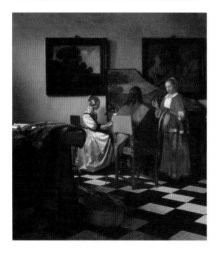

The Concert
c. 1664–1667, oil on canvas, 28.5 x 25.4 inches (72.5 x 64.7 cm)

Missing since March 18, 1990
from the Isabella Stewart Gardner Museum, Boston, Massachusetts
Estimated current value: priceless

Little is known about this Dutch painter, and only a few of his artworks have been preserved—the most famous of which is probably *Girl with a Pearl Earring*. *The Concert* is very similar to another painting by Vermeer entitled *The Music Lesson*.

ÉDOUARD MANET
(1832–1883)

Chez Tortoni
c. 1878–1880, oil on canvas, 10.2 x 13.3 inches (26 x 34 cm)

Missing since March 18, 1990
from the Isabella Stewart Gardner Museum, Boston, Massachusetts
Estimated current value: priceless

This was the only painting taken from the museum's Blue Room Gallery on the first floor. Manet's portrait depicts a well-dressed man sketching at a café table.

GOVAERT FLINCK
(1615–1660)

Landscape with an Obelisk
1638, oil on oak panel, 21.4 x 28 inches (54.5 x 71 cm)

Missing since March 18, 1990
from the Isabella Stewart Gardner Museum, Boston, Massachusetts
Estimated current value: priceless

This landscape is another of the pieces stolen in the Gardner Museum heist. It was taken from the Dutch Room Gallery. Dutch Baroque painter Govaert Flinck studied under Rembrandt in Amsterdam in 1631 and 1632. Consequently, until very recently, this landscape was attributed to Rembrandt.

LUCIAN FREUD
(1922–)

Portrait of Francis Bacon
1952, oil on metal, 7 x 5 inches (17.8 x 12.7 cm)

Missing since May 27, 1988
from the Neue Nationalgalerie, Berlin, Germany
Estimated current value: $1.5 million

The theft took place while Freud's famous portrait was on loan from London's Tate Gallery. A camera crew was in the gallery on May 27, and at 11:00 AM the portrait was still on the wall. Four hours later, staff noticed that the picture was gone. It had simply been unscrewed and pocketed. The gallery, which had no alarms and no security cameras, accepted full liability.

ANDREW WYETH

(1917–)

Moon Madness

1982, tempera, 18 x 20 inches (45.7 x 50.8 cm)

Missing since the mid-1980s

Contact lost with owner during political unrest in the Philippines
Estimated current value: approx. $3 million

In the 1980s Wyeth's office tried without success to make contact with the private collector/owner of *Moon Madness* in order to include it in the artist's catalog raisonné. The office communicated through a lawyer. No contact was made. At the time of this writing, the fate of the painting remains unknown.

PIERRE-AUGUSTE RENOIR

(1841–1919)

Jeunes femmes à la compagne

1916, oil on canvas, 16.4 x 20 inches (41 x 51 cm)

Missing since March 13, 1981

from the Musée de Bagnols-sur-Cèze, Gard, France
Estimated current value: unknown

During the last two decades of his life, Renoir suffered terribly from arthritis, which affected his painting. As is evidenced here, his style became softer and his work had sketchier outlines. Eventually, when he was unable to move his hands, a brush was strapped to his arm so that he could still paint.

ALBERT MARQUET

(1875–1947)

The Old Port of Marseille

1918, oil on canvas, 13.7 x 18 inches (38 x 46 cm)

Missing since November 12, 1972

from the Musée de Bagnols-sur-Cèze, Gard, France
Estimated current value: unknown

Marquet's painting was one of nine Impressionist works stolen that day and never recovered. Albert Marquet began his studies at L'École des Beaux-Arts in Paris. During his lifetime, he traveled extensively in France, Italy, Germany, Holland, North Africa, Russia, and Scandinavia. Consequently, he painted many harbor scenes of Marseille, Rouen, Le Havre, Venice, Naples, and Hamburg.

HENRI MATISSE
(1869–1954)

View of Saint-Tropez
1904, oil on board, 13.7 x 18.8 inches (35 x 48 cm)

Missing since November 12, 1972
from the Musée de Bagnols-sur-Cèze, Gard, France
Estimated current value: unknown

Henri Matisse's work encompassed paintings, drawings, sculptures, etchings, lithographs, paper cutouts, and book illustrations. His subjects included landscape, still life, portraiture, interiors, and the female figure. His early work showed the influence of his French compatriots Édouard Manet and Paul Cézanne. In the summer of 1904, while visiting his artist-friend Paul Signac in the fishing village of Saint-Tropez, Matisse discovered the bright light of southern France, which changed his palette.

PIERRE-AUGUSTE RENOIR
(1841–1919)

Portrait de Madame Albert André
1904, oil on canvas, 12 x 11 inches (31 x 28 cm)

Missing since November 12, 1972
from the Musée de Bagnols-sur-Cèze, Gard, France
Estimated current value: unknown

In 1868, Léon Alègre, a humanist from Bagnols, established a museum in eight rooms of the third floor of the town hall in Bagnols-sur-Cèze. It included fossils and artifacts as well as paintings. In 1917, the artist Albert André became the curator. At his instigation and thanks to the generosity of his painter friends, including Renoir, Monet, Signac, Marquet, Bonnard, and Jean Puy, the museum began to concentrate on paintings. This portrait is of André's wife.

PIERRE-AUGUSTE RENOIR
(1841–1919)

Roses in a Vase
1905, oil on canvas, 15 x 12 inches (38 x 31 cm)

Missing since November 12, 1972
from Musée de Bagnols-sur-Cèze, Gard, France
Estimated current value: unknown

Renoir studied at L'École des Beaux-Arts in Paris, where his fellow students were Monet, Sisley, and Bazille. He studied the eighteenth-century paintings in the Louvre and also met Corot and Millet. During the 1870s, he painted with Monet at Argenteuil and also came to know Cézanne, Degas, and Pissarro. Renoir's early work as a porcelain painter is reflected, in works such as this one, in his attention to decoration and craftsmanship.

Rembrandt Harmensz van Rijn
(1606–1669)

Landscape with Cottages
1654, oil on panel, 10 x 15 inches (25.4 x 39.3 cm)

Missing since September 4, 1972
from the Montreal Museum of Fine Arts, Montreal, Canada
Estimated current value: priceless

This is the most valuable painting taken during the largest theft in Canadian history. Three masked thieves entered the museum via a skylight where the alarm system had been shut down while the roof was being repaired. They fled with jewelry and eighteen paintings. Some twenty more paintings were left behind after the thieves accidentally set off a door alarm while leaving the museum.

Jean-Baptiste-Camille Corot
(1796–1875)

La rêveuse à la fontaine
c. 1855–1863, oil on canvas, 25 x 18 inches (64 x 46 cm)

Missing since September 4, 1972
from the Montreal Museum of Fine Arts, Montreal, Canada
Estimated current value: priceless

This painting, signed "Corot" in the lower-right corner, is one of two by the artist stolen during this large heist. Although known mainly for his landscapes, Corot turned to painting figures late in his career.

Jean-Baptiste-Camille Corot
(1796–1875)

Jeune fille accoudée sur le bras gauche
c. 1865, oil on canvas, 18 x 15 inches (46.3 x 38 cm)

Missing since September 4, 1972
from the Montreal Museum of Fine Arts, Montreal, Canada
Estimated current value: priceless

Corot did not make art his career until he was twenty-six years of age. In the later years of his career, he produced several paintings of young women in pensive moods.

THOMAS GAINSBOROUGH
(1727–1788)

Portrait of Brigadier General Sir Robert Fletcher
c. 1771, oil on canvas, 29.8 x 25 inches (75.8 x 63.3 cm)

Missing since September 4, 1972
from the Montreal Museum of Fine Arts, Montreal, Canada
Estimated current value: priceless

Thomas Gainsborough is considered one of the great English masters of landscape and portrait painting. At the age of thirteen, he was sent to London to pursue his art studies. His marriage to Margaret Burr, an illegitimate daughter of the Duke of Beaufort who received an annuity, allowed him to start his career as a portrait painter.

JEAN-FRANÇOIS MILLET
(1814–1875)

Portrait de Madame Millet
Oil on canvas, 13.3 x 10.4 inches (33.9 x 26.6 cm)

Missing since September 4, 1972
from the Montreal Museum of Fine Arts, Montreal, Canada
Estimated current value: priceless

French artist Millet built an early career as a portraitist, but he moved to Barbizon and joined the art movement there in 1849. In Barbizon, he converted to painting landscapes and scenes of peasants and laborers. This portrait is of his wife.

JEAN-FRANÇOIS MILLET
(1814–1875)

La baratteuse
1849–1850, oil on panel, 11.5 x 6.5 inches (29.2 x 16.5 cm)

Missing since September 4, 1972
from the Montreal Museum of Fine Arts, Montreal, Canada
Estimated current value: priceless

Millet was inspired by the social issues in France, particularly after the revolution of 1848. He stated that he wished to portray the human side of life.

FERDINAND-VICTOR-EUGÈNE DELACROIX
(1798–1863)

Lionne et lion dans une caverne
1856, oil on canvas, 15.2 x 18 inches (38.7 x 46 cm)

Missing since September 4, 1972
from the Montreal Museum of Fine Arts, Montreal, Canada
Estimated current value: priceless

Delacroix was a member of the French Romantic school of painting. He was orphaned at sixteen, and in 1816 entered L'École des Beaux-Arts in Paris. Six months spent in North Africa in 1832 inspired many of his paintings, including *The Fanatics of Tangier* (1837–1838), *The Sultan of Morocco and His Entourage* (1845), and *The Lion Hunt in Morocco* (1854).

MICHELANGELO MERISI DA CARAVAGGIO
(c. 1571–1610)

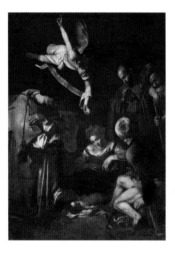

Nativity with St. Francis and St. Lawrence
1608, oil on canvas, 8.8 x 6.5 feet (268 x 197 cm)

Missing since October 1969
from the Church of San Lorenzo, Palermo, Italy
Estimated current value: $20 million

Caravaggio's *Nativity* was stolen by two thieves who entered the Oratory of San Lorenzo and removed the painting from its frame using razor blades. In 1996, a Mafia drug-runner claimed in court that he had helped carry out the heist, but that the huge canvas had been damaged and the collector who had commissioned the theft had burst into tears on seeing it and refused to take it. It is suspected that the Sicilian Mafia took the artwork.

JAN VAN EYCK
(c. 1390–1441)

The Just Judges
1427–1430, oil on wood, 57 x 20 inches (145 x 51 cm)

Missing since April 10, 1934
from the Cathedral of St. Bavo, Ghent, Belgium
Estimated current value: unknown

The Just Judges (the panel on the far left) forms part of the altarpiece known as *The Adoration of the Mystical Lamb*, painted by Flemish master Jan van Eyck. The original panel was replaced by a copy made in 1945 by Jef Vanderyken.

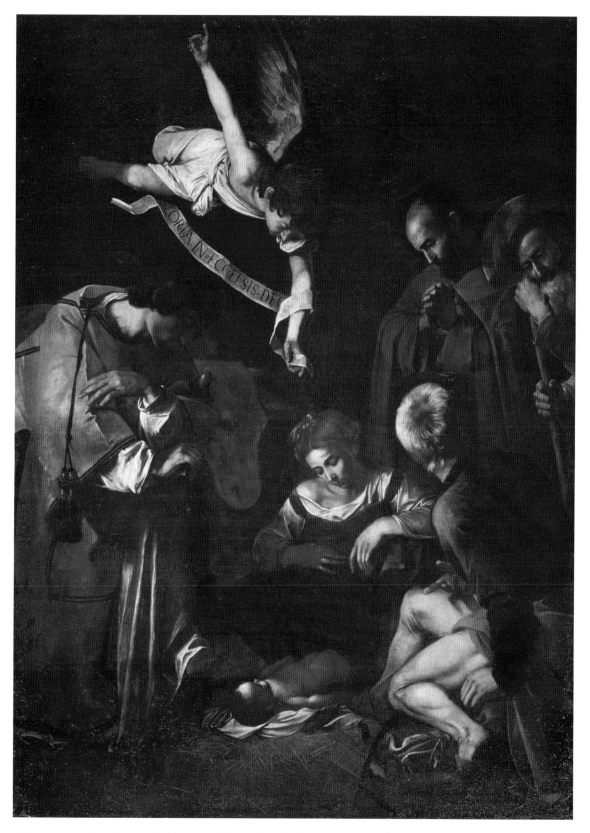

Michelangelo Merisi da Caravaggio, *Nativity with St. Francis and St. Lawrence* (see entry, facing page)

PICTURE CREDITS

Every effort has been made to correctly attribute all material reproduced in this book. If errors have unwittingly occurred, we will be happy to correct them in future editions.

1: Pieter Brueghel (the Elder), *Christ and the Woman Taken in Adultery*, oil on panel. © The Samuel Courtauld Trust, Courtauld Institute of Art Gallery, London.

2: © Photograph by Cary Wolinsky.

6: © NTB / Scanpix.

INTRODUCTION

10: Johannes Vermeer, *The Concert*, oil on canvas. © Isabella Stewart Gardner Museum, Boston, MA, U.S.A. / Bridgeman Art Library.

11: © AP.

13: Anders Zorn, *Mrs. Gardner in Venice*, oil on canvas. © Isabella Stewart Gardner Museum, Boston, MA, U.S.A. / Bridgeman Art Library.

CHAPTER ONE

14: Paul Cézanne, *Le garçon au gilet rouge*, oil on canvas. Collection of Mr. and Mrs. Paul Mellon, in honor of the 50th anniversary of the National Gallery of Art. Image © Board of Trustees, National Gallery of Art, Washington.

15: © Getty Images.

16: Pierre-Auguste Renoir, *Young Woman Seated* (*La Pensée*), oil on canvas. © The Barber Institute of Fine Arts, University of Birmingham / Bridgeman Art Library.

17: © Getty Images.

18: Vincent van Gogh, *Irises*, 1889, oil on canvas, 28 x 36.6 in. (71.1 x 93 cm). © The J. Paul Getty Museum, Los Angeles.

19: © Getty Images.

20: Pablo Picasso, *Garçon à la pipe*, 1905, oil on canvas. Artwork © Estate of Pablo Picasso / SODRAC (2006). Collection of Mr. and Mrs. John Hay Whitney, New York, U.S.A. / Bridgeman Art Library.

21: Martin Johann Schmidt, *Madonna and Child*, pen and ink on paper. © The Trustees of The British Museum. All rights reserved.

22: Godfrey Kneller, *Portrait of John Locke*, oil on canvas. © State Hermitage Museum, St. Petersburg.

23: John Wootton, *Sir Robert Walpole*. © Mary Evans Picture Library.

24: Brass plaque. © The Trustees of The British Museum. All rights reserved.

25: © HIP Science Museum, London/ Art Resource, NY.

26: © Alinari / Art Resource, NY.

27: © Bettmann / CORBIS.

28: © Scala / Art Resource, NY.

29: © Isabella Stewart Gardner Museum, Boston, MA, U.S.A.

CHAPTER TWO

30: Unknown artist, *The Lion of Nimrud*. © Scala / Art Resource, NY.

31: © Getty Images.

32: © Erich Lessing / Art Resource, NY.

33: (Top) Robert Lefèvre, *Portrait of Baron Dominique-Vivant Denon*, oil on canvas. © Réunion des Musées Nationaux / Art Resource, NY. (Bottom) Ferdinand Waschmuth, *François Joseph Lefèbvre*, oil on canvas. © Réunion des Musées Nationaux / Art Resource, NY.

34: © Réunion des Musées Nationaux / Art Resource, NY.

35: Louis-Charles-Auguste Couder, *Napoleon I Visits the Louvre, Accompanied by Architects Percier and Fontaine*. © Erich Lessing / Art Resource, NY.

36: Max Beckmann, *Carnival*, 1920, oil on canvas. Artwork © Estate of Max Beckmann / SODRAC (2006). Photograph © Tate Gallery, London / Art Resource, NY.

37: © Getty Images.

38: © Landeshauptstadt München, Germany.

39: Ernst Ludwig Kirchner, *Self-portrait with Model*, 1910, oil on canvas. © by Ingeborg & Dr. Wolfgang Henze - Ketterer Wichtrach / Bern. Photograph © Bildarchiv Preussischer Kulturbesitz / Art Resource, NY.

41: Henri Matisse, *Bathers with a Turtle*, 1908, oil on canvas. Artwork © H. Matisse Estate / SODART (Montreal) 2006. Photograph © Bridgeman Art Library.

42: Vincent van Gogh, *Self-portrait Dedicated to Paul Gauguin*, oil on canvas. © Fogg Art Museum, Harvard University Art Museums, U.S.A. Bequest from the Collection of Maurice Wertheim, Class 1906 / Bridgeman Art Library.

43: Gustav Klimt, *The Kiss*, oil and gold on canvas. © Erich Lessing / Art Resource, NY.

44: Gustav Klimt, *Portrait of Mrs. Adele Bloch-Bauer I*, oil and gold on canvas. © Erich Lessing / Art Resource, NY.

46: © Time & Life Pictures / Getty Images.

47: David Teniers (the Younger), *Archduke Leopold Wilhelm and the Artist in the Archducal Picture Gallery in Brussels*, oil on canvas. © Erich Lessing / Art Resource, NY.

48: Johannes Vermeer, *The Astronomer*, oil on canvas. © Réunion des Musées Nationaux / Art Resource, NY.

49: Raphael, *Portrait of a Young Man*. © AP.

50: Hubert and Jan van Eyck, *The Adoration of the Mystical Lamb*, oil on panel. © Erich Lessing / Art Resource, NY.

52: Johannes Vermeer, *The Art of Painting*, oil on canvas. © Erich Lessing / Art Resource, NY.

54: © Getty Images.

55: Claude Monet, *Water Lilies*. © AP.

56: © AP.

57: Dieric Bouts, *Last Supper*, oil on canvas. © Erich Lessing / Art Resource, NY.

58: Jean-Baptiste-Camille Corot, *Pensive Young Brunette*, oil on canvas. © Philadelphia Museum of Art: The Louis E. Stern Collection, 1963.

59: © Getty Images.

60: © AP.

61: © AP.

62: © MARY EVANS / MELEDIN COLLECTION.

63: (Top) Sidney Hodges, *Portrait of Heinrich Schliemann*, oil on canvas. © Bildarchiv Preussischer Kulturbesitz / Art Resource, NY. (Bottom) © Bildarchiv Preussischer Kulturbesitz / Art Resource, NY.

65: (Top) Peter Paul Rubens, *Tarquinius and Lucretia*, oil on canvas. © Courtesy of Stiftung Preußische Schlösser und Gärten Berlin-Brandenburg. (Bottom) © AFP / Getty Images.

66: © Bildarchiv Preussischer Kulturbesitz / Art Resource, NY.

68: © AP.

69: Pablo Picasso, *Femme en blanc*, 1922. Artwork © Estate of Pablo Picasso / SODRAC (2006). Photograph © AP.

CHAPTER THREE

70: Francisco José de Goya, *Duke of Wellington*, oil on mahogany. © Erich Lessing / Art Resource, NY.

71: Claude Monet, *San Giorgio Maggiore by Twilight*, oil on canvas. © National Museum and Gallery of Wales, Cardiff / Bridgeman Art Library.

72: © Getty Images.

73: (Top) Rembrandt Harmensz van Rijn, *Storm on the Sea of Galilee*, oil on canvas. © Isabella Stewart Gardner Museum, Boston, MA, U.S.A. / Bridgeman Art Library. (Bottom) Pablo Picasso, *Poverty*, 1903, pen and ink and watercolor. Artwork © Estate of Pablo Picasso / SODRAC (2006). Photograph © Whitworth Art Gallery, The University of Manchester, U.K. / Bridgeman Art Library.

74: Thomas Gainsborough, *Portrait of Georgiana, Duchess of Devonshire*, oil on canvas. © The Devonshire Collection, Chatsworth. Reproduced by permission of the Chatsworth Settlement Trustees.

75: Image courtesy of the Pinkerton National Detective Agency Collection, Prints & Photographs Division, Library of Congress, PR 13 CN 2001:141.

76: Paul Gauguin, *Vase de fleurs*, oil on canvas. Image courtesy of the Federal Bureau of Investigation.

79: François Boucher, *Sleeping Shepherd*, oil on canvas. © Réunion des Musées Nationaux / Art Resource, NY.

80: © AP.

81: Lucas Cranach (the Elder), *Sybille, Princess of Cleves*, oil on panel. © Schlossmuseum, Weimar, Germany / Bridgeman Art Library.

82: Benvenuto Cellini, *Saliera*, gold, niello, and ebony. © Nimatallah / Art Resource, NY.

83: Leonardo da Vinci, *Mona Lisa*, oil on wood. © Réunion des Musées Nationaux / Art Resource, NY.

84: © Roger Viollet / Getty Images.

85: Auguste Rodin, *The Trunk of Adele*, bronze. © AP.

86: © Seth Joel / CORBIS.

87: © Image courtesy of Clara Peck Collection, Transylvania University Library, Lexington, Kentucky.

88: Henry Moore, *Reclining Figure*, bronze. © Reproduced by permission of the Henry Moore Foundation / photograph by Michael Phipps.

89: Pablo Picasso, *Nude Before a Mirror*, 1932. Artwork © Estate of Pablo Picasso / SODRAC (2006). Photograph © AP.

90: Claude Monet, *Customs Officer's Cabin at Pourville*. © AP.

92: Marc Chagall, *Study for Over Vitebsk*, 1914, oil on canvas. Artwork © Estate of Marc Chagall / SODRAC (2006). Digital Image © The Museum of Modern Art / Licensed by SCALA / Art Resource, NY.

93: © Photograph courtesy of Jonathan Player.

94: Johannes Vermeer, *The Love Letter*, oil on canvas. © Rijksmuseum Amsterdam.

95: Johannes Vermeer, *Lady Writing a Letter with Her Maid*, oil on canvas. © Bridgeman Giraudon / Art Resource, NY.

97: Thomas Gainsborough, *Madame Bacelli*, oil on canvas. The Beit Collection. Reproduced by permission of the Alfred Beit Foundation. Photograph © The National Gallery of Ireland.

98: Leonardo da Vinci, *Madonna with the Yarnwinder*, oil on wood. © By kind permission of His Grace the Duke of Buccleuch & Queensberry, KT.

99: © Reuters / CORBIS.

100: Edvard Munch, *Madonna*, 1893–1894, oil on canvas. Artwork © The Munch Museum / Munch-Ellingsen Group / SODART (Montreal) 2006. Photograph © The Munch Museum (Andersen / de Jong).

103: © AP.

CHAPTER FOUR

104: Rembrandt Harmensz van Rijn, *Self-portrait*, oil on copper. © The National Museum of Fine Arts, Stockholm, Sweden / Bridgeman Art Library.

105: © Reuters / CORBIS.

106: "El" Lazar Markovich Lissitzky, Untitled, c. 1920–1929, photograph. Artwork © Estate of Lazar Lissitzky / SODRAC (2006). Image courtesy of the LAPD Art Theft Detail.

107: © AP.

109: Pierre-Auguste Renoir, *Conversation*, oil on canvas. © The National Museum of Fine Arts, Stockholm, Sweden.

110: Pierre-Auguste Renoir, *Young Parisian*, oil on canvas. © The National Museum of Fine Arts, Stockholm, Sweden.

112: © AFP / Getty Images.

113: © AFP / Getty Images.

115: © Firstlight / Bernard Weil / Toronto Star.

118: Gabriel Metsu, *Man Writing a Letter*, oil on canvas. © The National Gallery of Ireland. Photograph by Roy Hewson.

119: Francisco José de Goya, *Portrait of Doña Antonia Zárate*, oil on canvas. © The National Gallery of Ireland. Photograph by Roy Hewson.

121: Caspar David Friedrich, *Waft of Mist*, oil on canvas. © Hamburger Kunsthalle, Hamburg, Germany / Bridgeman Art Library.

122: J.M.W. Turner, *Shade and Darkness—The Evening of the Deluge*, oil on canvas. © Clore Collection, Tate Gallery, London / Art Resource, NY.

123: J.M.W. Turner, *Light and Colour—The Morning after the Deluge*, oil on canvas. © Clore Collection, Tate Gallery, London / Art Resource, NY.

125: See page 125.

127: Édouard Manet, *Chez Tortoni*, oil on canvas. © Isabella Stewart Gardner Museum, Boston, MA, U.S.A. / Bridgeman Art Library.

129: Lucian Freud, *Portrait of Francis Bacon*, oil on metal. Reproduced by permission from Lucian Freud. Photograph © Tate Gallery, London / Art Resource, NY.

130: Rembrandt Harmensz van Rijn, *Portrait of Man with Red Cap and Gold Chain*. © AP.

131: Andrew Wyeth, *The Studio*, watercolor. Courtesy of Frank E. Fowler. © Andrew Wyeth.

CHAPTER FIVE

132: © Photograph by Cary Wolinsky.

133: Edvard Munch, *The Scream*, 1893, oil on board.

Group / **SODART** (Montreal) 2006. Photograph © The Munch Museum (Andersen / de Jong).

134: © Getty Images.

135: © AP.

136: © AFP / Getty Images.

137: © AP.

138: © AP.

139: Unknown artist, *Expulsion from the Garden of Eden.* Photograph courtesy of the San Diego Museum of Art.

140: © AP.

141: © AP.

142: Jean-Baptiste-Camille Corot, *Le chemin de Sèvres*, oil on canvas. © Louvre, Paris, France / Bridgeman Art Library.

143: © AP.

145: © Alexandra Boulat / VII / AP.

GALLERY OF MISSING ART

146: Henri Matisse, *Luxembourg Gardens*, 1904. Artwork © H. Matisse Estate / **SODART** (Montreal) 2006. Photograph © Museus Castro Maya, Rio de Janeiro, Brazil / Bridgeman Art Library

147: See entry for page 146.

148: (Top) Claude Monet, *Marine.* © Museus Castro Maya, Rio de Janeiro, Brazil. (Middle) August Strindberg, *Night of Jealousy.* © Erich Lessing / Art Resource, NY. (Bottom) Pablo Picasso, *Femme regardant par la fenêtre*, 1959. Artwork © Estate of Pablo Picasso / **SODRAC** (2006). Photograph © Courtesy of Modern Masters Fine Art, Palm Desert, CA.

149: See middle entry for page 148.

150: (Top) Marc Chagall, *The Tribe of Dan*, 1964. Artwork © Estate of Marc Chagall / **SODRAC** (2006). Photograph © Courtesy of Modern Masters Fine Art, Palm Desert, CA. (Middle) See entry for page 88. (Bottom) Jacob Waben, *Vanitas.* © Courtesy of the Westfries Museum, the Netherlands.

151: (Top) Matthias Withoos, *Harbour in Hoorn (1).* © Courtesy of the Westfries Museum, the Netherlands. (Middle) Matthias Withoos, *Harbour in Hoorn (2).* © Courtesy of the Westfries Museum, the Netherlands. (Bottom) Jan Claesz Rietschoof, *View on the Oostereiland (Hoorn).* © Courtesy of the Westfries Museum, the Netherlands.

152: (Top) Herman Henstenburgh, *Still-life, Memento Mori.* © Courtesy of the Westfries Museum, the Netherlands. (Middle) Herman Henstenburgh, *Untitled.* © Courtesy of the Westfries Museum, the Netherlands. (Bottom) Workshop of Donatello, *The Virgin and Child in a Niche.* © AP.

153: (Top) Emile Gallé, *Dragonfly Bowl.* © Musée Ariana, Geneva, Switzerland. Photograph © Jacques Pugin, Geneva, Switzerland. (Middle) See entry for page 133. (Bottom) See entry for page 100.

154: (Top) Parmigianino, *The Holy Family.* © AP. (Middle) Giuseppe Cesari, *Flagellazione.* © AP. (Bottom) See entry for page 98.

155: See top entry for page 154.

156: See middle entry for page 157.

157: (Top) See entry for page 30. (Middle) Vincent van Gogh, *Congregation Leaving the Reformed Church in Nuenen.* © Getty Images. (Bottom) Vincent van Gogh, *View of the Sea at Scheveningen.* © Getty Images.

158: (Top) Henri Matisse, *Odalisque in Red Pants,* 1925. Artwork © H. Matisse Estate / **SODART** (Montreal) 2006. Private Collection / Bridgeman Art Library. (Middle) Maxfield Parrish, *Gertrude Vanderbilt Whitney Mansion Murals, Panel 3A,* 1912–1916. Artwork © VAGA (New York) / **SODART** (Montréal) 2006. Photograph © Private collection. (Bottom) Maxfield Parrish, *Gertrude Vanderbilt Whitney Mansion Murals, Panel 3B,* 1912–1916. Artwork © VAGA (New York) / **SODART** (Montréal) 2006. Photograph © Private collection.

159: (Top) Alberto Giacometti, *Figurine (sans bras),* 1956. Artwork © Estate of Alberto Giacometti / **SODRAC** (2006). Photograph © Bildarchiv Preussischer Kulturbesitz / Art Resource, NY. (Middle) Cornelius Dusart, *Drinking Bout.* Frans Hals Museum, Haarlem, the Netherlands. (Bottom) Adriaen van Ostade, *Drinking Peasant in an Inn.* Frans Hals Museum, Haarlem, the Netherlands.

160: (Top) Cornelius Bega, *Festive Company before an Inn.* Frans Hals Museum, Haarlem, the Netherlands. (Middle) Jean-Léon Gérôme, *Pool in the Harem.* © Hermitage, St. Petersburg, Russia / Bridgeman Art Library. (Bottom) Howard Pyle, *The Battle of Bunker Hill.* © Delaware Art Museum.

161: See middle entry for page 160.

162: Claude Monet, *Beach in Pourville.* © Courtesy of the National Museum, Poznań, Poland.

163: (Top) See entry for page 162. (Middle) Thomas Sully, *Portrait of Frances Keeling Valentine Allan.* © Valentine Richmond History Center. (Bottom) Paul Cézanne, *Near Auvers-sur-Oise.* © Ashmolean Museum, University of Oxford, U.K. / Bridgeman Art Library.

164: (Top) See entry for page 142. (Middle) Gustav Klimt, *Portrait of a Woman.* © Scala / Art Resource, NY. (Bottom) Georges Braque, *Still Life,* 1928. Artwork © Estate of Georges Braque / SODRAC (2006). Photograph © Moderna Museet, Stockholm, Sweden.

165: See middle entry for page 164.

166: Narcisse Garnier, *Portrait of Regnerus de Kempenaer.* © Courtesy of the Museum Van Loon, Amsterdam, the Netherlands.

167: (Top) Louis-Bernard Coclers, *Portrait of Jan van Loon Jr.* © Courtesy of the Museum Van Loon, Amsterdam, the Netherlands. (Middle) Louis-Bernard Coclers, *Portrait of Maria Backer.* © Courtesy of the Museum Van Loon, Amsterdam, the Netherlands. (Bottom) See entry for page 166.

168: (Top) Narcisse Garnier, *Portrait of Tjallinga thoe Schwarzenberg.* © Courtesy of the Museum Van Loon, Amsterdam, the Netherlands. (Middle) Jean-Baptiste Oudry, *The White Duck.* © Private collection / Bridgeman Art Library. (Bottom) Thomas Gainsborough, *Portrait of William Pitt the Younger.* By kind permission of the Treasurer and Masters of the Bench of Lincoln's Inn. Photograph © Photographic Survey, Courtauld Institute of Art.

169: See middle entry for page 168.

170: (Top) See entry for page 73. (Middle) Rembrandt Harmensz van Rijn, *A Lady and Gentleman in Black.* © Isabella Stewart Gardner Museum, Boston, MA, U.S.A. / Bridgeman Art Library. (Bottom) See entry for page 10.

171: (Top) See entry for page 127. (Middle) Govaert Flinck, *Landscape with an Obelisk.* © Isabella Stewart Gardner Museum, Boston, MA, U.S.A. / Bridgeman Art Library. (Bottom) See entry for page 129.

172: (Top) Andrew Wyeth, *Moon Madness.* © Andrew Wyeth. (Middle) Pierre-Auguste Renoir, *Jeunes femmes á la compagne.* © Musée des Beaux-Arts et d'Archéologie, Besançon, France, Lauros / Giraudon / Bridgeman Art Library. (Bottom) Albert Marquet, *The Old Port of Marseille,* 1918. Artwork © Estate of Albert Marquet / SODRAC (2006). Image © Courtesy of the Musée de Bagnols-sur-Cèze, France.

173: (Top) Henri Matisse, *View of Saint-Tropez,* 1904. Artwork © H. Matisse Estate / SODART (Montreal) 2006. (Middle) Pierre-Auguste Renoir, *Portrait de Madame Albert André.* Musée Albert André, Bagnols-sur-Cèze, France, Giraudon / Bridgeman Art Library. (Bottom) Pierre-Auguste Renoir, *Roses in a Vase.* © Réunion des Musées Nationaux / Art Resource, NY.

174: (Top) Rembrandt Harmensz van Rijn, *Landscape with Cottages.* Reproduced by permission from the Montreal Museum of Fine Arts. Photograph © The Montreal Museum of Fine Arts. (Middle) Jean-Baptiste-Camille Corot, *La rêveuse à la fontaine.* Reproduced by permission from the Montreal Museum of Fine Arts. Photograph © The Montreal Museum of Fine Arts. (Bottom) Jean-Baptiste-Camille Corot, *Jeune fille accoudée sur le bras gauche.* Reproduced by permission from the Montreal Museum of Fine Arts. Photograph © The Montreal Museum of Fine Arts.

175: (Top) Thomas Gainsborough, *Portrait of Brigadier General Sir Robert Fletcher.* Reproduced by permission from the Montreal Museum of Fine Arts. Photograph © The Montreal Museum of Fine Arts. (Middle) Jean-François Millet, *Portrait de Madame Millet.* Reproduced by permission from the Montreal Museum of Fine Arts. Photograph © The Montreal Museum of Fine Arts. (Bottom) Jean-François Millet, *La baratteuse.* Reproduced by permission from the Montreal Museum of Fine Arts. Photograph © The Montreal Museum of Fine Arts.

176: (Top) Ferdinand-Victor-Eugène Delacroix, *Lionne et lion dans une caverne.* Reproduced by permission from the Montreal Museum of Fine Arts. Photograph © The Montreal Museum of Fine Arts. (Middle) Michelangelo Caravaggio, *Nativity with St. Francis and St. Lawrence.* © Scala / Art Resource, NY. (Bottom) Jan van Eyck, *The Just Judges.* © Erich Lessing / Art Resource, NY.

177: See middle entry for page 176.

INDEX

All references to images and captions are indicated in italics.

A

Abetz, Otto, 54
Academy of Arts, 36
Albertina Museum, 33
Alègre, Léon, 173
Alexander Palace, 59
Allen, Charles T. III, 87
Altmann, Fritz, 43
Altmann, Maria, 43, *44*, 67–68, *68*
Amber Room, 59–61, *60*
American Association of Museums, 68, 134
Amherst College, 102
Anderson, Robert, 28
André, Albert, 173
Andreossi, Antoine François, 33
Andy Warhol Foundation, 115
antiquities, illicit trade in, 141, *141*
Applied DNA Sciences, 138
art dealers, role of, 18
Art Gallery of Ontario, 115, *115*
artifacts
 ivory reliefs, 115, *115*
 Parthenon frieze, *28*
 in Priam remains, 63
 religious, 49–50, *50*, 66, *66*
 theft of, 64–67, 80, 157
Art Loss Register (ALR), 113
art sales
 methods, 16
 prices, 20

Ashmolean Museum, 163
Atta, Mohammed, 31
auctioneers, role, 16
auction houses, 16, 18. *See also* Christie's, Sotheby's
Audubon, John James, 87
 Birds of America, 86
 Viviparous Quadrupeds of North America, 86
Australia, thefts in, 116
Austria, thefts in, 80, 82

B

Bacon, Francis, 129, *129*, 171, *171*
Bakwin, Michael, 113
Beckman, Walter. *See* Lipka, Walter C.
Beckmann, Max
 Carnival, 36
 works by, stolen, 38
Bega, Cornelius
 Festive Company before an Inn, 160, 160
 works by, stolen, 160
Beit, Lady Clementine, 96, 98
Beit, Sir Alfred, 96, 98
Belgium, thefts in, 80, 95, 176
Belvedere Gallery, 67
Benin, kingdom of, *24,* 25–26
Bennigson, Tom, 69
Beranger, Antoine, *34*
Berenson, Bernard, 29
Berlin State Museums, 29, 49
Betts, Harold
 works by, stolen, 84

Bloch-Bauer, Adele, *43, 44, 68*
Bloch-Bauer, Ferdinand, 43–45, 67
Bonaparte, Charles Lucien
 American Ornithology, 86
Bonaparte, Napoleon
 art theft by, 32–34
books, as targets for theft, 84–87
Borsuk, Eric, 87
Boston Museum of Fine Arts, 103
Boucher, François
 Sleeping Shepherd, 79, 80
 works by, stolen, 47, 79, 80
Bouilloire et fruits, 113, *113*
Bouts, Dieric
 Last Supper, 50, 56, *57*
Boyd, Arthur, 116
Braque, Georges
 burning of works by, 40
 Still Life, 164, *164*
Brazil, thefts in, 147, 148
Breitwieser, Stephane, 77–83, *79, 81*
British Council, 129, *129*
British Museum, 21, 26, 28, 29, 34
Brooklyn Museum, *138*
Brosnan, Pierce, 71, 102
Brown, Susan, 86
Bruce, Thomas. *See* Elgin, Earl of
Brueghel, Pieter (the Elder)
 works by, stolen, 12
Brueghel, Pieter (the Younger)
 Cheat Profiting from His Master, 80
 works by, stolen, 80
Bulger, Whitey, 124
burning, of art, 40

C

Cahill, Martin, 96–101, 110, 117

Canada, thefts in, 12, 115, 174, 175, 176

Caravaggio
 Nativity with St. Francis and St. Lawrence, 176, *176*, *177*
 works by, stolen, 13, 176

Cathedral of St. Bavo, 176

Catherine Palace, 59, *60*, 61

Catherine the Great, 25, 59

Cellini, Benvenuto
 Saliera, 82, *82*
 works by, stolen, 82, *82*

Cesari, Guiseppe
 Flagellazione, 154, *154*
 works by, stolen, 154

Cézanne, Paul, 173
 Bouilloire et fruits, 113, *113*
 Le garçon au gilet rouge, 14, 17, 18
 Near Auvers-sur-Oise, 163, *163*
 Son in a High Chair, 116
 Sotheby's 1958 sale, 15
 works by, stolen, 13, 113, *113*, 116

Chácara do Céu Museum, 147, 148

Chagall, Marc
 Study for Over Vitebsk, 92, *92*
 The Tribe of Dan, 148, 150, *150*
 works by, stolen, 38, 92, *92*, 116, 148, 163, *163*

Chile, thefts in, 84

Christie's
 annual sales, 18
 identifying stolen art, 130
 Parmigianino appraisal, 116
 rivalry with Sotheby's, 18, 19
 sale of Audubon books, 86–87
 sale of Gauguin forgery, 76
 Smith, Harold J., 125

Church of San Lorenzo, 176

Cleveland Museum of Art, 103

Coclers, Louis-Bernard
 Portrait of Jan van Loon Jr., 167, *167*
 Portrait of Maria Backer, 167, *167*

Connery, Sean, 71, 72

Connor, Myles Jr., 102

Constable, John
 works by, stolen, 13

Cooperman, Steven, 89–91

Corot, Jean-Baptiste-Camille, 78
 Jeune fille accoudée sur le bras gauche, 174, *174*
 La rêveuse à la fontaine, 174, *174*
 Le chemin de Sèvres, 12, *142*, 164, *164*
 Pensive Young Brunette, 58
 works by, stolen, *12*, *58*, 174

Couder, Louis-Charles-Auguste, 35

Cranach, Lucas (the Elder)
 Sybille, Princess of Cleves, 80, *81*

Czartoryski Mueum, 49

Czernin, Count Jaromir, 51–53

D

Dalí, Salvador
 destruction of stolen art, 128
 Two Balconies, 147
 works by, stolen, 13, 147

Dalkeith, Richard, 99

Dalrymple, Mark, 114, 120, 124
 damage to artwork, 65, *65*, 73, *94*, *136*

Darwin, Charles, 87

da Vinci, Leonardo
 Codex Leicester, 84, 86
 Madonna with the Yarnwinder, 98, *98*, *105*, 105–107, 154, *154*
 Mona Lisa, 19, 56, 83, *83*, 84, *84*, 135, *135*, *145*
 Portrait of a Lady with an Ermine, 49
 works by, stolen, 13, 83, *83*, 84, 98, *98*, 99, 154

Davis, Pamela, 91

Dealing in Cultural Objects Act, 144

Degas, Edgar
 works by, stolen, 13

Degenerate Art exhibition, 37, 38, *38*, 40

Delacroix, Ferdinand
 The Lion Hunt in Morocco, 176
 Lionne et lion dans une caverne, 176, *176*
 The Sultan of Morocco and His Entourage, 176
 works by, stolen, 12, 176

de la Haye, Corneille
 Madeleine of France, Queen of Scotland, 80
 works by, stolen, 80

Delaware Art Museum, 160

Denmark, thefts in, 80

Denon, Dominique-Vivant, 33, *33*, 34
 destruction of artwork, 40, 80, 128

de Valfierno, Eduardo, 84

Devonshire, Duchess of, *74*, 75, *75*, 76, 77

Dietrich, Christian Wilhelm, 78

Donatello
 The Virgin and Child in a Niche, 152, *152*
 works by, stolen, 152

Dortsmann, Adriaan, 168

Douglas, Kirk, 16

Dresden Art Gallery, 51

Dreyfus, Rebecca, 125, *125*

Drumlanrig Castle, 98, *99*, 105, *105*, 154

Dugdale, Rose, 95–96, 98

Dürer, Albrecht, 33
 works by, stolen, 13, 64–67

Dusart, Cornelius
 Drinking Bout, 159, *159*
 works by, stolen, 159

Düsseldorf Academy of Fine Arts, 36

Duveen, Joseph, 20–28, *27*, *29*

Duveen Brothers, 27

Duveen Gallery, 26

E

Edenhurst Gallery, 158

Egypt, artifacts stolen from, 93, *93*

Einsatzstab Reichsleiter Rosenberg (ERR), 46

Elgin, Earl of, *25*, 26, *26*

Elgin Marbles, 21, 26–29, *28*, 29, 34

El Greco, 54

Elicofon, Edward, 64–67

Elizabeth II (queen of England), 16

Ellis, Dick, *105*, 126

England, thefts in, 73, 75–77, 84, 88, 163, 168

Entrapment, 71

Erie International, 113

F

fakes. *See* forgeries

Farouk, king of Egypt, 16

Federal Bureau of Investigation (FBI), 72, 91, 105, 107, 110, 117, 124–126, 128, 170

Feldmann, Arthur, 21, *21*

Feldmann, Gisela, 21

Feliciano, Hector, 69

Ferguson, Mike, 115

Fine Arts Museum, 95

Flinck, Govaert

 Landscape with an Obelisk, 171, *171*

 works by, stolen, 11

Fonteyn, Margot, 16

forgeries, 76, *76,* 125, 158

Four Horses of San Marco, 32, *32, 33*

Fragonard, Jean-Honoré, 21

 works by, stolen, 47

France

 looting in China, 25

 thefts in, 12, 80, 83, 164, 172, 173

François I (king of France), 82, 83

Frank, Hans, 49

Frans Hals Museum, 159, 160

Freud, Lucian, 129, *129*

 Portrait of Francis Bacon, 129, 171, *171*

Frick, Henry Clay, 27

Friedrich, Caspar David

 Waft of Mist, 121

 works by, stolen, 121

Funk, Walther, 54

G

Gainsborough, Thomas, 75–77

 Portrait of Brigadier General Sir Robert Fletcher, 175, 175

 Portrait of Georgiana, Duchess of Devonshire, 74

Portrait of Madame Bacelli, 96, *97*

Portrait of William Pitt the Younger, 168, *168*

Sir John Skynner, 168

works by, stolen, 12, 75–77, 96, *97,* 175

Gallé, Emile

 Dragonfly Bowl, 153, *153*

 works by, stolen, 153

Galleria Ricci Oddi, 164

Gardner, Isabella Stewart, 12, 13, *13,* 29, 101. *See also* Isabella Stewart Gardner Museum

Garnier, Narcisse

 Portrait of Regnerus de Kempenaer, 166, 167, 167

 Portrait of Tjallinga thoe Schwarzenberg, 168, *168*

Gates, Bill, 84

Gauguin, Paul

 Tahitian Landscape, 73

 Vase de fleurs, 76, *76*

 works by, forged, 76, *76*

 works by, stolen, 40, 73

Geiger, Ernst, 82

Geneva Conventions (1949), 62

George III (king of England), 77

Georgia O'Keeffe Museum, 128

Germany, thefts in, 80, 121, 129, 159, 171

Gérôme, Jean-Léon

 Pool in the Harem, 160, *160, 161*

 works by, stolen, 160, 161

Ghent Altarpiece, 49–50, 56

Giacometti, Alberto

 Figurine (sans bras), 159, *159*

 works by, stolen, 159

Goebbels, Joseph, 36–38, *37,* 49

Goering, Hermann, 43, 53, *54,* 54–56, *56,* 68

Goethe, J.W., *122*

Goldschmidt, Jakob, 15–16, *16*

Gooch, B.J., 86

Goudstikker, Jacques, 68

Goya, Francisco José de, *70*

 The Duke of Wellington, 70, 71, *71*

Portrait of Doña Antonia Zárate, 117, *119*

recovered works, 120

works by, stolen, 47, 70, 117

Great Britain, looting in China, 25–26. *See also* England, Scotland

Guggenheim Museum, 29

Guinness Book of World Records, 19

H

Haddasah Hospital, 150

Hague Conventions, 62

Halloran, Melanie, 86, 87

Hamburg Museum, 159

Hasan, Mushin, *31*

Hearst, William Randolph, 27

Hecht, Emanuel Robert, 103

Henry Moore Foundation, 150

Henry VII (king of England), *87*

Henstenburgh, Herman

 Still life, Memento Mori, 152, *152*

 Untitled, 152, *152*

 works by, stolen, 152

Hermitage Museum, 25, 29, 62, 64, 160

Hill, Charley, 112–120, 124

Himmler, Heinrich, 54

Hitler, Adolf, 36, *36,* 38, *54,* 56

 art collection, 47, *48,* 50, 53

 and House of German Art, 37, *37*

 museum plans, 51

Hofer, Walter Andreas, 54

Hofstra University, 88

Houghton Hall, 168

House of German Art, 37, *37*

Hrycyk, Don, 126–128, 130

Hughes, Robert, 18

Hussein, Saddam, 31

I

Ingres, Jean

 Baroness Betty de Rothschild, 47

insurance fraud, 89–91

Internet, role of, 106

Interpol, 12

Iraq, thefts in, *30,* 31, *31,* 157

Iraq National Museum, 31, *31,* 157

Ireland, thefts in, 95–98, 99–101
Isabella Stewart Gardner Museum,
 124–126, *132*, *134*, 135, 142, 171
 thefts from, *11*, 11–12, 73, *73*, *127*,
 170
Italy, thefts in, 103, 154, 164, 176

J
J. Paul Getty Museum, *18*, 103, *103*, 120
Jeu de Paume museum, 46, 47, 54
Jewish Museum, 92
Johansson, Thomas, 108

K
Kadhum, Baha, 110, 111–112
Kadhum, Dieya, 110, 112
Kaiser Frederick Museum, 50
Kandinsky, Wassily
 works by, stolen, 38
Kann, Alphonse, *58*
Keller, Steve, 143
Kennedy, Edward, 142
Kirchner, Ernst Ludwig
 Self-portrait with Model, 39
Klee, Paul, 36
 works by, stolen, 38
Kleinklauss, Anne-Catherine, 78
Klimt, Gustav
 The Kiss, 43, *43*
 Portrait of a Woman, 164, *164*, *165*
 Portrait of Mrs. Adele Bloch-Bauer I,
 44, 67, *68*
 works by, stolen, 67
Kneller, Godfrey, *22*
Koenigs, Franz, 47–49, 51
Kokoschka, Oskar
 works by, stolen, 38
Kümmel, Otto, 49
Kunsthistorisches Museum, 53, 82

L
Lacey, Robert, 22
Landsberg, Carlotta, 69
Laocoon, statue of, 33, *34*
Last Supper, 50, 56, *57*
Lawrence, Mike, 121

Leader, Darian, 135
Leary, Denis, 144
L'École des Beaux-Arts, 172, 173, 176
Lefébvre, François, 33, *33*
Lefèvre, Robert, *33*
Léger, Fernand, 40
Le Marchand, David, 115
Liebrucks, Edgar, 121
Lincoln's Inn, 168
Lipka, Walter C., 84–87
Lissitzky, "El" Lazar Markovich, 106,
 106
Little, James, 91
Lloyd's of London, 89, *89*, 91, 113, 125,
 125
Locke, John, *22*
Lodge, Henry Cabot, 160
Logvinenko, Vladimir, 64
Los Angeles County Museum of Art,
 89
Los Angeles Police Department, 106
Louvre Museum, 19, 29, 46, 47, *48*, 56,
 84, *84*, 135, *135*, 145, 164, 173
 looted art in, 33
 thefts from, 12, 83, *83*
Luce Center for American Art, *138*

M
Macintyre, Ben, 75
Manet, Édouard, 173
 Chez Tortoni, *127*, 171, *171*
 Sotheby's 1958 sale, 15
 works by, stolen, 13, 171
Mang, Robert, 82
Mannheimer, Fritz, 51
Marlborough Gallery, 158
Marquet, Albert
 The Old Port of Marseille, 172, *172*
 works by, stolen, 172
Masson, André, 40
Matisse, Henri
 Bathers with a Turtle, 40, *41*
 Luxembourg Gardens, *146*, 147, *147*
 Odalisque, 69
 Odalisque in Red Pants, 158, *158*
 View of Saint-Tropez, 173, *173*

works by, stolen, 13, 40, 69, 147,
 158, 173
Maugham, Somerset, 16
Mazzola, Francesco. *See* Parmigianino
Meador, Joe Tom, 64, 66
Medici, Giacomo, 103
Mellon, Andrew, 27, *27*
Metropolitan Museum of Art, 29, 53,
 71, 103
Metsu, Gabriel
 Man Writing a Letter, 117, *118*
 works by, stolen, 117
Mexico, thefts in, 139
M.H. de Young Museum, 130
Millet, Jean-François
 La baratteuse, 175, *175*
 Portrait de Madame Millet, 175,
 175
 works by, stolen, 175
Miró, Jóan
 works by, stolen, 13
Moderna Museet, 164
Modern Masters Fine Art Gallery, 148,
 150
Modigliani, Amedeo
 works by, stolen, 38
Monet, Claude
 Beach in Pourville, *162*, 163, *163*
 *Customs Officer's Cabin at
 Pourville*, 89, *90*
 Marine, 147, 148, *148*
 San Giorgio Maggiore by Twilight,
 71, *71*
 Water Lilies, 113
 works by, stolen, 13, 54, *55*, 71, *71*,
 147, 148, 163
Montpellier Museum, 80
Montreal Museum of Fine Arts, 12,
 174, 175, 176
Moore, Henry
 Reclining Figure, 88, *88*, 150, *150*
Morgan, J.P., 27
Morgan, Junius Spencer, 75
Morritt, Andrew, 21
 motives, for thefts, 87, 92–96, 101,
 102, 111, 128

Müller-Westermann, Iris, 133–134
Mulvihill, Niall, 117, 120
Munch, Edvard
 Madonna, 12, 100, 135, 153, *153*
 recovered works, 120
 The Scream, 12, 73, 95, 100, 101,
 120, 133, *133*, 135, 153, *153*
 works by, stolen, 12, 38, 73, 95, *100*
Munch Museum, 73, 100, 101, 133, 135,
 137, 153
 security at, 143, *143*
 thefts from, 12
Musée de Bagnols-sur-Cèze, 172, 173
Musée D'Orsay, 19
Museum of Fine Arts, 113
Museum of Modern Art, 29, 115, 125
museums, security in, 20
Museum Van Loon, 167, 168

N
Nairne, Sandy, 121
National Art Gallery, 137
National Gallery (London), 27, 70, 71,
 71, 131
National Gallery (Oslo), 95, 153
National Gallery of Art, *17*
National Gallery of Ireland, *95*
National Museum, 107, *109*, 112, *112*
National Museum of Fine Arts, 84, *85*
National Physical Laboratory, 138
Nazi Party, thefts by, 69, 113
Netherlands, thefts in, 80, 150, 151,
 152, 157, 159, 160, 167, 168
Neue Nationalgalerie, 129, 171
Neumann Foundation, 153
Nigeria, reclamation of brasses, 26
Nolde, Emil, 36
Nordstern Allgemeine Versicherungs,
 89, 91
Norway, thefts in, 12, 95, 100, 101, 133,
 153

O
Office Central de lutte contre le trafic
 des Biens Culturels (OCBC), 138

Office of Strategic Services (OSS),
 50–53
O'Keeffe, Georgia
 Red Canna, 128
Onfray, Luis, *85*
Oudry, Jean-Baptiste
 The White Duck, 168, *168*, 169

P
Pakistan, smuggling of antiquities
 from, *141*
Parmigianino, 21, 114, 116
 The Holy Family, 154, *154*, *155*
 works by, stolen, 154
Parrish, Maxfield
 *Gertrude Vanderbilt Whitney
 Mansion Murals, Panel 3A*, 158,
 158
 *Gertrude Vanderbilt Whitney
 Mansion Murals, Panel 3B*, 158,
 158
 works by, stolen, 158
Pavia, Philip
 The Ides of March, 88
Peale, Charles Willson, 22
Peruggia, Vincenzo, *83*, 83–84, *84*, 135
Peter the Great, 59
Philippines, thefts in, 172
Phillips, "Junka," 75
 photography, 106, *106*
Picasso, Pablo
 burning of works by, 40
 Dance, 147
 Femme en blanc, 69, *69*
 Femme regardant par la fenêtre,
 148, *148*
 Garçon à le pipe, 20, *20*
 Nude Before a Mirror, 89, *89*
 Poverty, 73, *73*
 works by, stolen, 13, 38, 40, 69, *69*,
 73, *73*, 147, 148
Pissarro, Camille
 works by, stolen, 13, 38, 116
Pitti Palace, 45
Poland, thefts in, 163
Polish National Museum, 163

Pollock, Jackson
 works by, stolen, 13
Posse, Hans, 51–53
Prado Museum, 29
Princeton University Art Museum, 103
Pulitzer, Joseph Jr., 40
Putin, Vladimir, *60*, 61
Pyle, Howard
 The Battle of Bunker Hill, 160, *160*
 works by, stolen, 160

R
Rand Corporation, 18
Raphael
 Man with a Red Hat, 47
 Portrait of a Young Man, 49, *49*
 works by, stolen, 13
Rawson, Harry, *24*, 25–26
Raymond, Henry Judson.
 See Macintyre, Ben
recovery of artwork, 49, *55*, *59*, 66, 67,
 112, *112*, 113, 115, 120, 130
Reinhardt, Spencer, 87
Rembrandt
 A Lady and Gentleman in Black,
 170
 Landscape with Cottages, 174, *174*
 paintings attributed to, 171
 *Portrait of a Man with Red Cap
 and Gold Chain*, 130
 Self-portrait, *104*, 107–108, *109*, *112*,
 170
 Storm on the Sea of Galilee, 73, *73*,
 170, *170*
 works by, stolen, 11, 12, 13, 21, 73,
 73, *104*, 107–108, *109*, 170, 174
Renfrew, Colin, 141
Renoir, Pierre-Auguste
 *Bal au moulin de la Galette,
 Montmartre*, 19
 Conversation, 107–108, *109*
 Jeunes femmes à la compagne, 172,
 172
 La Pensée (Young Woman Seated), 16
 Portrait de Madame Albert André,
 173, *173*

Roses in a Vase, 173, *173*
Sotheby's 1958 sale, 15
works by, stolen, 13, 107–108, *109,*
 110, 172, 173
Young Parisian, 107, 107–108, *110*
restitution of stolen art, 26, 28–29, 67,
 68, 69
Reynolds, Joshua
 Francis Hargrave, 168
Richard Wagner Museum, 80
Rietschoof, Jan Claesz
 View on the Oostereiland (Hoorn),
 151, *151*
 works by, stolen, 151
Rijksmuseum, 29, *94,* 95
Rikers Island, 128
Rockefeller, John D., 27
Rodin, Auguste
 The Trunk of Adele, 84, *85*
 works by, stolen, 84, *85*
Rokoszynski, Jurek "Rocky," 121
Rose, Andrea, *129*
Rosenberg, Alfred, 46
Rosenberg, Paul, 54, 69, 113
Rosetta Stone, 21, 34
Rothschild collection, *47, 47, 48*
Rubens, Peter Paul
 Massacre of the Innocents, 19, *19*
 Tarquinius and Lucretia, 64, *65*
 works by, stolen, 12, 13, 64, *65*
Russborough House, 95, 96, 98,
 99–101, 117
Russia
 and stolen art, 63–64
 thefts in, 160
Russo, Rene, 71, 124, 144

S
Saddam Art Centre, 31
Saint Louis Art Museum, 40
Sakhai, Ely, 76, *76*
Samuhel Gospels, 66, *66*
San Diego Museum of Art, 139
Sanssouci Palace, 64
Santo Spirito Hospital, 154
Schirn Gallery, 121

Schliemann, Heinrich, 63, *63*
Schloss, Adolphe, 46
Schmidt, Martin Johann
 Madonna and Child, 21, *21*
Schroeder, Gerhard, *60,* 61
Schwarzburg Castle, 67
Scotland, thefts in, 98, 105–107, 154
Scotland Yard, 105, 112, 117, 120
Sears–Vincent Price Gallery, 130
Seattle Art Museum, 69
security, in museums, 133–138, 134, *137,*
 143, *143*
Smith, Grace Cossington, 116
Smith, Harold J., 125, *125*
Sofia Imber Contemporary Art
 Museum, 158
Sotheby's, *20,* 67, 76, 113
 annual sales, 18
 auction in 1958, *15,* 15–18, *16, 17*
 competition with Christie's, 19
Stalin, Josef, 61–63
State Pushkin Museum of Fine Arts,
 63, 64
Stengel, Mireille, 80–83
Strauss, Richard, 43
Strindberg, August
 Night of Jealousy, 148, *148, 149*
 works by, stolen, 148
Strindberg Museum, 148
Sully, Thomas
 Portrait of Frances Keeling
 Valentine Allan, 163, *163*
 Queen Victoria, 163
 works by, stolen, 163
Sweden, thefts in, 107–112, 148, 164
Switzerland, thefts in, 78, 80, 153

T
Tate Gallery, 27, 121, *122, 123,* 129, 171
Taylor, Francis H., 53
Teniers, David (the Younger)
 Archduke Leopold Wilhelm and
 the Artist in the Archducal
 Picture Gallery in Brussels, 47
 The Monkey's Ball, 80
 works by, stolen, 80

Thomas Agnew & Sons, 75
Thomas Alcock Collection, 93
The Thomas Crown Affair, 71, 124, 144
Thomson, Sir Kenneth, 115, *115*
Tierney, James, 91
Tischbein, Johann Friedrich August
 Elizabeth Hervey Holding a Dove,
 67
 works by, stolen, 67
Titian
 works by, stolen, 13
Tokeley-Parry, Jonathan, 93, *93*
Transylvania University, 86, 87
Treaty of Versailles, 49, 50
True, Marion, 103
Turkey, looting in, 63
Turner, Joseph (J.M.W.)
 Light and Colour—The Morning
 After the Deluge, 121
 Shade and Darkness—The
 Evening of the Deluge, 121, *122*
 works of, stolen, 13, 121

U
Uffizi Gallery, 45, *46,* 83, *84*
United Nations Educational, Scientific,
 and Cultural Organizations
 (UNESCO), 141
United States, thefts in, 11, 84, 86–87,
 89–90, 92, 101–102, 130, 148, 150,
 158, 160, 163, 170, 171

V
Valentine Museum, 163
van Dyck, Anthony
 Henriette of France as a Child, 47
van Eyck, Hubert, 50
van Eyck, Jan
 The Adoration of the Mystical
 Lamb, 176
 The Just Judges, 176, *176*
van Gogh, Vincent
 Congregation Leaving the
 Reformed Church in Nuenen,
 157, *157*
 The Fortification of Paris with

Houses, 73
Irises, *18*, 19
Portrait of Dr. Gachet, 19
Self-portrait Dedicated to Paul Gauguin, *42*
Sotheby's 1958 sale, 15
View of the Sea at Scheveningen, *156*, 157, *157*
works by, stolen, 13, 40, 73
Van Gogh Museum, 157
van Loon, Jan Jr., 167
van Ostade, Adriaen
Drinking Peasant in an Inn, 159, *159*
The Quack, 159
works by, stolen, 159
van Rijn, Michel, 126
van Wittel, Caspar, 151
Vasquez, Roberta, 91
Venezeula, thefts in, 158
Verard, Antoine
Hortus Sanitatis, 87, *87*
Vermeer, Johannes
The Art of Painting, 51–53
The Astronomer, 47, *48*
The Concert, *10*, 11, 170, *170*
Girl with a Pearl Earring, 170
Lady Writing a Letter with Her Maid, *95*, 96, 99, 117
The Little Street, 94
The Love Letter, 94, *95*

The Milkmaid, 94
The Music Lesson, 170
Portrait of the Artist in His Studio, *52*
recovered works, 120
Woman in Blue Reading a Letter, 94
works by, stolen, 11, 13, 51–53, *94*, *95*, *95*, 96, 99, 117, 170
Vestier, Antoine
works by, stolen, 117
Victoria & Albert Museum, 12, 137, 152
Vilkov, Anatoly, 63
von Behr, Kurt, 54
von Ribbentrop, Joachim, 54, *55*
von Saher, Charlène, 68

W
Waben, Jacob
Vanitas, 150, *150*
works by, stolen, 150
Waft of Mist, 121, *121*
Walpole, Sir Robert, *22*, 22–25, *23*
Walton, Izaak
Compleat Angler, 86
war
art looted, 21, 31, 32–34, 40-59, 64–67
role in art theft, 25–26
Warhol, Andy
works by, stolen, 13
Watteau, Jean-Antoine

L'Indifférent, 84
A Study of Two Men, 80
works by, stolen, 47, 80
Wellesley, Arthur. *See* Wellington, Duke of
Wellington, Duke of, *70*
Westfries Museum, 150, 151, 152
Whitney, Gertrude Vanderbilt, 158
Whitney Museum, 29
Whitworth Art Gallery, 73
Wilson, Peter Cecil, *15*, 16
Withoos, Matthias
Harbour in Hoorn (1), 151, *151*
Harbour in Hoorn (2), 151, *151*
works by, stolen, 151
Wittman, Robert K., 72, 105, 107, 108, 110, 111–112, 126
Wootton, John, *23*
Worth, Adam, 72–75, *75*, 77
Wyeth, Andrew
Moon Madness, 172, *172*
The Studio, 130, 131
works by, stolen, 172

Z
Zeta-Jones, Catherine, 71
Ziegler, Adolph, 38
Zorn, Anders Leonard, *13*

SELECTED BIBLIOGRAPHY

Alford, Kenneth D. *The Spoils of World War II: The American Military's Role in Stealing Europe's Treasures*. New York: Birch Lane Press, 1994.

Atwood, Roger. *Stealing History: Tomb Raiders, Smugglers, and the Looting of the Ancient World*. New York: St. Martin's Press, 2004.

Dolnick, Edward. *The Rescue Artist: A True Story of Art, Thieves, and the Hunt for a Missing Masterpiece*. New York: HarperCollins, 2005.

Feliciano, Hector. *The Lost Museum: The Nazi Conspiracy to Steal the World's Greatest Works of Art*. New York: Basic Books, 1997.

Goldstein, Malcolm. *Landscape with Figures: A History of Art Dealing in the United States*. New York: Oxford University Press, 2000.

Hart, Matthew. *The Irish Game: A True Story of Crime and Art*. New York: Walker & Company, 2004.

Haywood, Ian. *Faking It: Art and the Politics of Forgery*. New York: St. Martin's Press, 1987.

Herbert, John. *Inside Christie's*. New York: St. Martin's Press, 1990.

Honan, William H. *Treasure Hunt: A New York Times Reporter Tracks the Quedlinburg Hoard*. New York: Fromm International Publishing Corporation, 1997.

Lacey, Robert. *Sotheby's—Bidding for Class*. New York: Little, Brown & Company, 1998.

Lord, Barry and Gail Dexter Lord. Foreword by Nicholas Serota. *The Manual of Museum Management*. London: The Stationery Office, 1997.

Messenger, Phyllis Mauch, ed. Foreword by Brian Fagan. *The Ethics of Collecting Cultural Property*. Albuquerque: University of New Mexico Press, 1989.

Meyer, Karl E. *The Plundered Past*. New York: Atheneum, 1973.

Simpson, Elizabeth, ed. *The Spoils of War*. New York: Harry N. Abrams, Inc., 1997.

Watson, Peter. *Sotheby's—The Inside Story*. New York: Random House, 1997.

ACKNOWLEDGMENTS

Many individuals and organizations eased the way for the research and writing of this book. I am unable to mention some by name because of pledges of confidentiality, but I would like to thank the private detectives and museum staff in Canada, the United States, and Europe who generously offered their insight into the world of security and art theft. Thanks to those who spoke with me on the record, including Robert Wittman at the FBI in Philadelphia and Mark Dalrymple in London. And thanks to the librarians from New York to London who didn't blanch when I approached with some unusual requests.

I have immense respect for Elizabeth Simpson, Konstantin Akinsha, and Jonathan Petropoulos for their individual work as historians and journalists, and their collective efforts on The Documentation Project at Loyola University, which was very helpful in researching Chapter 2.

In the sometimes-murky world of museums, auction houses, art theft, and especially theft in the time of war, there is an extraordinary amount of misinformation, unfounded conjecture, and sloppy reporting disguised as fact. I have strived to ensure this book contains no factual errors. Readers who have a comment on the text are invited to contact me c/o Madison Press Books.

Thanks to editor Jonathan Webb for giving me the strong bones that I could wrap in flesh and muscle, and everyone at Madison Press, including Shima Aoki for her patience and steady hand and especially Oliver Salzmann for his original vision and rare intelligence.

Special thanks to Rosemary, Sascha, and Michal, for understanding the importance of this story.

This book is for my parents, the artists.

—Simon Houpt

Madison Press Books would like to thank Simon Houpt for being such a pleasure to work with. He has eloquently brought to light the often-murky world of art theft. We would also like to thank Jonathan Webb, Carolyn Jackson, and Cathy Fraccaro for their invaluable editorial contributions throughout the project. We are grateful to Linda Gustafson for her beautiful design, and to Peter Ross for his meticulous work with the illustrations.

This book benefited immensely from all of the people who offered their assistance to the project, including: Donald Hrycyk of the Los Angeles Police Department's Art Theft Detail; Betsy Glick, James Margolin, and James Wynne of the Federal Bureau of Investigation; Richard Perry from the *Espadaña Press*; Susan Brown of the Transylvania University Library; and all of the museums, archives, and private collectors who so graciously sent us images for our use and helped us with any questions we had.

Last but not least, we are indebted to Julian Radcliffe and the staff of the Art Loss Register for their enthusiasm and commitment to this project, as well as for their generosity in lending us their time and expertise.

EDITORIAL DIRECTOR
Wanda Nowakowska

SUPERVISING EDITOR
Shima Aoki

MANUSCRIPT EDITOR
Jonathan Webb

PROJECT EDITOR
Carolyn Jackson

GALLERY EDITOR
Cathy Fraccaro

PHOTO RESEARCHER
Bao-Nghi Nhan

DESIGNER
Counterpunch,
Linda Gustafson

ART DIRECTOR
Jennifer Lum

PRODUCTION MANAGERS
Donna Chong
and Sandra L. Hall

VICE PRESIDENT, BUSINESS AFFAIRS AND PRODUCTION
Susan Barrable

PUBLISHER
Oliver Salzmann

PRINTED BY
Lotus Printing, China

MUSEUM OF THE MISSING
was produced by
Madison Press Books